THE GARDEN OF EARTHLY DELIGHTS

HIERONYMUS BOSCH

JOHN ROWLANDS

PHAIDON

For my father

The Garden of Earthly Delights

Ever since they were executed Hieronymus Bosch's paintings have held an irresistible fascination for those who in each generation took the trouble to regard them as more than purely objects of idle curiosity. Despite the variety of notions that have been entertained about them, it is important to remember that Bosch was brought up in Brabant in the Low Countries at the end of the Middle Ages, and that behind all his works lie the assumptions and preoccupations of his day. Life then was one of sharp contrasts, understood by people in the light of dogmas of the Pre-Reformation Church. The climate of thought was largely conditioned by a pessimistic view of man's fate in this world, in which the power of evil seemed to be driving him relentlessly towards his damnation. The hopeful message of the Merciful Redeemer who saves the repentant sinner is hardly touched on in Bosch's paintings.

Although Bosch's works are often complicated in their imagery, they are likely to be properly understood if we search in them for an overall theme consonant with the world in which the artist worked. We are concentrating here on one of his masterpieces, the *Garden of Earthly Delights*, which was also called in an early inventory 'the Vanity of the World'. It is perhaps his most beautiful, certainly his most complex creation, and one of the three large triptychs, now in the Prado Museum, Madrid, which were once the pride of Philip II.

Its subject is the Last Judgement, which is a recurrent one throughout his work, but which is treated here in a revolutionary way. A landscape with the high horizon usual for the period stretches continuously from the *Garden of Eden* on the left wing across the plain of the central panel, full of primitive men, birds and animals, to the cold, dark, murky plains of Hell lit by hideous fires. In the intriguing central panel early man untroubled by old age, is pictured naked satisfying his natural appetites to the full in the summer sun. Soft fruit, particularly strawberries are the staple diet, offered by one sex to the other. Women stand in a pool, balancing cherries on their heads, while around them, men ride bareback on animals careering along in herds. The sexual overtones of all this are obvious enough. In the distant background stand strange horn-like structures like giant crustaceans, that give a sense of poetic fantasy as well as compositional coherence to the landscape.

The contrasting picture of Hell on the right could hardly be more striking. For apart from the all-consuming flames of Satanic funaces Bosch's Hell is a frozen, dead place where nature has died. The pools are covered with ice, and a nightmare tree with the face of a man has lost its bark.

Although it has generally been explained as a condemnation of

The Third Day of Creation.
The closed wings of the Triptych.
There is inscribed across the top of the wings a Latin quotation, Psalm 33:9, which in the Common Prayer Book translation reads 'For He spake, and it was done: He commanded, and it stood fast'. It is interesting to note that this quotation had been used in a woodcut by Michel Wolgemut (1434–1519) of God the Father similarly enthroned, which served as the frontispiece of the *Nuremberg Chronicle* of 1493, the first bestseller in the history of printing. This book was obviously known to Bosch, and is a rare instance of the artist overtly copying the work of another.

It was then common in Northern Europe to paint the subjects on the outside wings of an altarpiece in grey tones, *en grisaille* in imitation of sculpture. Another fine example by Bosch is *the Mass of St. Gregory* on the closed wings of *the Adoration of the Magi* in Madrid. In the present painting Bosch shows us the still incomplete creation in shades of grey bathed in light like that of the moon. Each of the successive panels of the Triptych is painted with its own distinctive light and colour range.

Phaidon Press Limited, Littlegate House, St Ebbe's St, Oxford
English text © 1979 by Phaidon Press Limited
First published as Le Jardin des Délices de Jérôme Bosch
© 1977 by Editions Hier et Demain
Published in the United states of America by E.P. Dutton, New York
All rights reserved.
ISBN 0 7148 2015 6
Library of Congress Catalog Card Number 79-84861
Printed in Italy by G.E.A., Milan

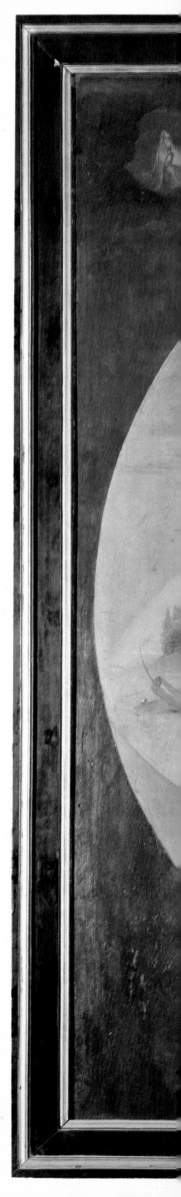

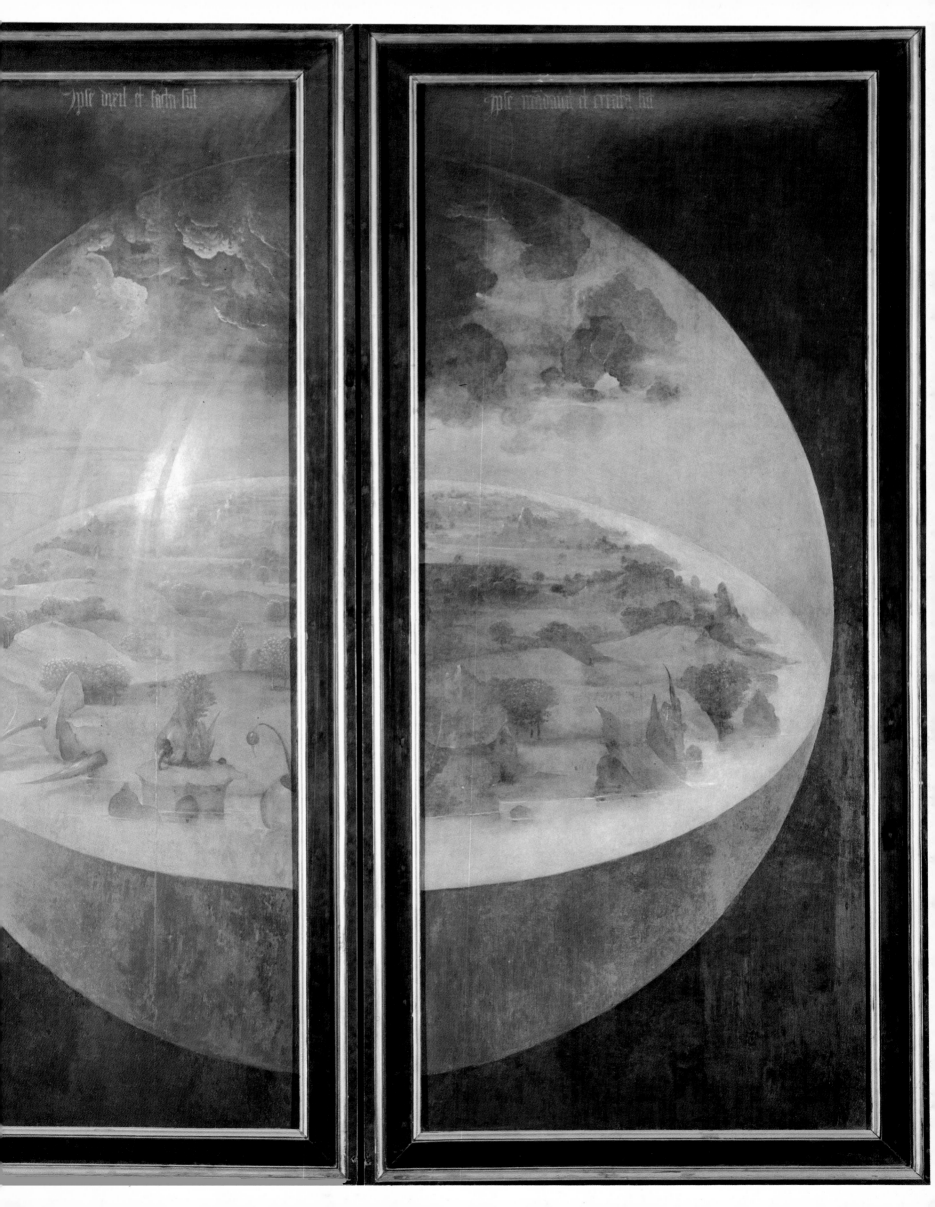

the follies of sinful man, cursed by carnal lust, some trying to probe deeper have seen the painting as a vision of an unearthly paradise. The dream-like quality of the painting has also called forth speculations based on a psychoanalytical approach. However fascinating these may be, they can be a snare for the unwary in that it is dangerous to use such modern insights to interpret the symbolism of an earlier age when man's expectations and assumptions were so different. It is not historically acceptable to divorce Bosch from his beliefs and those of his contemporaries. Bosch has created a kind of Garden of Love, a convention beloved of the Burgundian Court, in which, however, the sexual fantasy is laid bare and made explicit. Here man does not behave like a decorous courtier. In Bosch's garden the couples bathe and openly make love in the water. Then water was closely associated with love, for the children of Venus, lovers, were always represented embracing in water. Further astrological references occur elsewhere in his paintings. In *the Wayfarer* at Rotterdam, the beggar-like figure has been plausibly interpreted as the Child of Saturn, a man dogged by misfortune. Some also have pointed to references to alchemy in his paintings; this seems very likely as the artist would have had some knowledge of this medieval science because members of his wife's family were chemists. The lovers in various vessels in the central panel could perhaps be an allusion to the language of alchemy, in which procreation is the key to the evolution of the whole material world.

By contrast the linking of this triptych with an astrological programme has suggested ideas which harmonize less well with the traditional meaning of the painting, particularly the proposal that the central panel shows us the Heaven of Christ's elect. This is not only at variance with Bosch's pessimism but also conflicts with the subject of the wings. But the most startling interpretation of the triptych is that of Wilhelm Fraenger who views the work optimistically. For him the left-hand wing is merely that of the union of Adam and Eve, without any idea of the Fall. In the central panel we are introduced to some cult whose adherents seek a return to the supposed innocence of primitive man. With a curious logic it is assumed that Bosch, in creating such an extraordinary painting, must have been unorthodox in his religious beliefs. But there is no necessary connection between artistic originality and the holding of heretical opinions. This *non sequitur* encouraged the notion that Bosch was a secret member of a heretical sect, the Adamites, one of whose leaders is supposed to have been Jacob van Almangien, a member together with Bosch of the Brotherhood of Our Lady in 's Hertogenbosch the town where the artist lived. This man, according to Fraenger was responsible for the triptych's elaborate programme, which he presumed was drawn from a wide range of literature, which formed the basis for

its creation. Not only does this theory stretch one's credulity, especially as it involves accepting an inversion of the usual meaning of imagery then, but it reduces Bosch's role to the level of a clever illustrator. He is, of course, much more than that, a brilliant preacher who painted terrifying sermons warning of impending disaster. It also rests on a mistaken view of Bosch's imagery. There is, in my view, quite often more than one possible meaning that one might conceivably attach to a particular detail. With all their associations they would have prompted all kinds of responses in Bosch's contemporaries some of which we can only guess at and some of which perhaps are lost to us with the passage of time.

There is fortunately good contemporary evidence to counter the Adamite theory. On 30 July 1517 Antonio de Beatis, according to his diary, saw a painting by Bosch in the Palace of Henry III of Nassau in Brussels, whose general description could fit the present work. Although interested in it more for its satirical detail than its underlying religious message, he noticed in it 'others who defecate cranes'. This could be a slightly mistaken reference to the Rabelaisian detail of the large bird-like devil who devours the damned while birds, more like swallows than cranes, are flying from the buttocks of a victim whose head is being bitten off. Its identification is confirmed because it was among the paintings confiscated at the Palace by the Duke of Alba, that passed via his natural son to the Escorial in 1593. It would seem to be almost certain that the painting was commissioned from the artist by a member of the Nassau family, which was closely connected with Brabant, and not by a secret religious sect.

A more straightforward interpretation which takes account of the triptych as a whole is available to us. On the closed wings Bosch has painted the *Third Day of Creation*. God the Father looks down on his Creation when the light has been divided from the darkness, and on a flat world contained within a transparent globe. Dark rain clouds are gathering over a landscape which as yet lacks any animal life, but has the beginnings of that strange vegetation which has fully matured on the central panel. Disregarding the biblical reference inscribed across the top of the wings referring to the Creation, Gombrich has proposed that the closed wings show us the world after the flood. But there is none of the flotsam we should expect, and no Ark, as there is on the right hand wing of another triptych by Bosch at Rotterdam. His interpretation, however, of the central panel as the sinful descendants of Adam in the days of Noah is entirely convincing. Because the 'wickedness of man was great in the earth', it grieved God 'that he had made man on the earth' (Genesis 6:5,6). This explanation fits admirably into the overall scheme of the work. From the first

The Garden of Eden.
Left Wing of the Triptych. 220 x 97 cm.
In the foreground God the Father has just created Eve as the companion of Adam. No doubt Bosch chose this moment as Eve was held responsible, in accord with the Genesis text, for Man's Fall. On the left behind them is evidently the Tree of Knowledge of Good and Evil with its forbidden fruit, which we afterwards find the inhabitants of the plain on the central panel consuming freely. The animal life roaming Paradise includes not only types known to us but also some of the fabulous beasts that Bosch would have learnt of from medieval bestiaries. He also added a few of his own invention. The Garden is not an entirely peaceful place as in the foreground a cat is carrying off a mouse he has caught, and in the far background a dragon is fighting with a large wild boar.

stages of Creation, the Fall of Man is traced from the Creation of Eve in the Garden to the corruption in the time of Noah which caused God to say 'I will destroy man whom I have created from the face of the earth' (Genesis 6:7). The right wing contains the fateful message of the imminent end of the world, and the torments of Hell awaiting the unrepentant. Here there is no hint of the possibility of redemption through Christ's intercession as there is in another of his great triptychs also concerned with the Last Judgement, *The Haywain*. Bosch had a highly receptive audience for the apocalytic message, because people were then continually seeing signs of the coming of the Antichrist in all kinds of contemporary calamities and wonders. They watched for these because the Antichrist's reign would, according to the Book of Revelation, immediately precede Christ's second coming.

So much for the painting's message; there is, however, no scholarly explanation for the precise form that Bosch's imagery took. Like other artists of the period he had inherited a vocabulary of fantasy and anecdote present throughout late Gothic art, from the drolleries in the margins of manuscripts to the carved misericords and corbels in the churches. All these expressive elements, figments of men's minds, were plundered by Bosch and moulded by him into his own coherent language. While his rich imagination must be a cause for wonder, he also shows us that it is not enough merely to have fantastic visions, one has to be able to arrange them. We quickly see how sure Bosch's sense of space and composition is if we compare his works with those of his followers, whose imitations in the Bosch manner, apart from lacking the Master's invention, can be recognised from the haphazard jumble of their detail.

But perhaps Bosch's finest gift was his ability to reconcile the seemingly irreconcilable, in the juxtaposition of objects from daily life alongside his fantastic creatures, whose bodies are often themselves made up of disparate parts. It is probably his unerring sense of the appropriate scale which makes the incredible visually credible. All the musical instruments in *Hell,* for instance, dwarf the damned but are painted not only accurately in their detail, but also correctly in scale with one another. Similarly the birds are depicted much larger than the mortals on the central panel, based no doubt on drawings in a pattern book, and are likewise painted correctly in scale. Thus, in this way, Bosch keeps his exuberant ideas under control.

The more we gaze on this extraordinary masterpiece the more we are fascinated by the strange and enchanted vision he has created in the *Garden of Earthly Delights*. But even with his colourful pallette Bosch is warning us of the dangers that lie in wait for us in the seductive beauty of this world.

The Sinful Descendants of Adam.
The central panel of the Triptych. 220 x 195 cm.
In an early description of the paintings that belonged to Philip II in the Escorial in the *History of the Order of St. Jerome* of 1605, Fra José de Siguenza states that the present painting's chief subject is the strawberry plant, the characteristic of whose fruit is that once it has been eaten it leaves little taste behind in the mouth. This was the fruit symbolising the transitoriness of earthly delights, that brought death into the world. According to Fra José the artist has given us an elaborate fantastic picture of Man's Fall, conquered by Sin, with the jaws of Hell awaiting him. This subject, he added, the artist has also portrayed in a much simpler way in his Triptych, *The Haywain*.

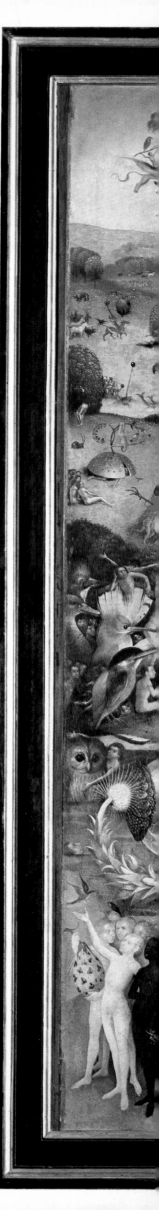

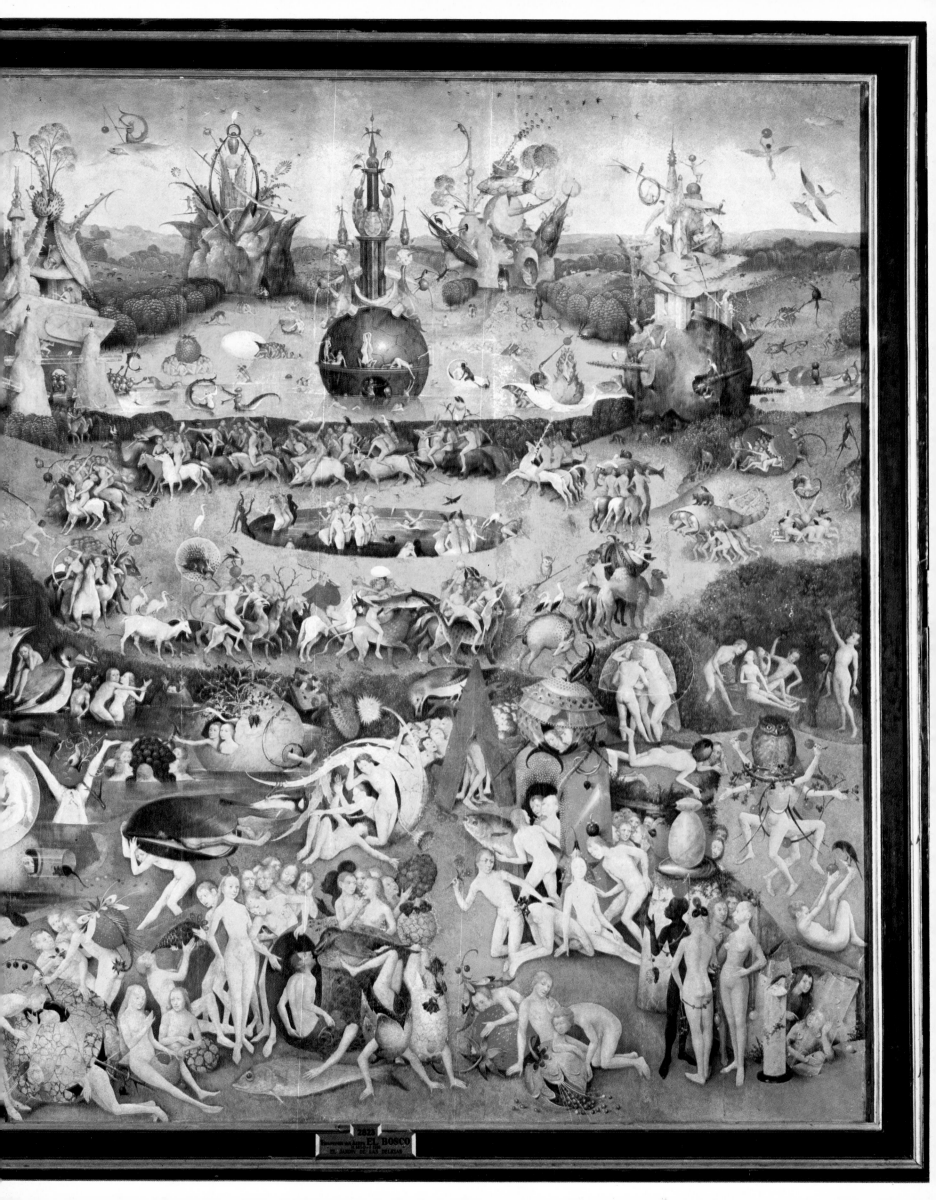

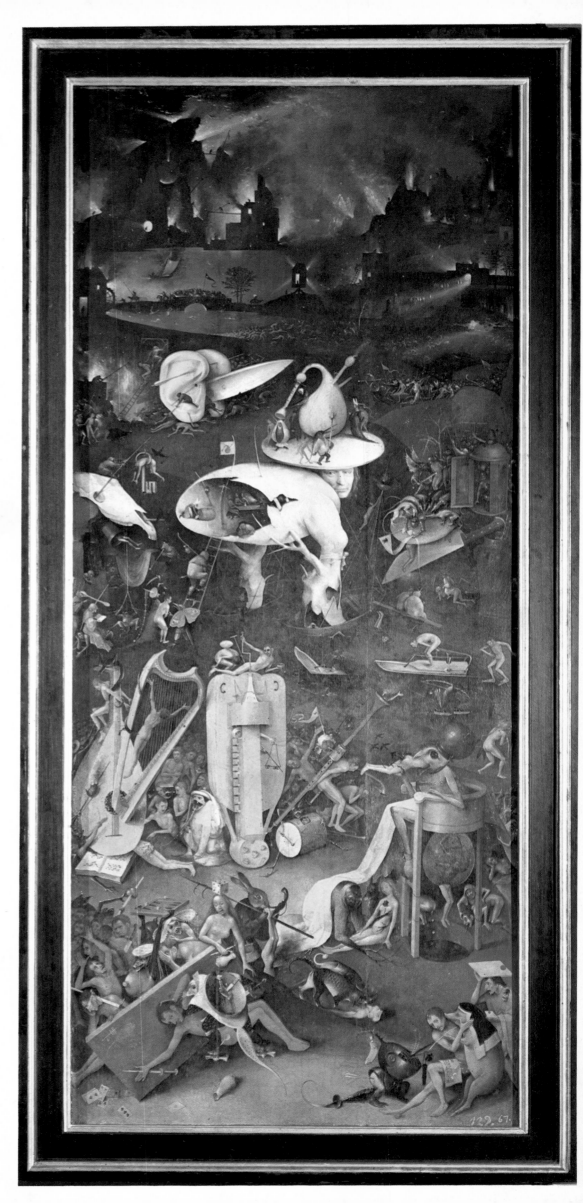

Hell.

Right wing of the Triptych. 220 x 97 cm.
The foreground is cluttered with objects from everyday
life that were then associated with possible occasions for
sin. The cards, dice, and backgammon board, by the
overturned table are a clear reference to a drunken gamb-
ling brawl which often ended in violent death. The knifed
victims, Bosch shows us, being herded off by devils.
Bosch's contemporaries had a great fear of dying
unshriven.

The musical instruments further back could be a refer-
ence to the seductive charms of music and the dance. The
damned to the right of the giant hurdy-gurdy appear to be
dancing to a deafening hellish tune. To its left a group are
singing with a devil a partsong which is written out across
a man's buttocks. It was evidently a low one.

THE GARDEN OF EDEN

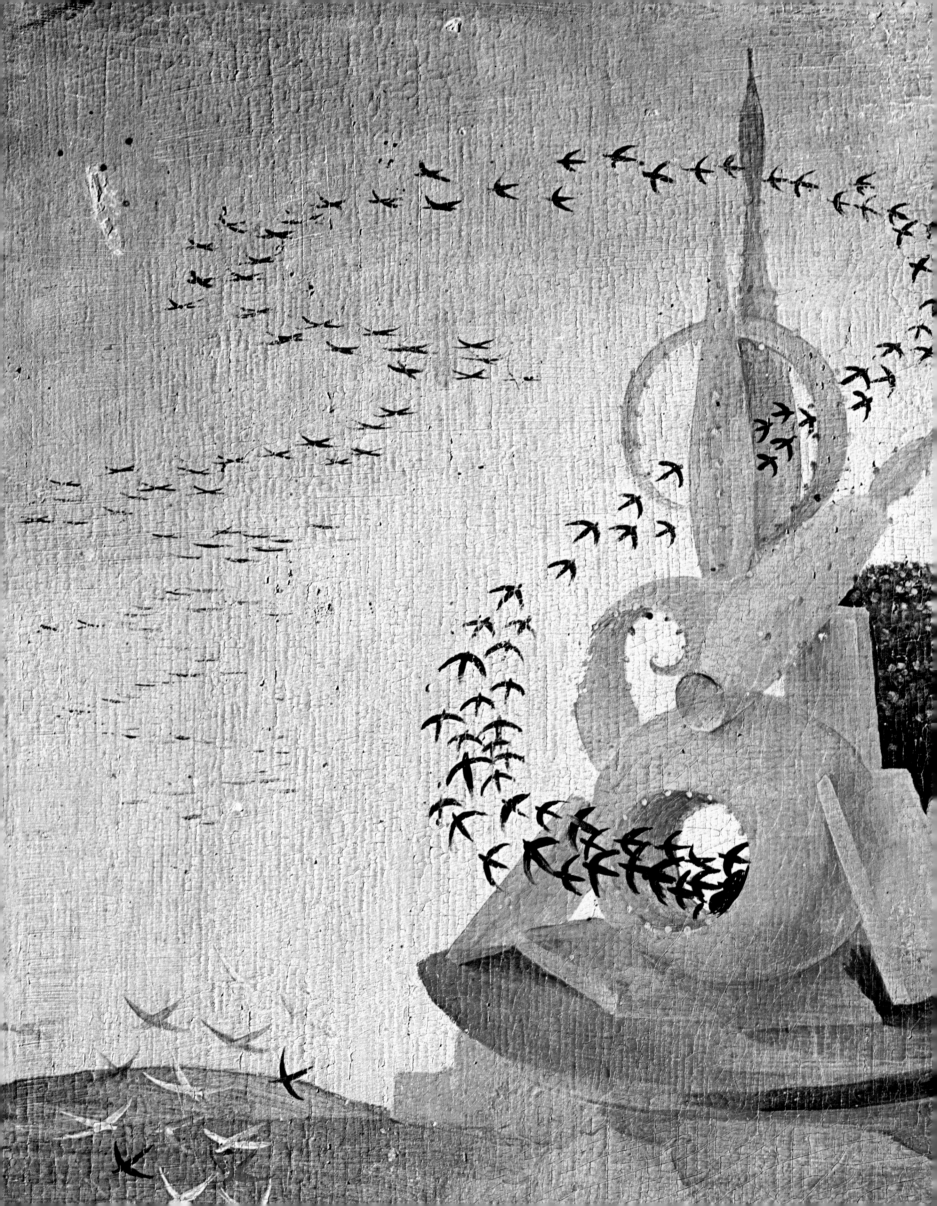

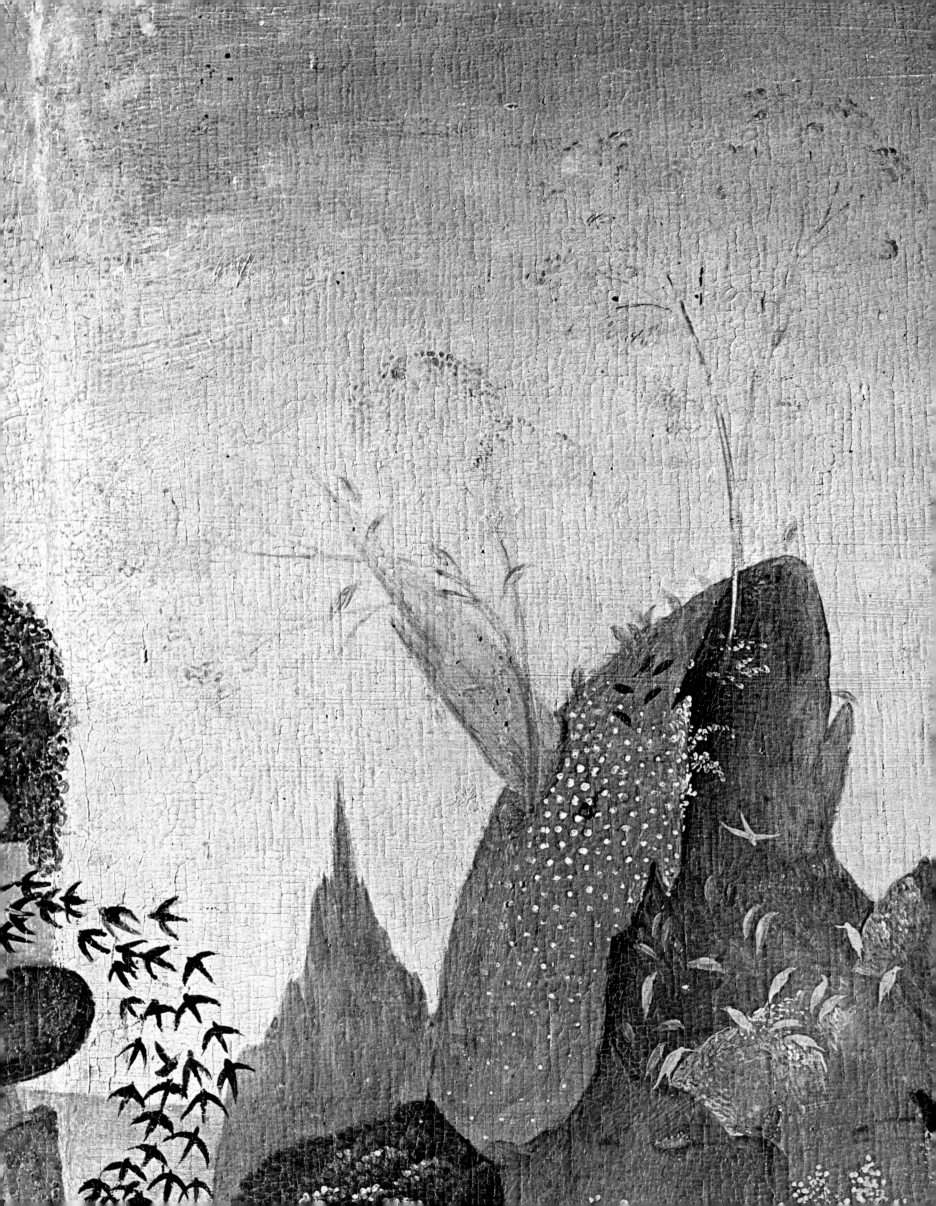

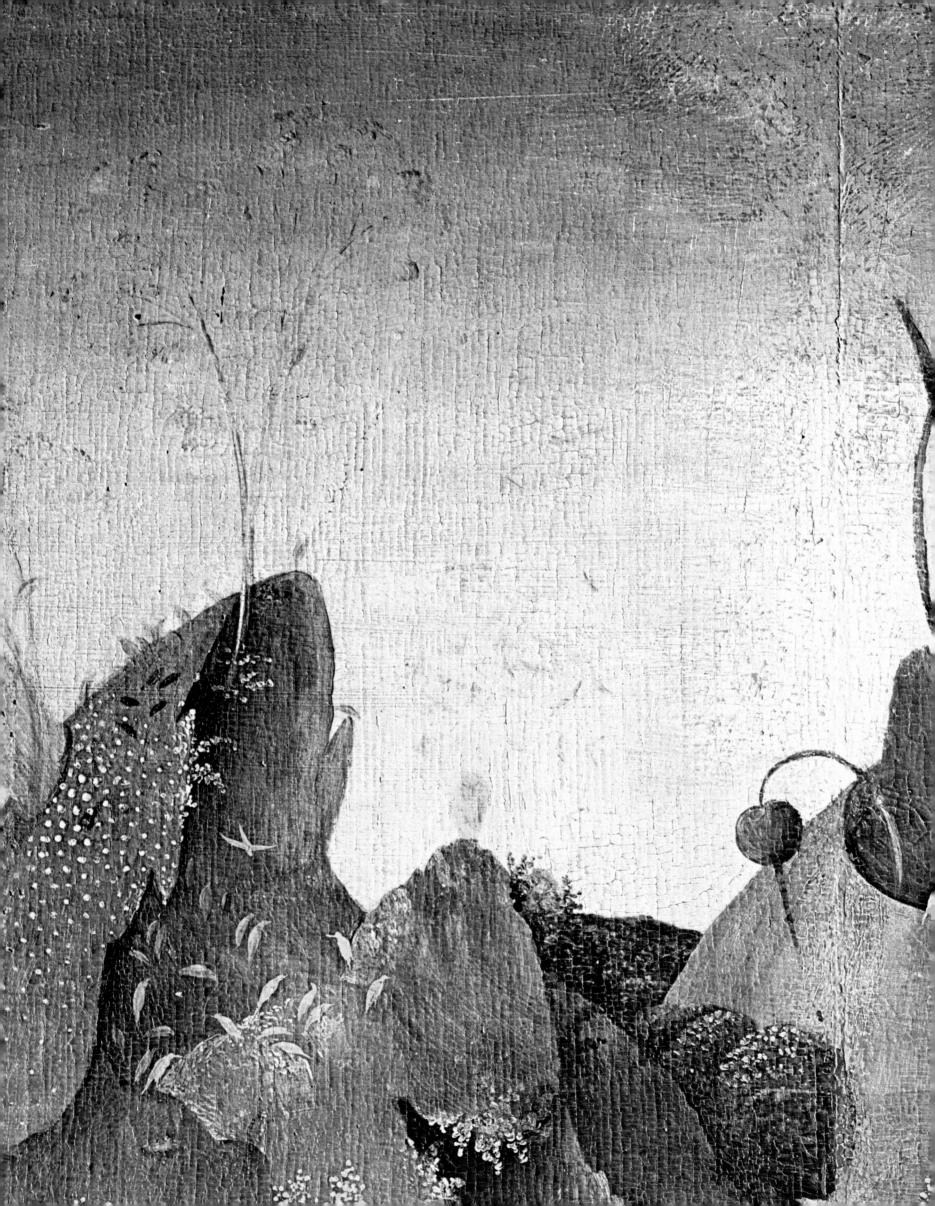

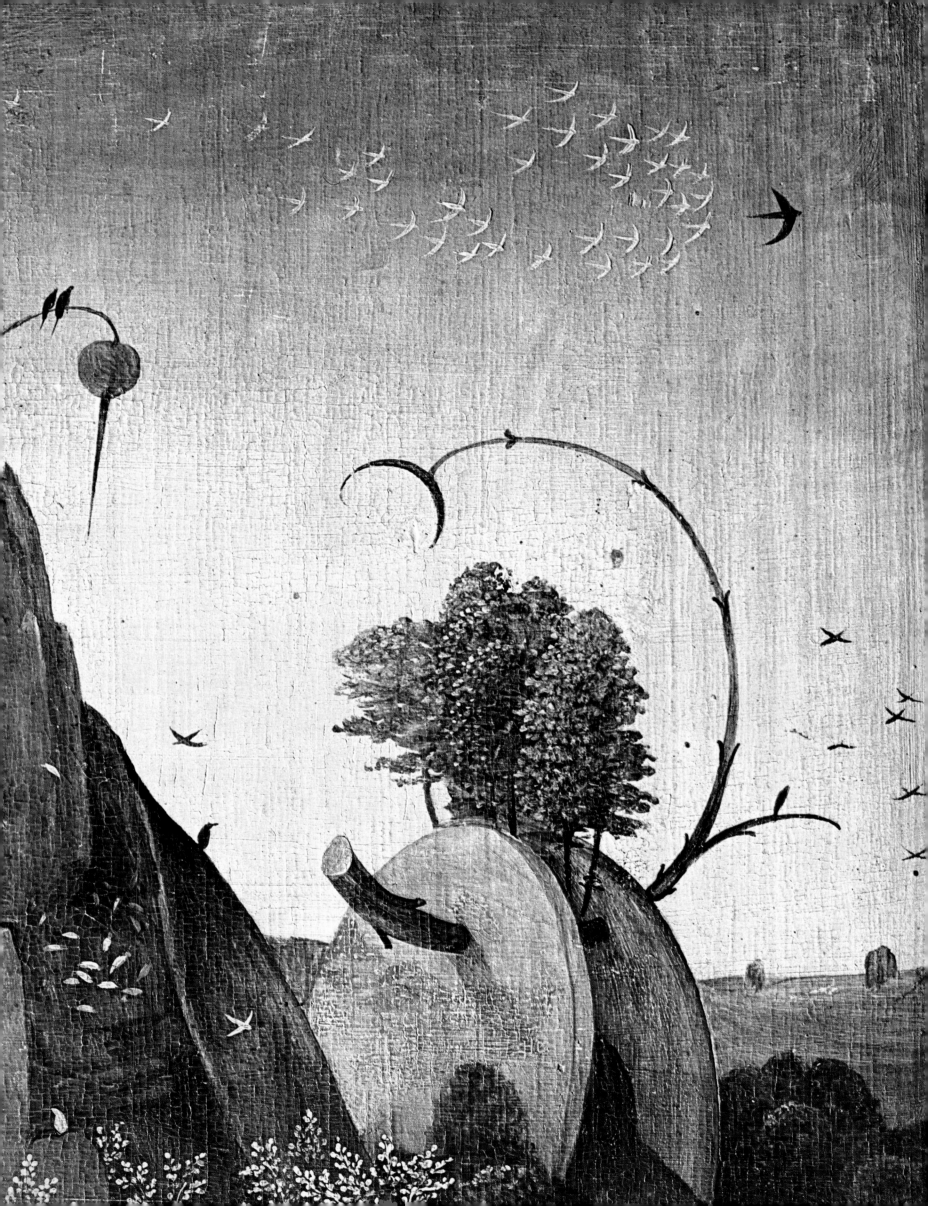

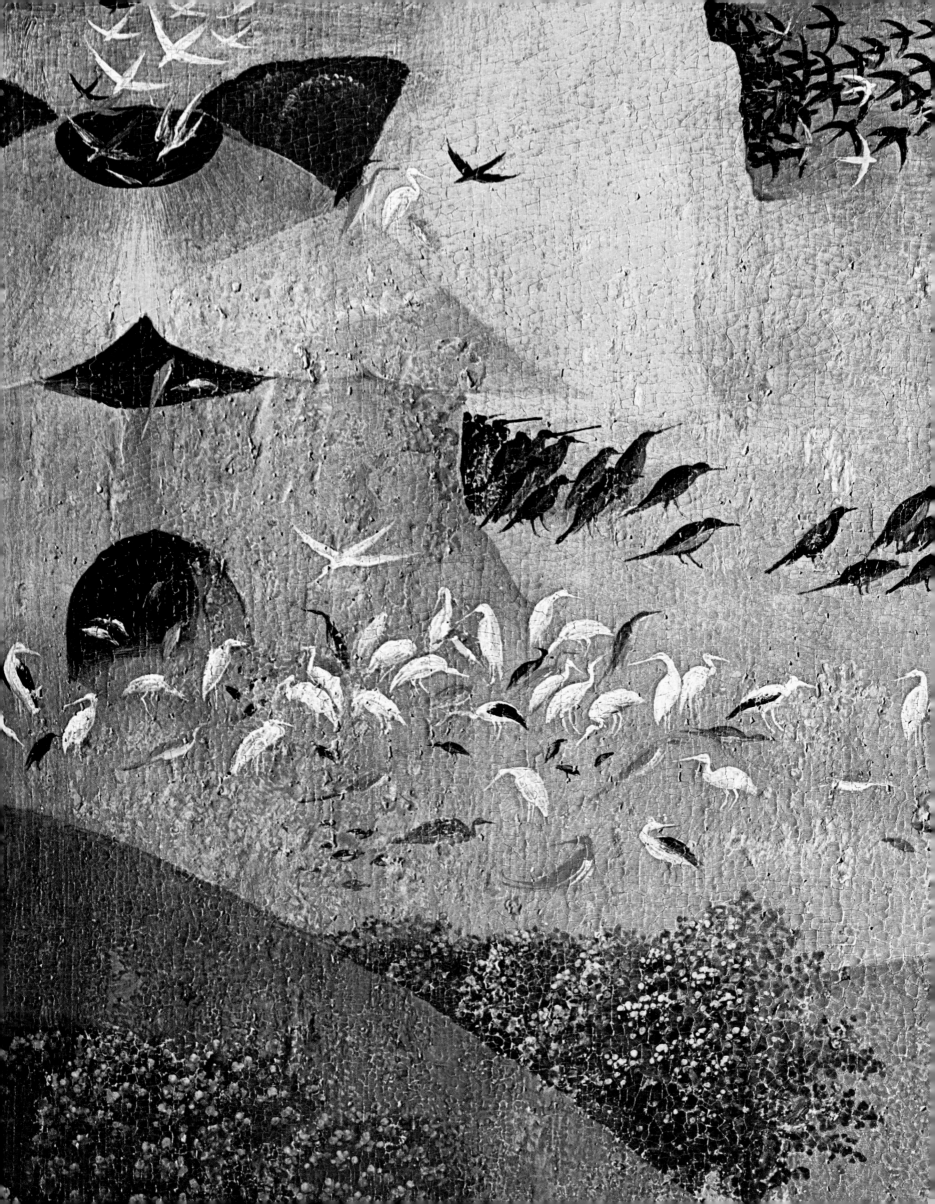

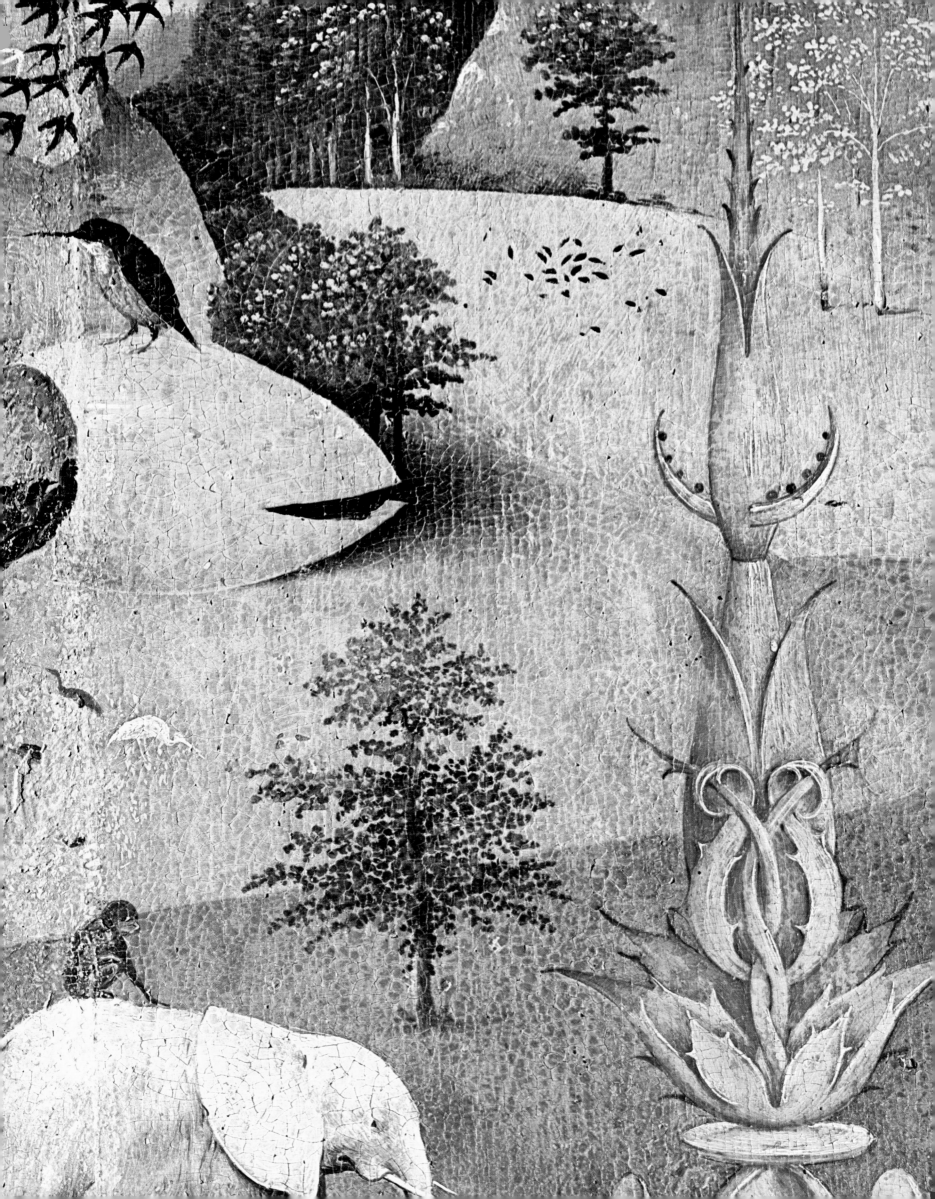

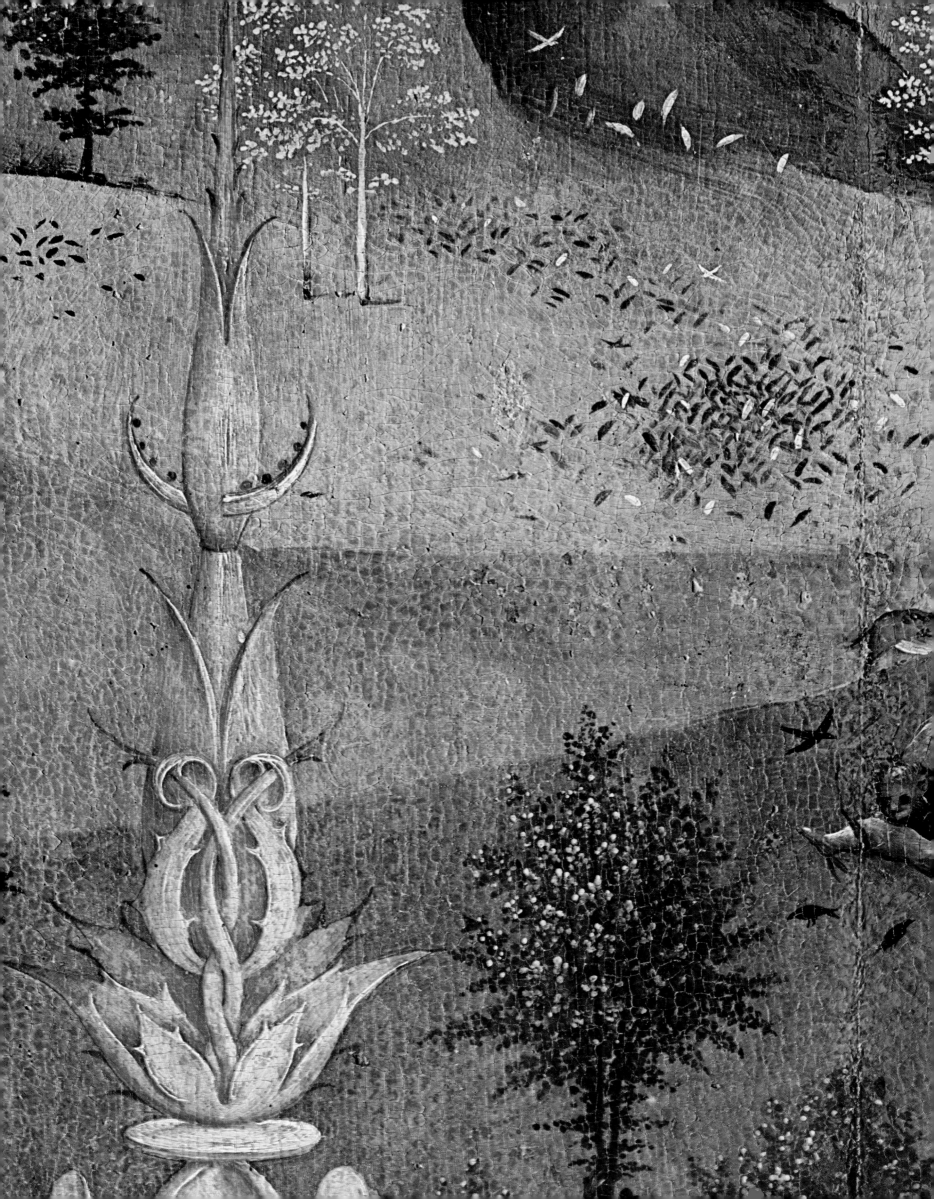

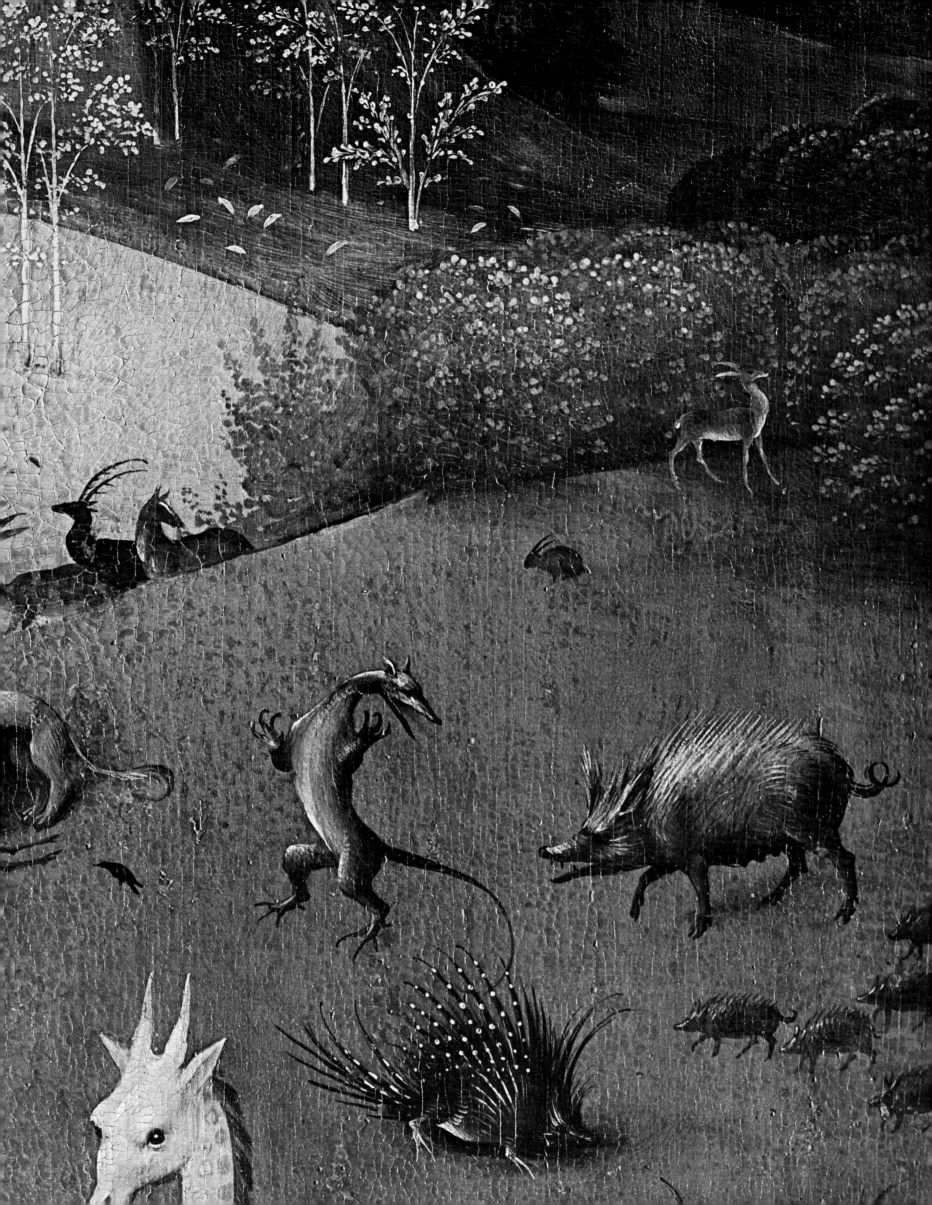

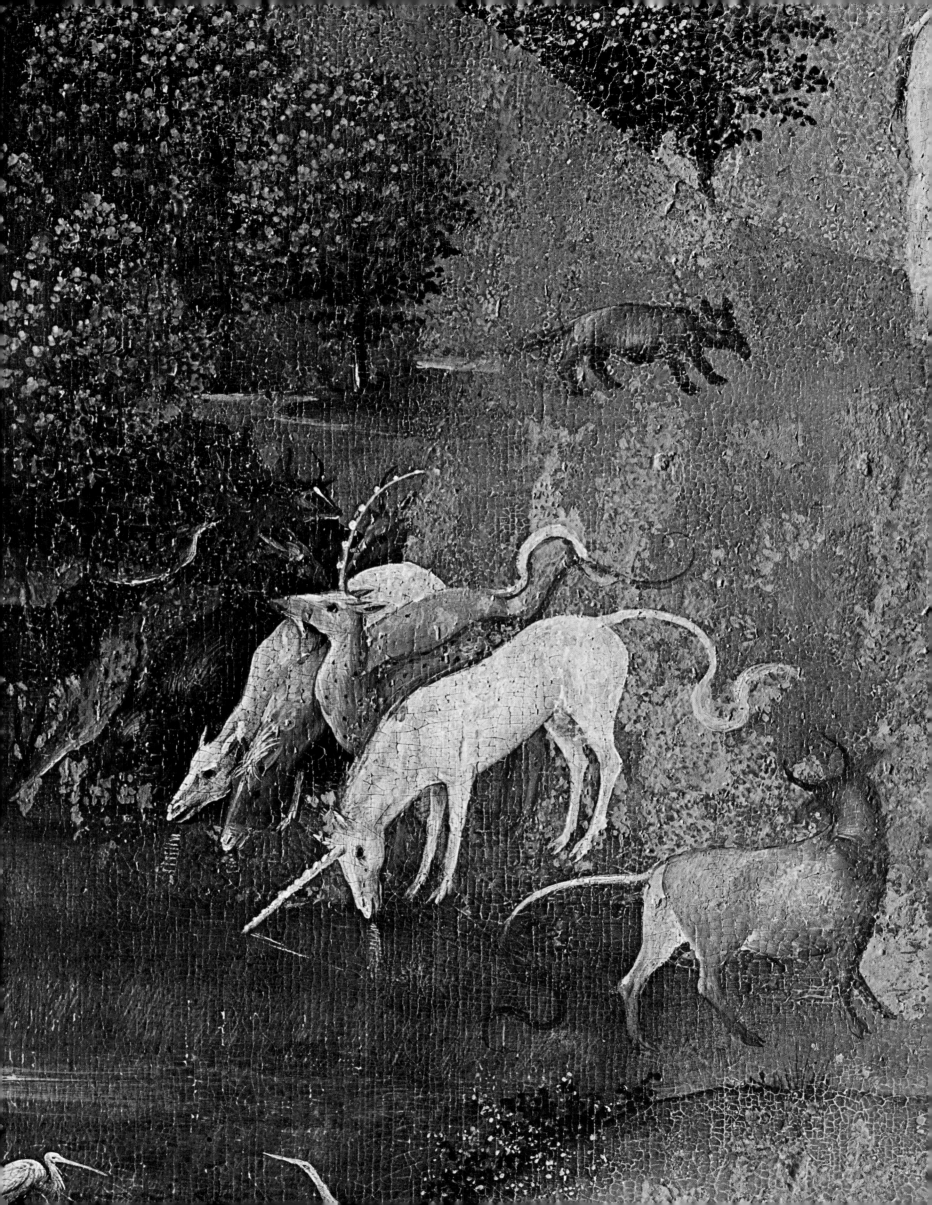

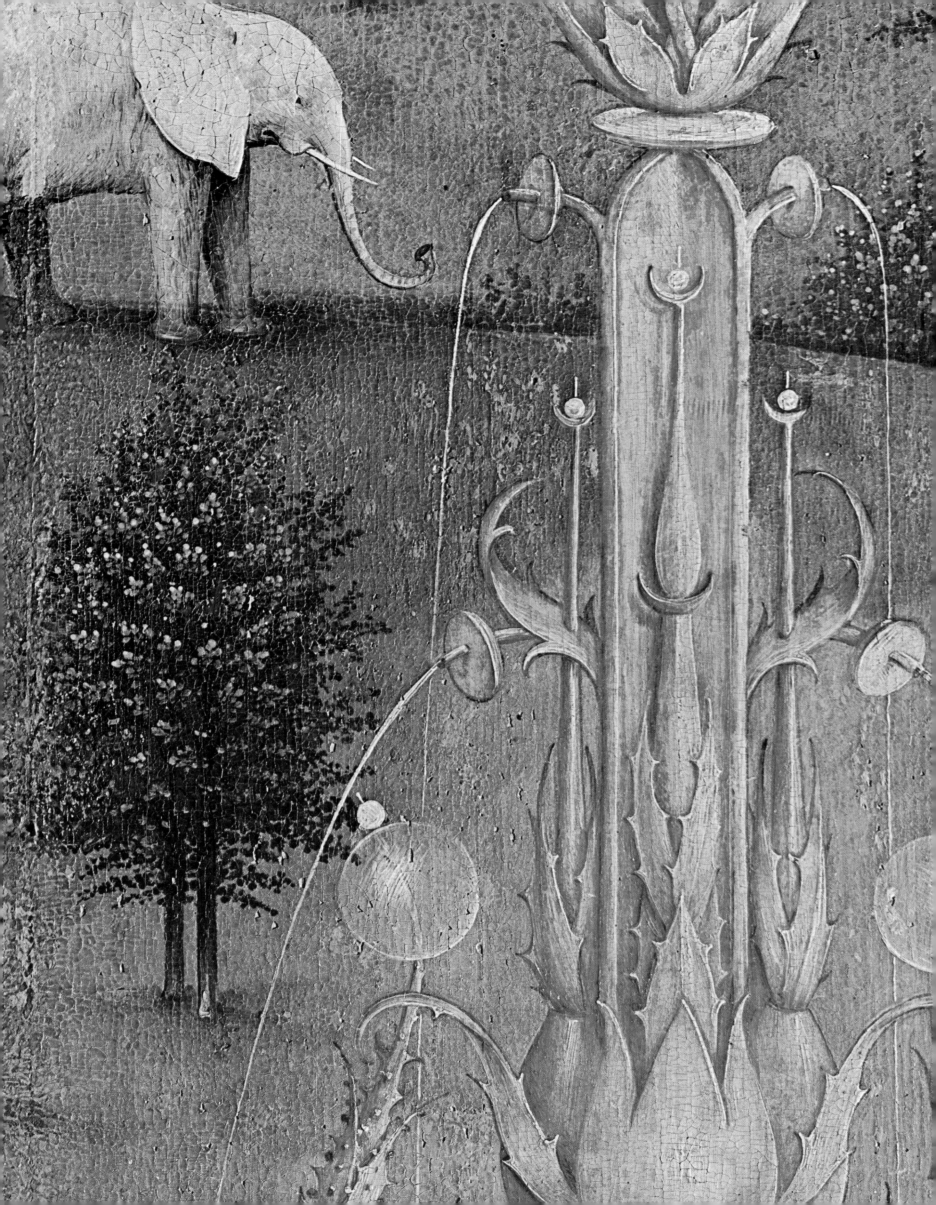

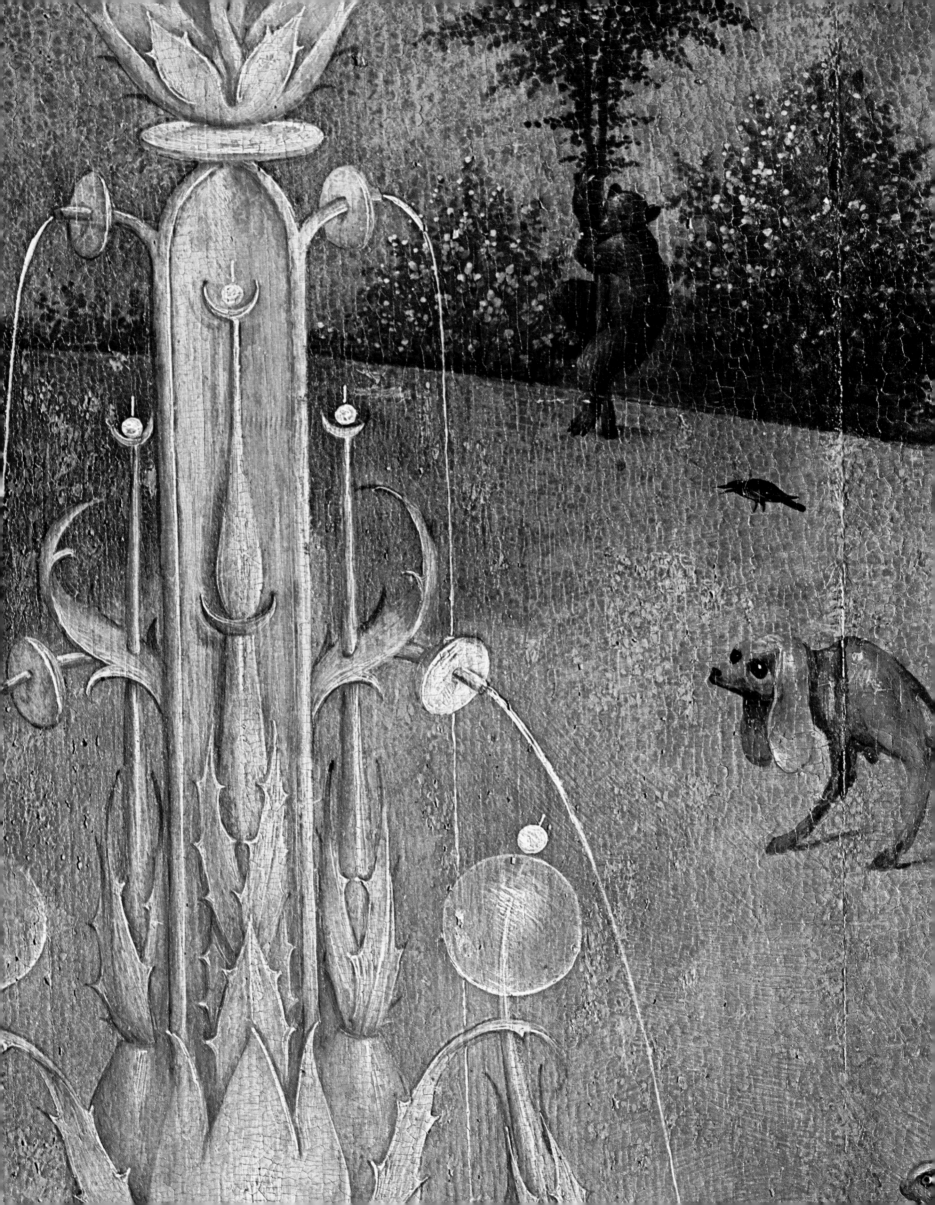

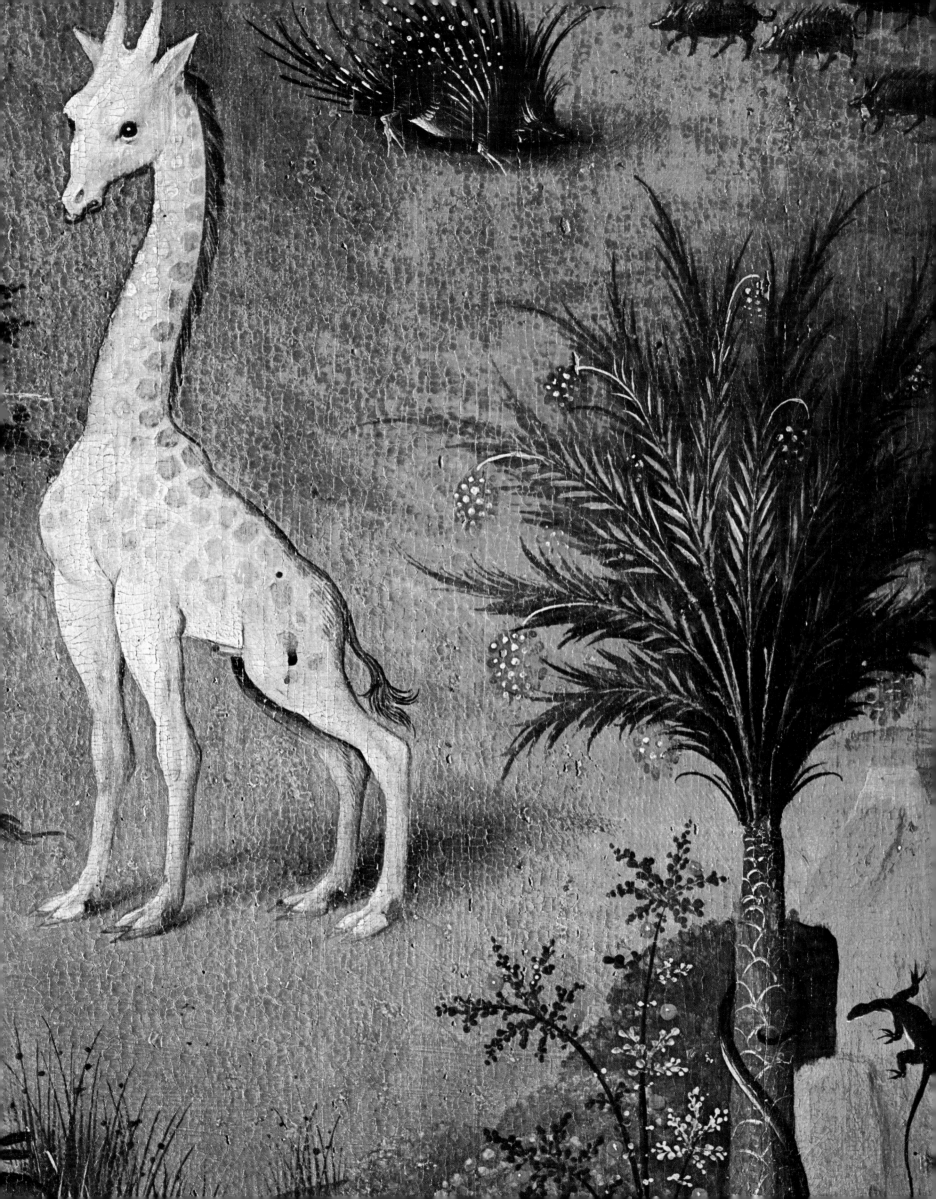

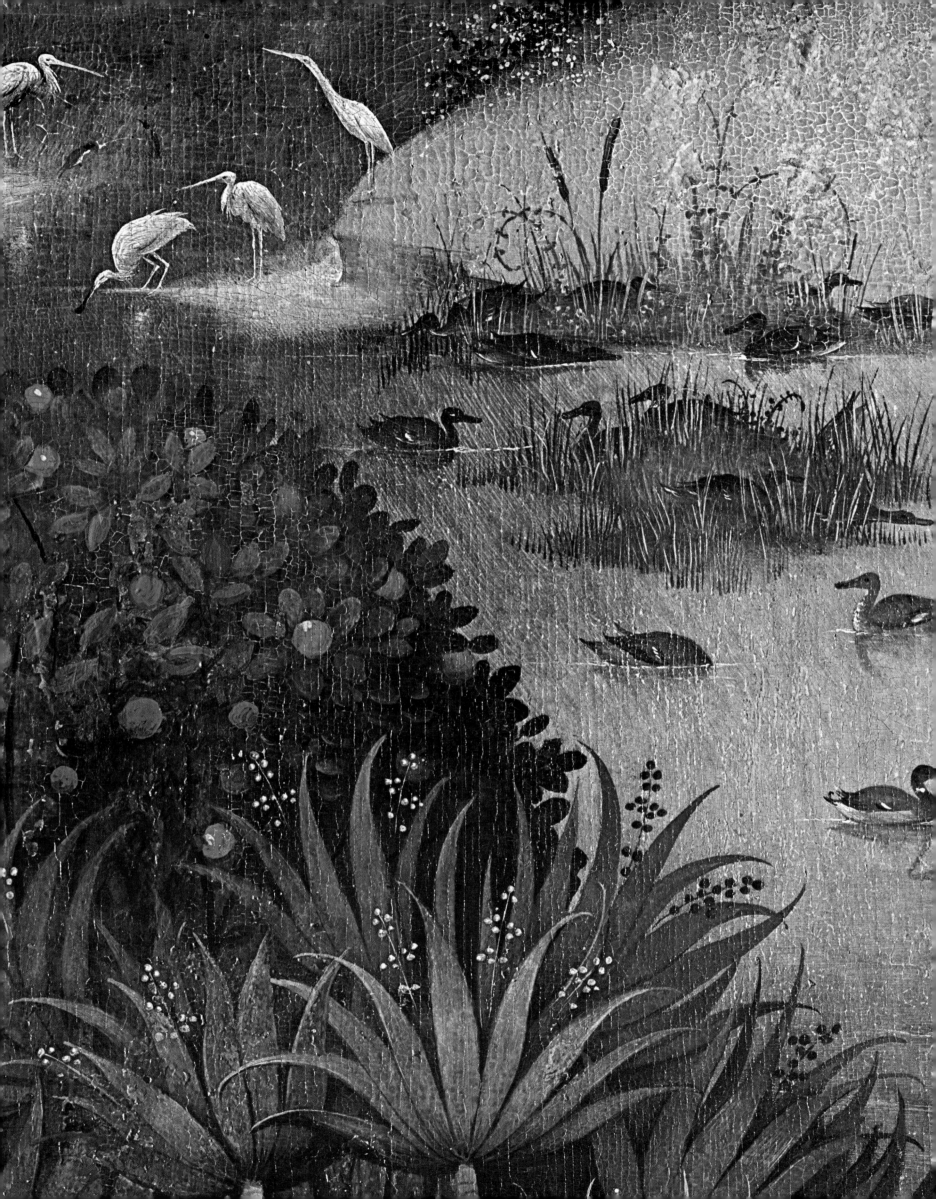

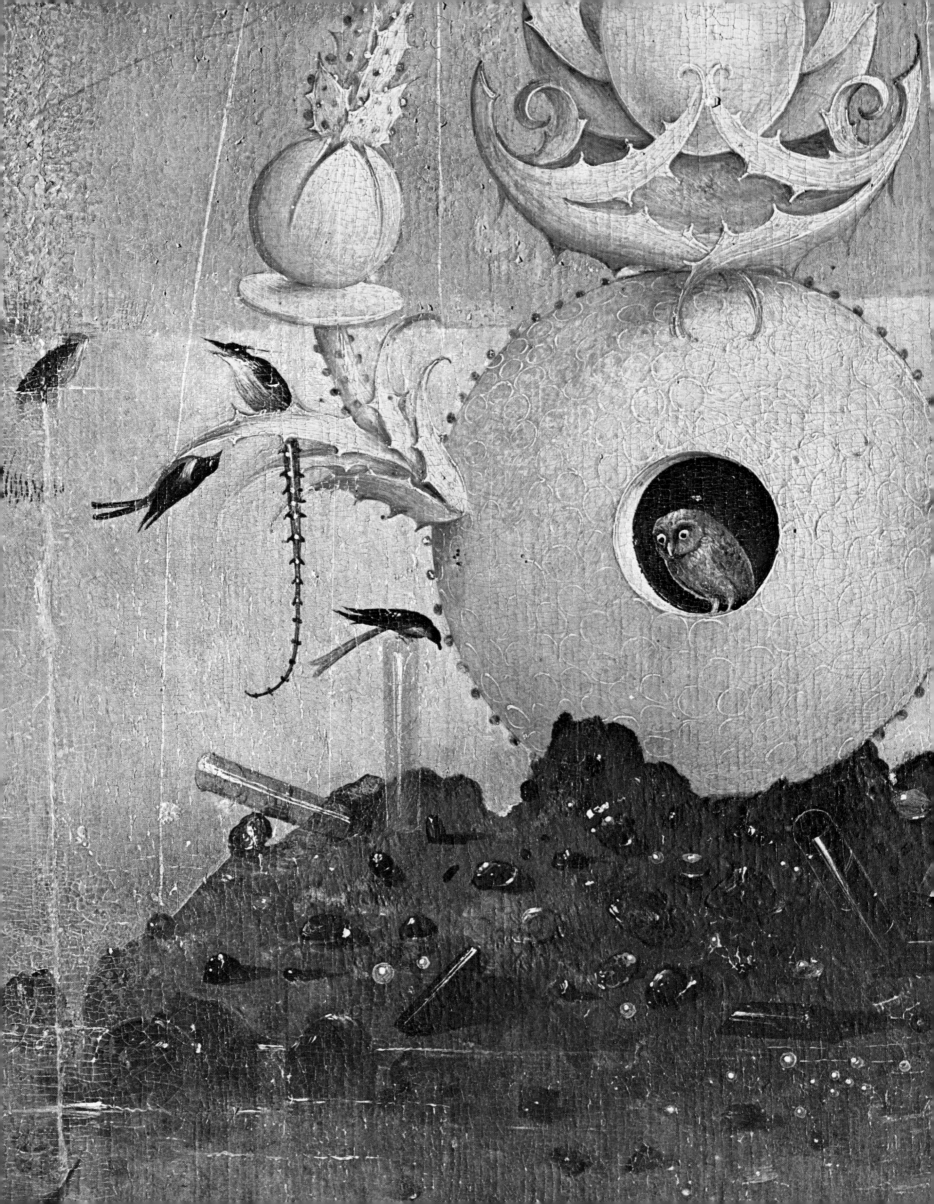

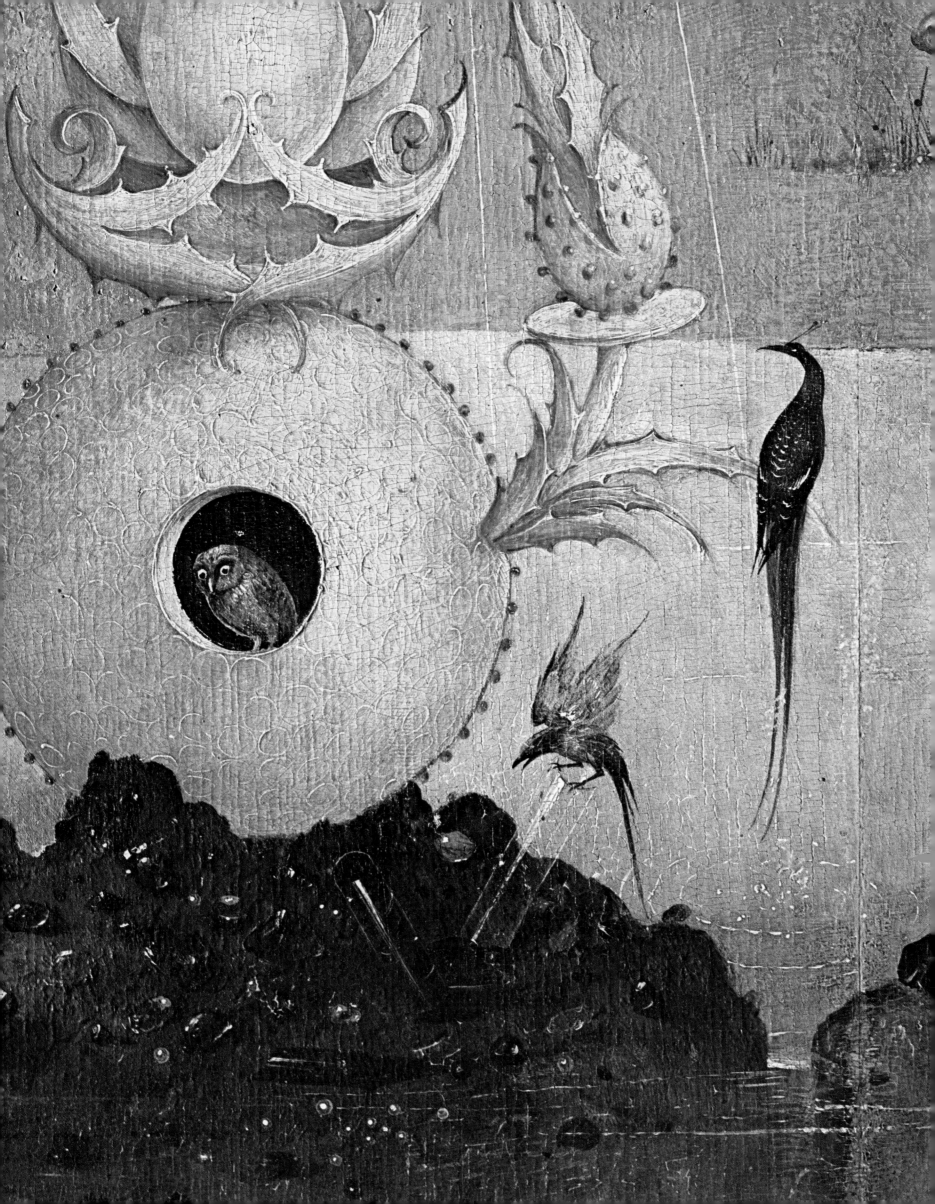

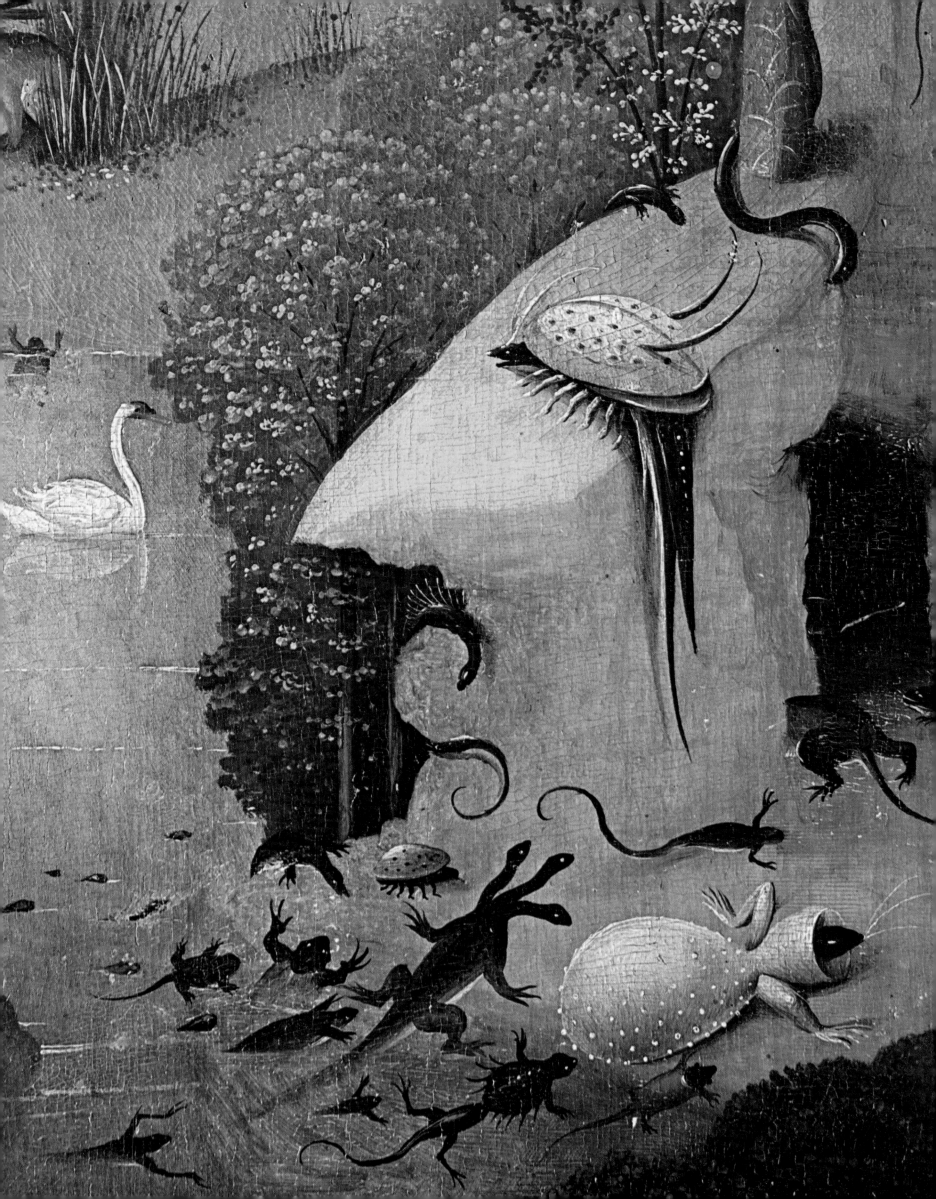

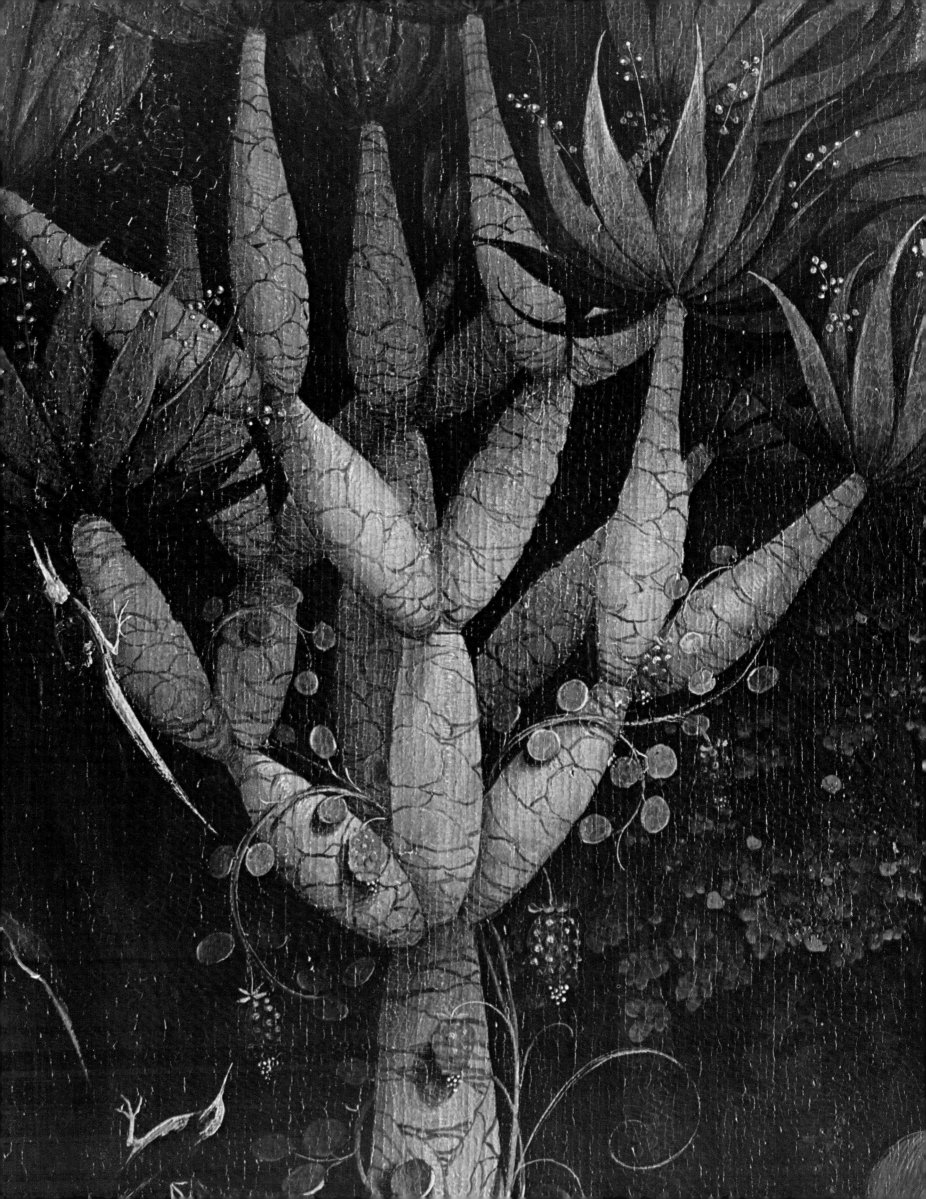

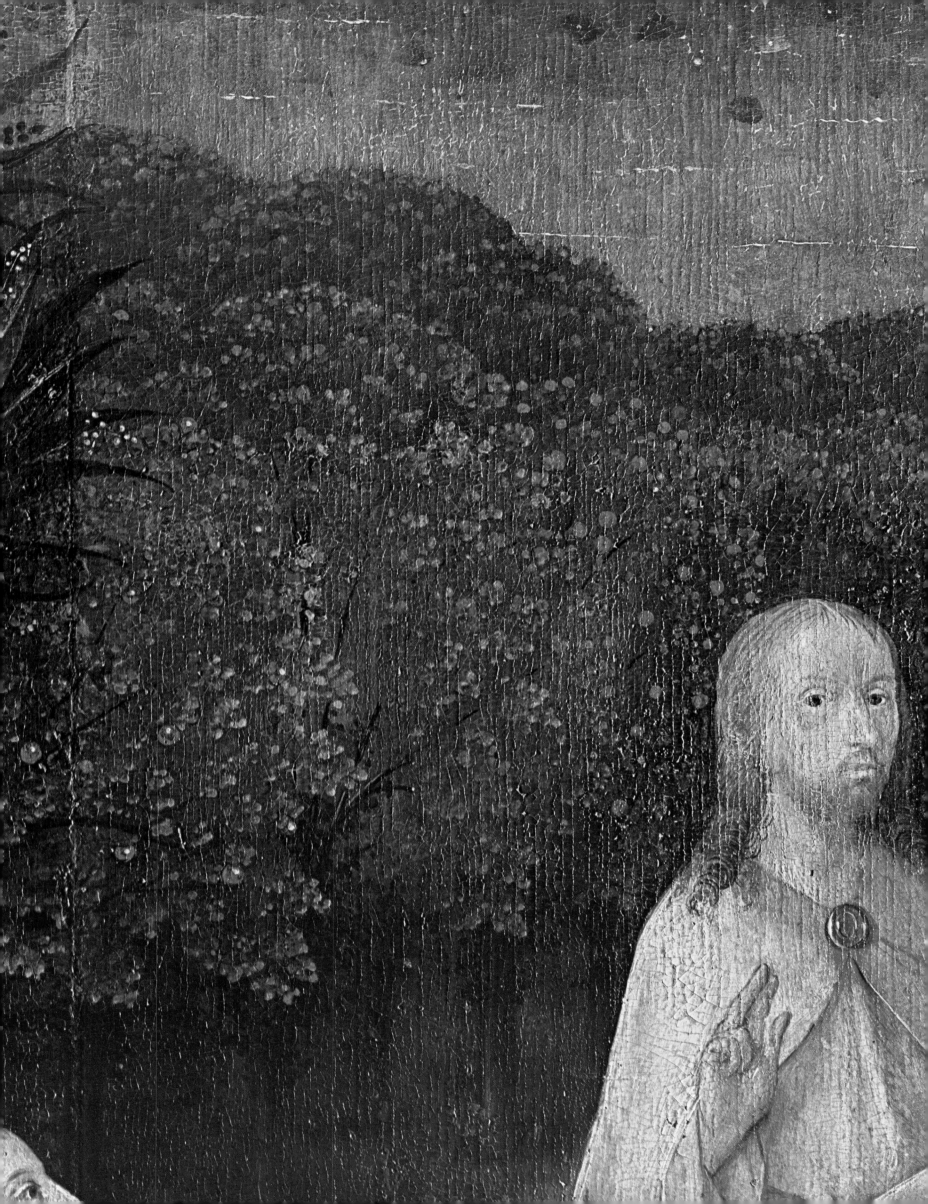

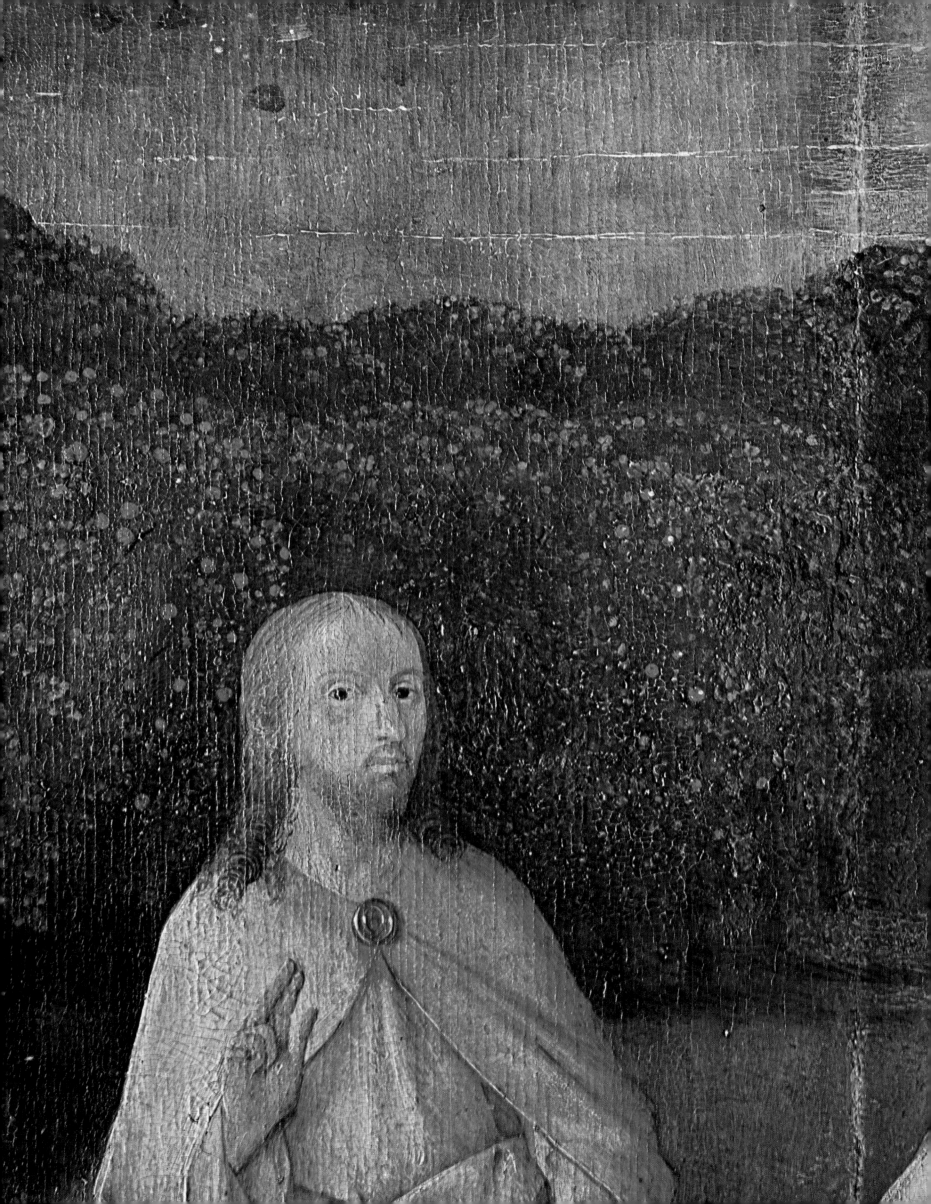

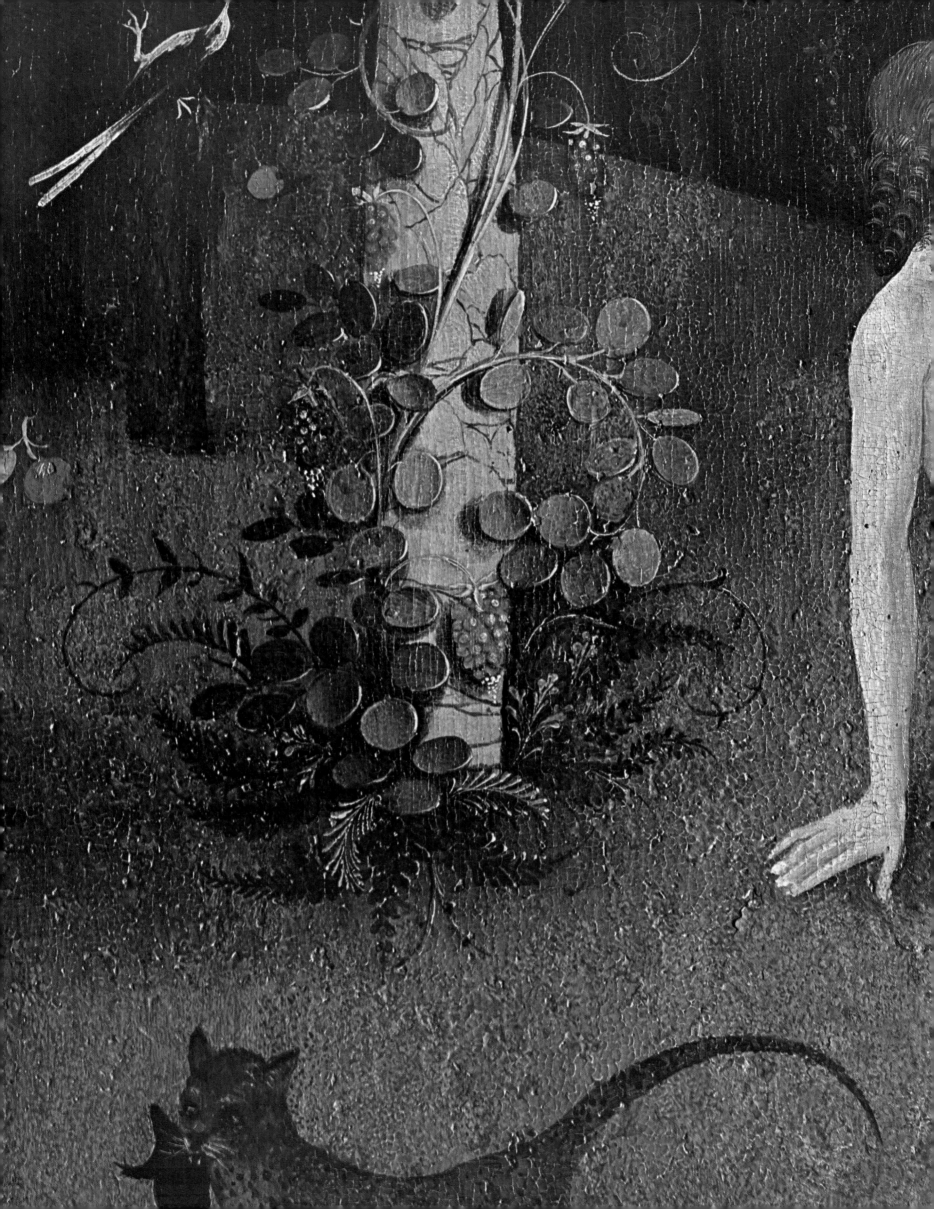

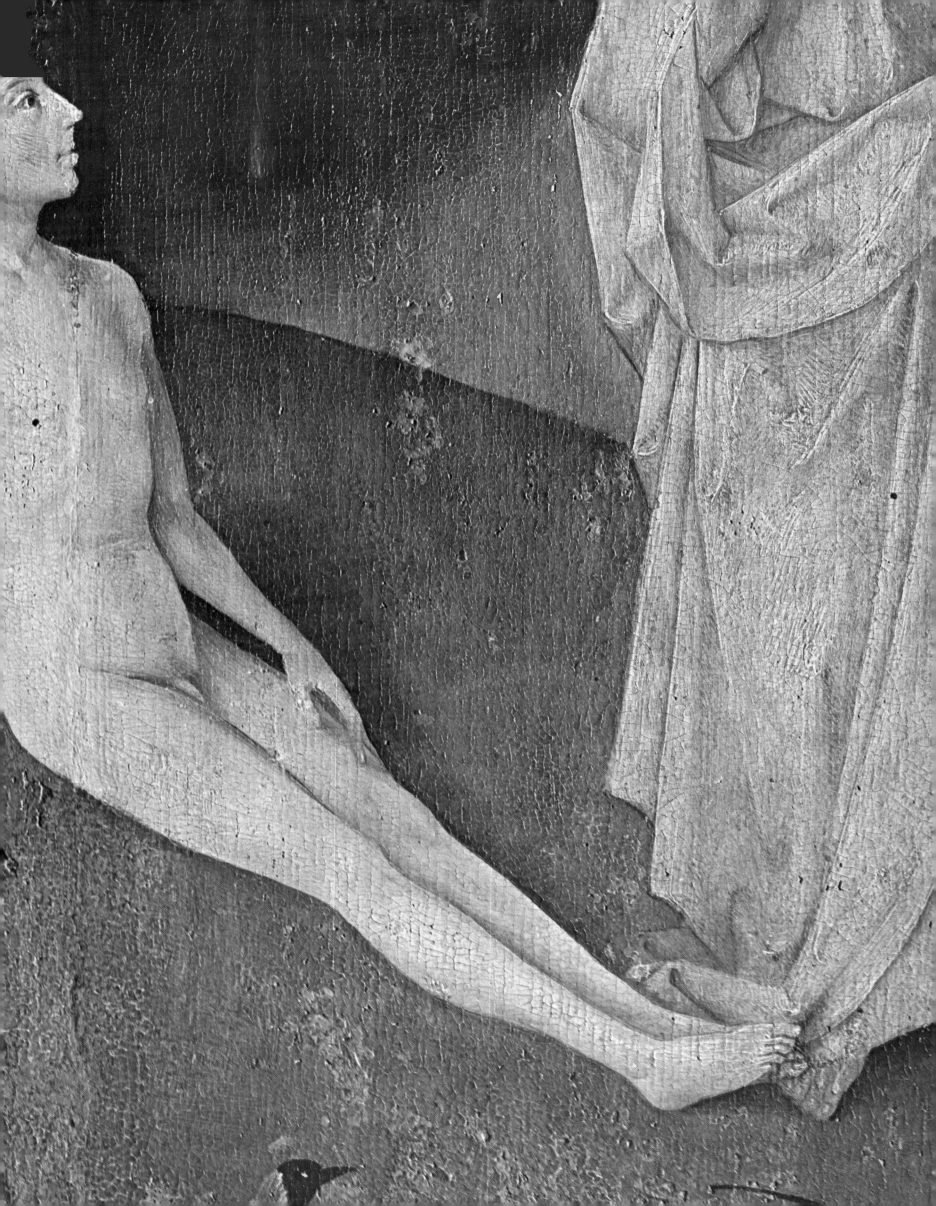

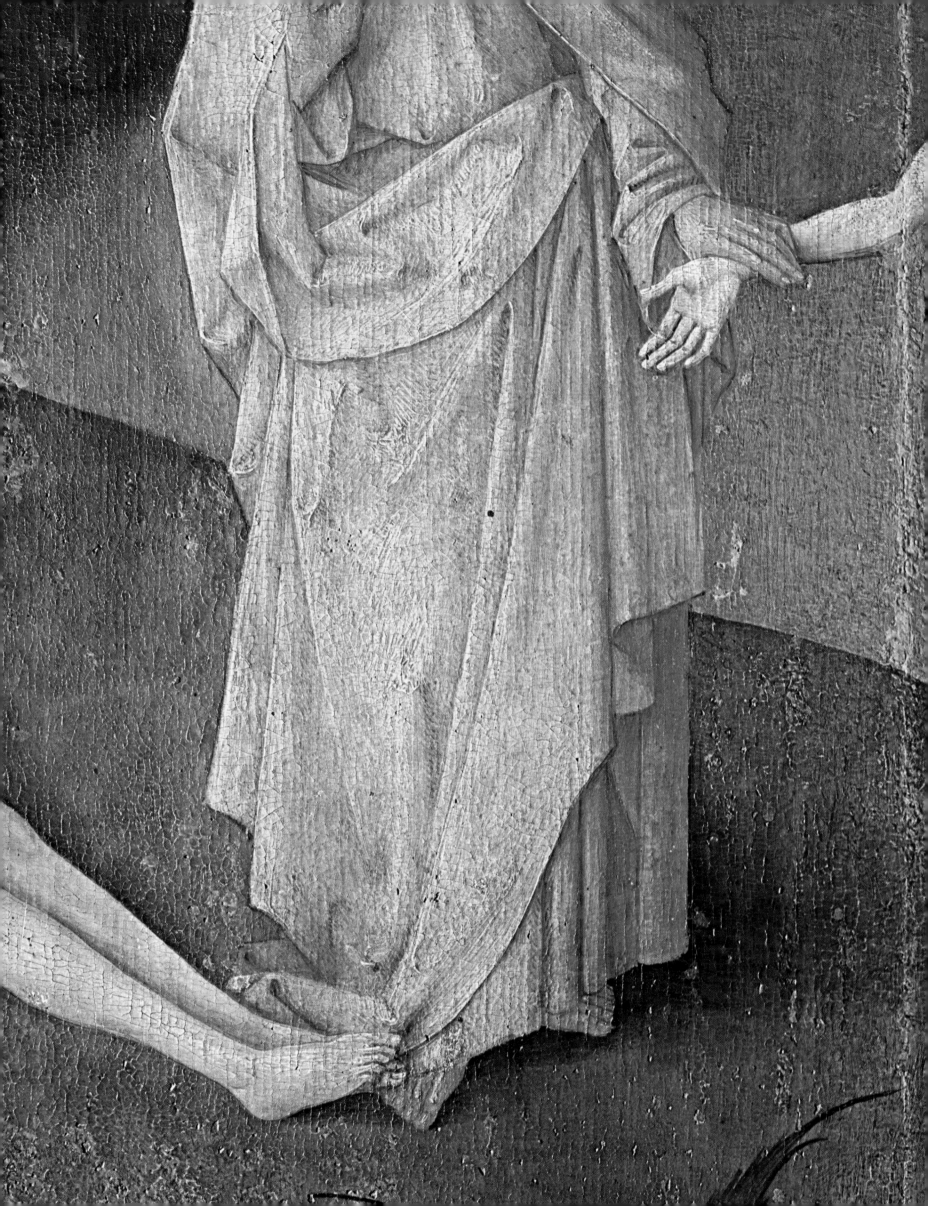

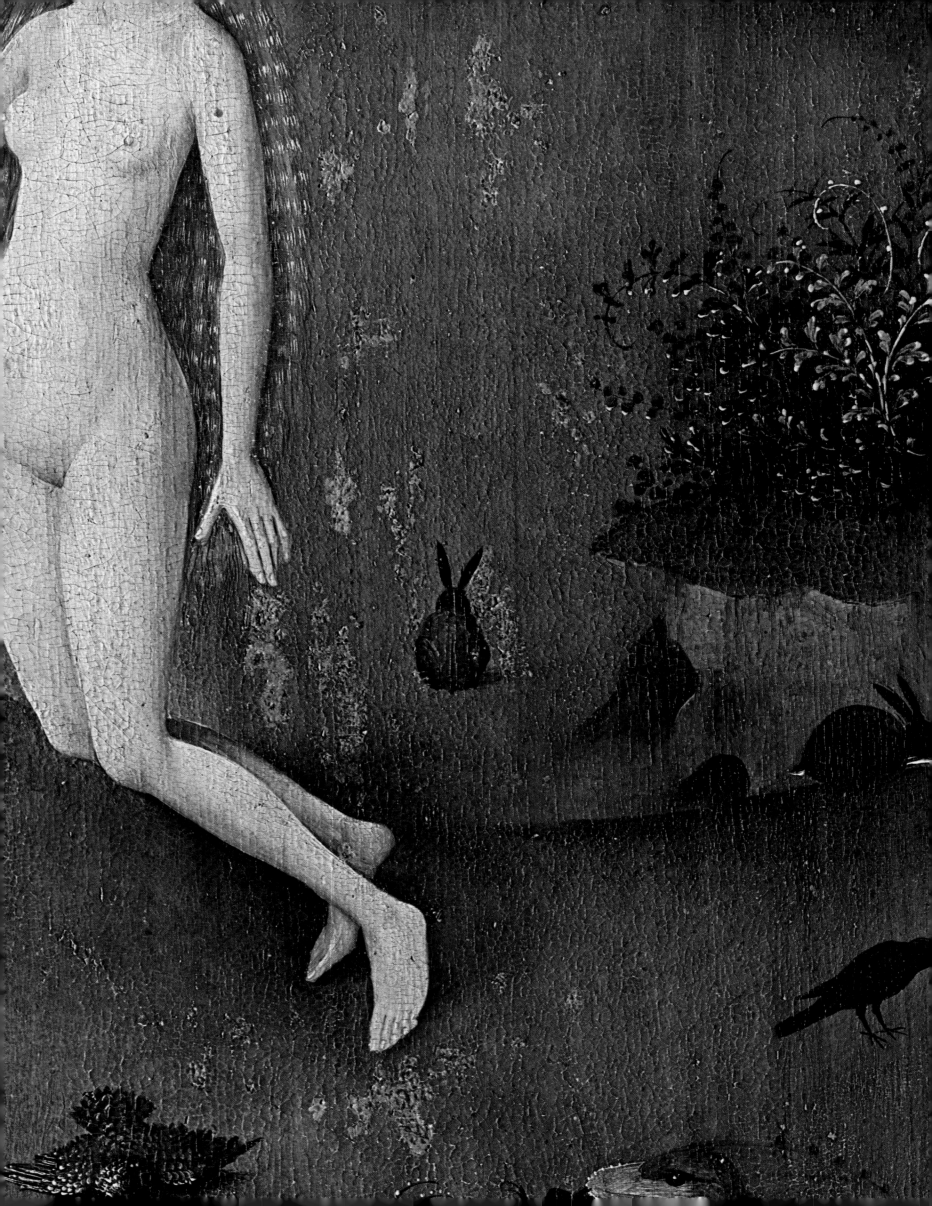

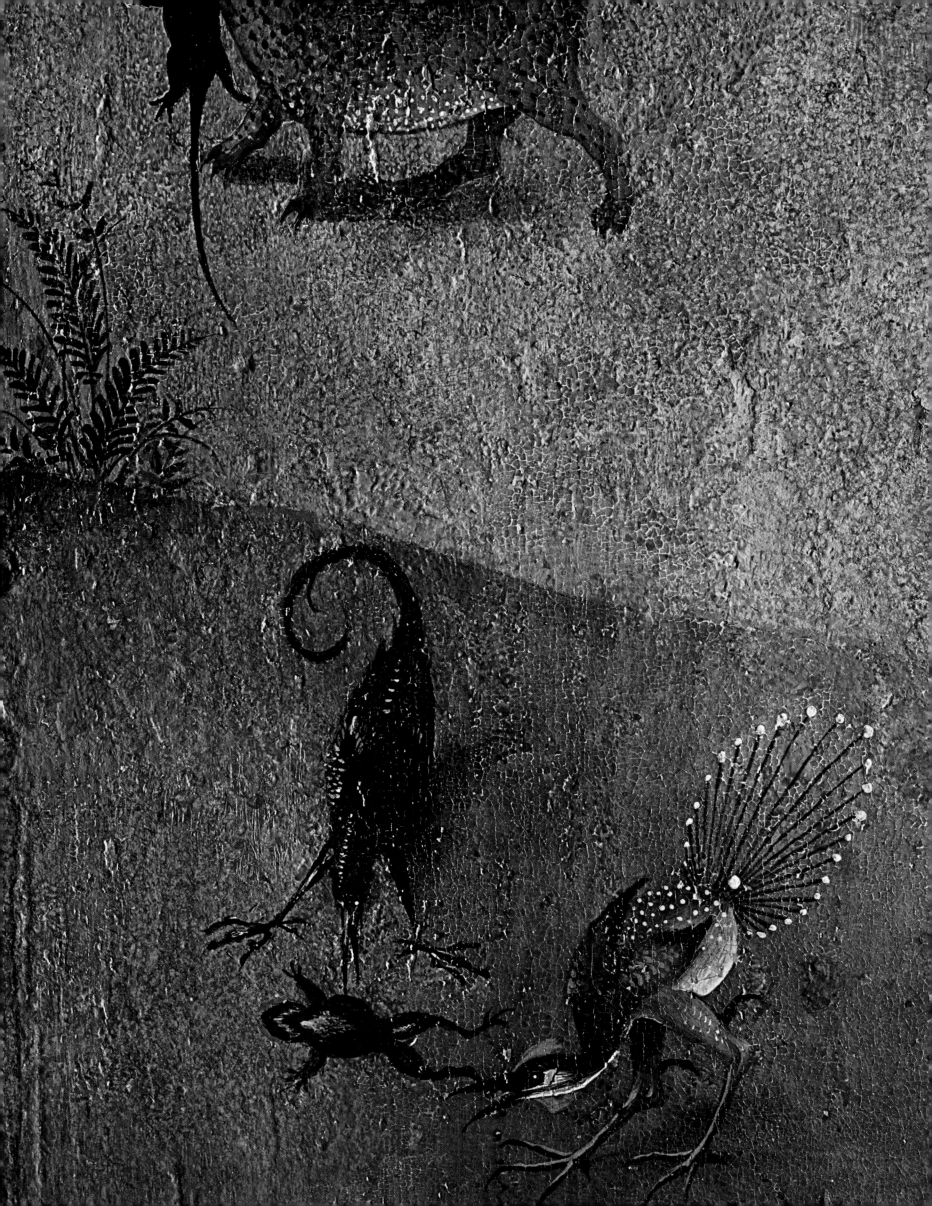

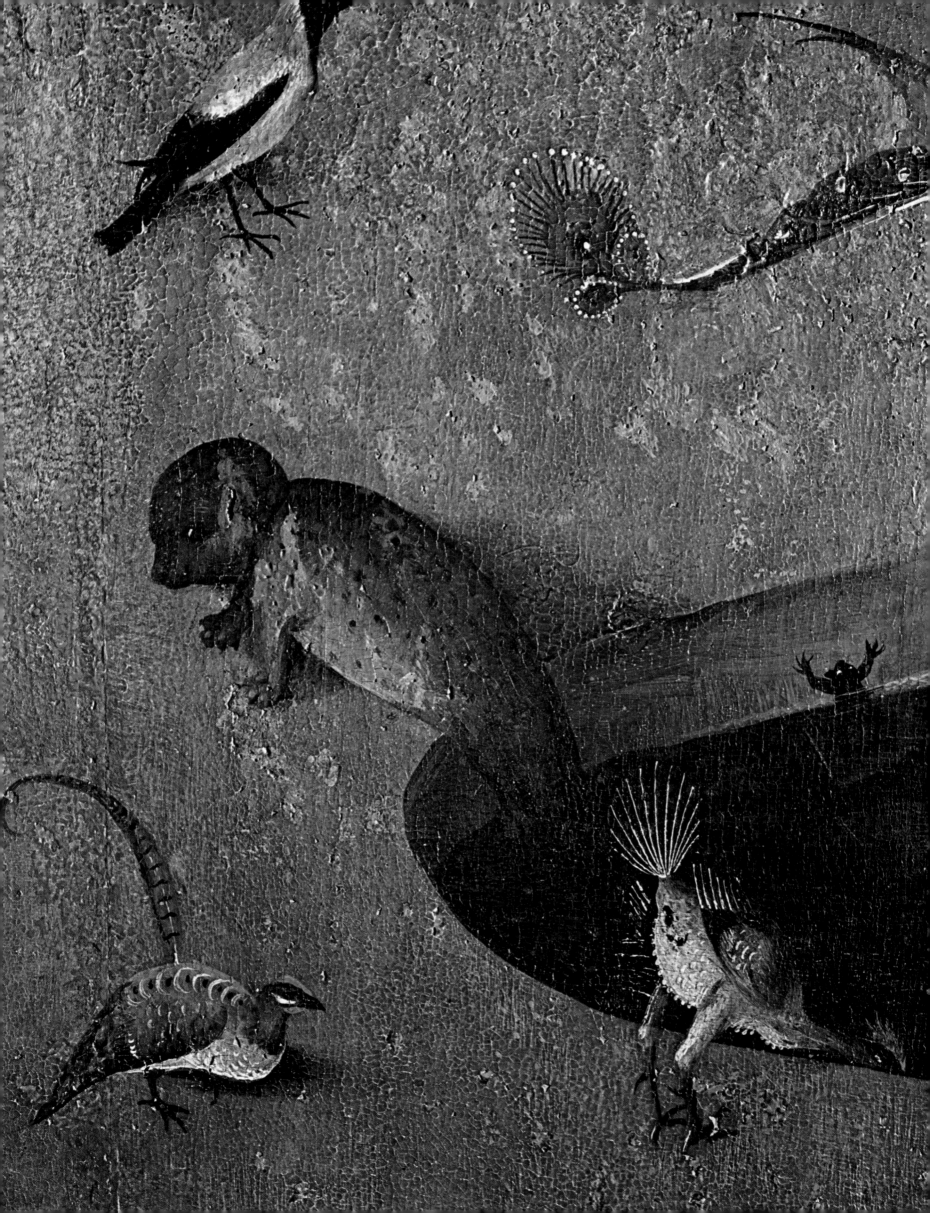

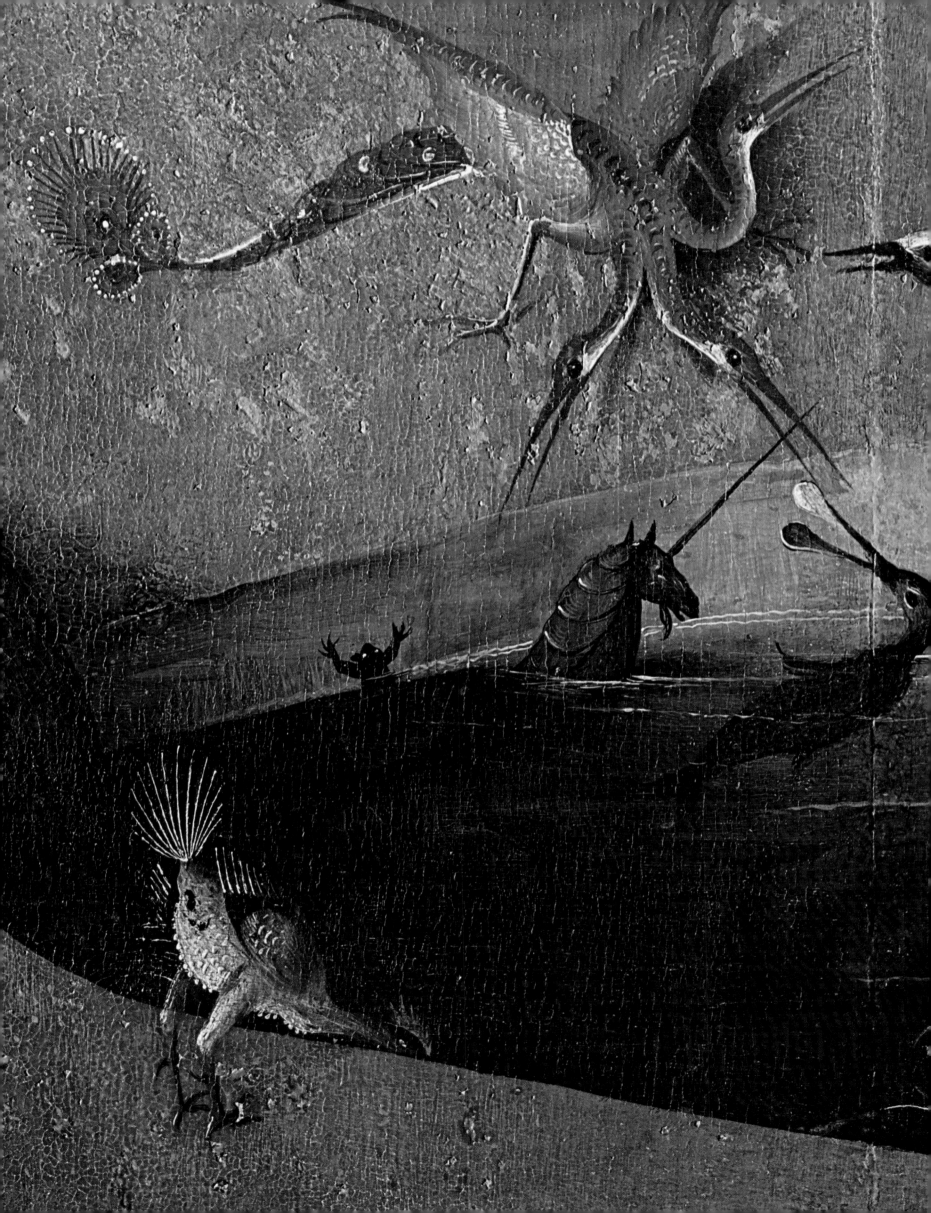

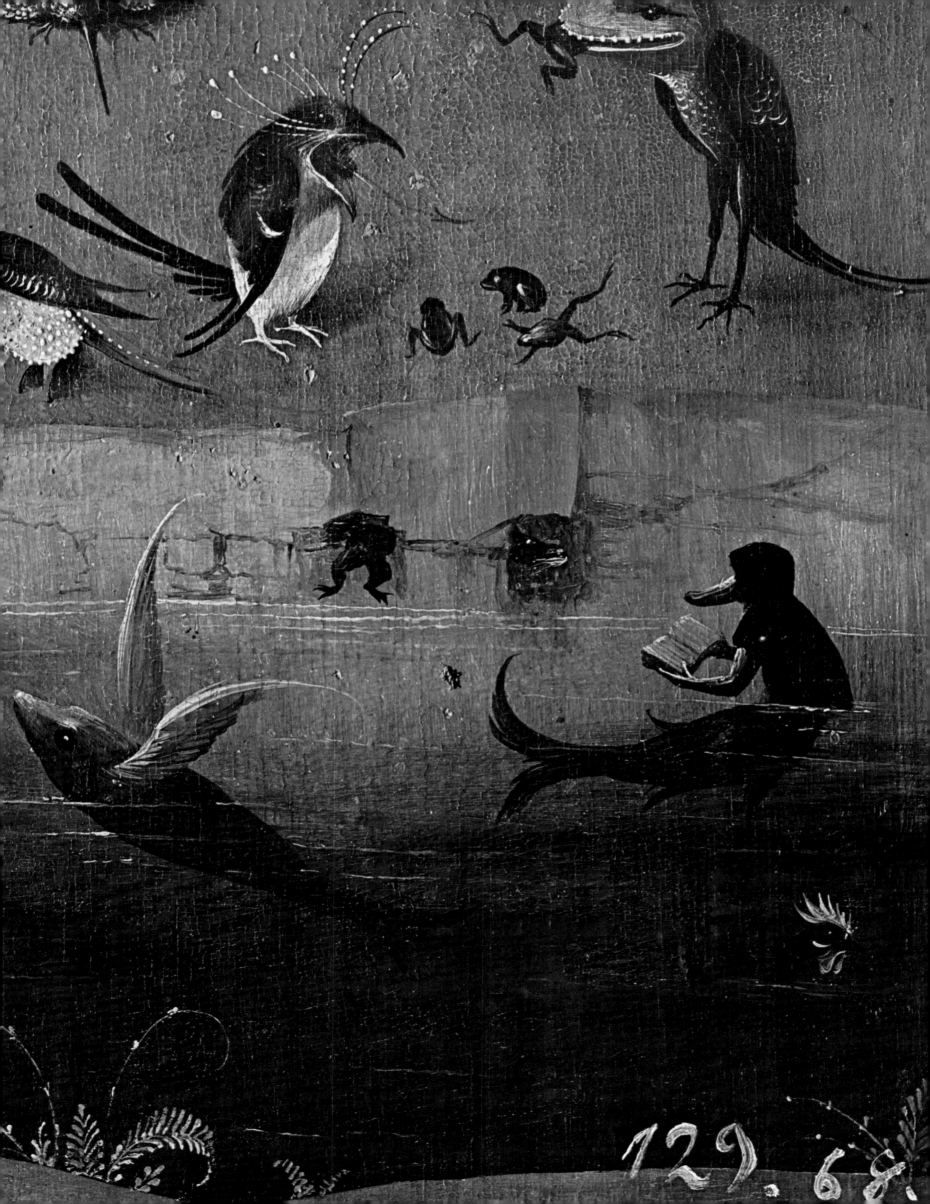

THE GARDEN OF EARTHLY DELIGHTS

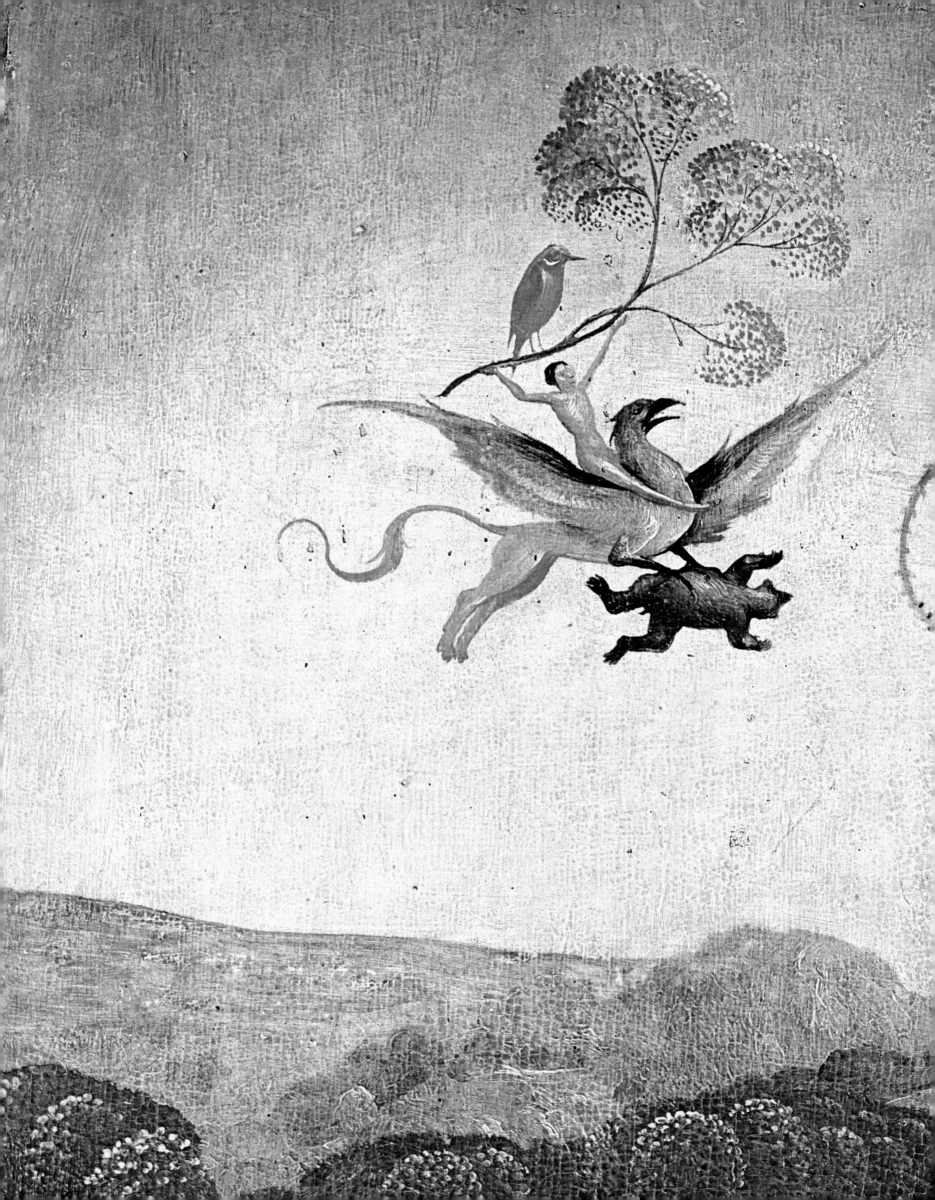

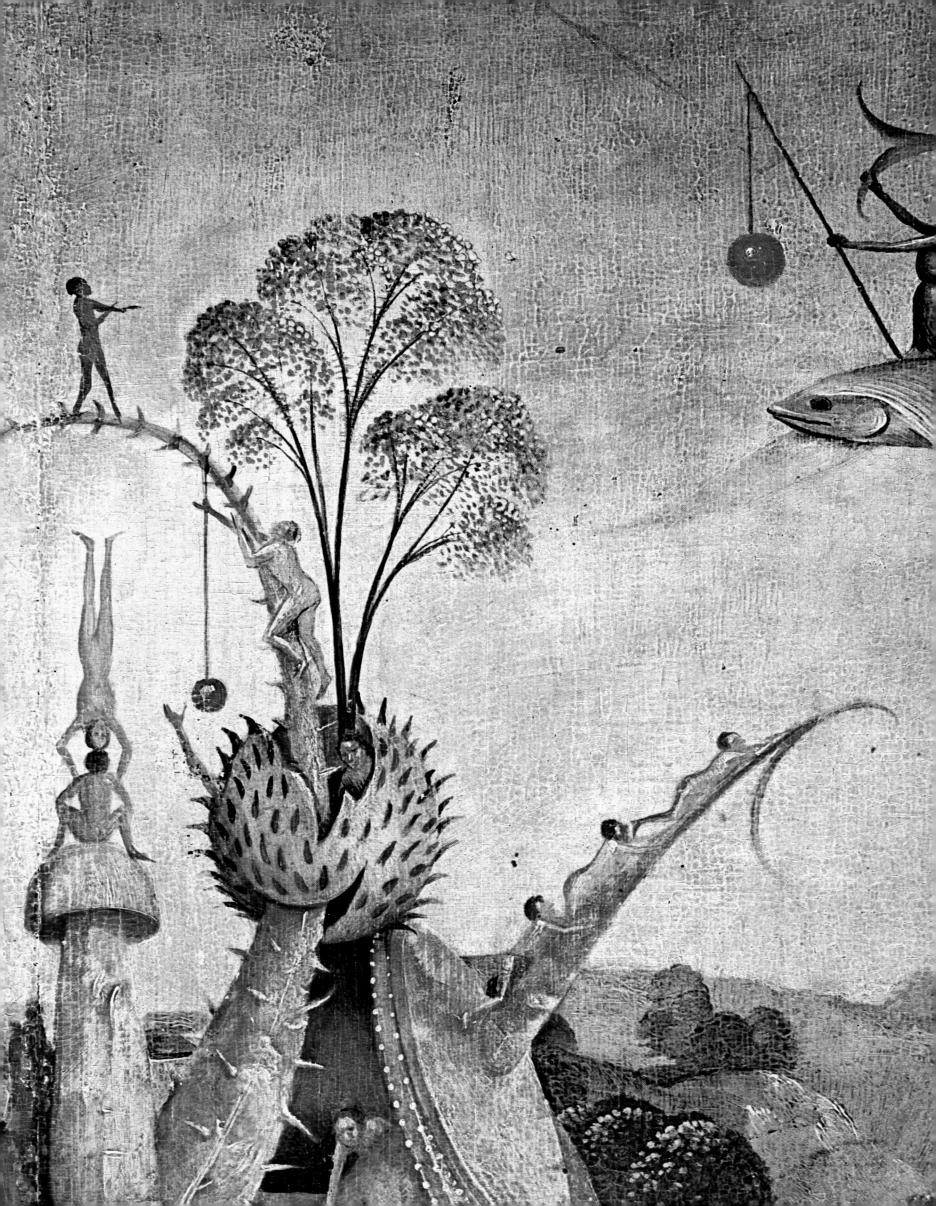

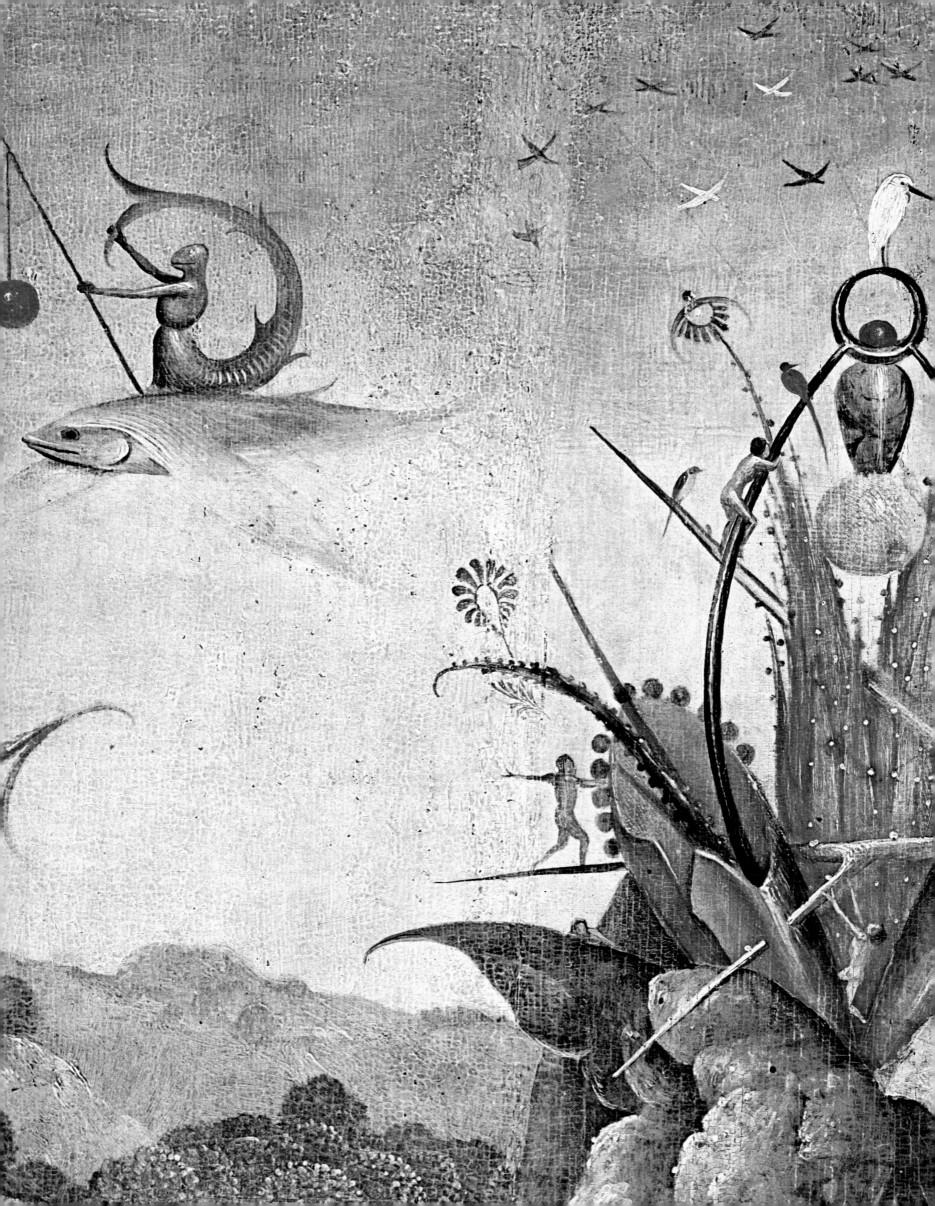

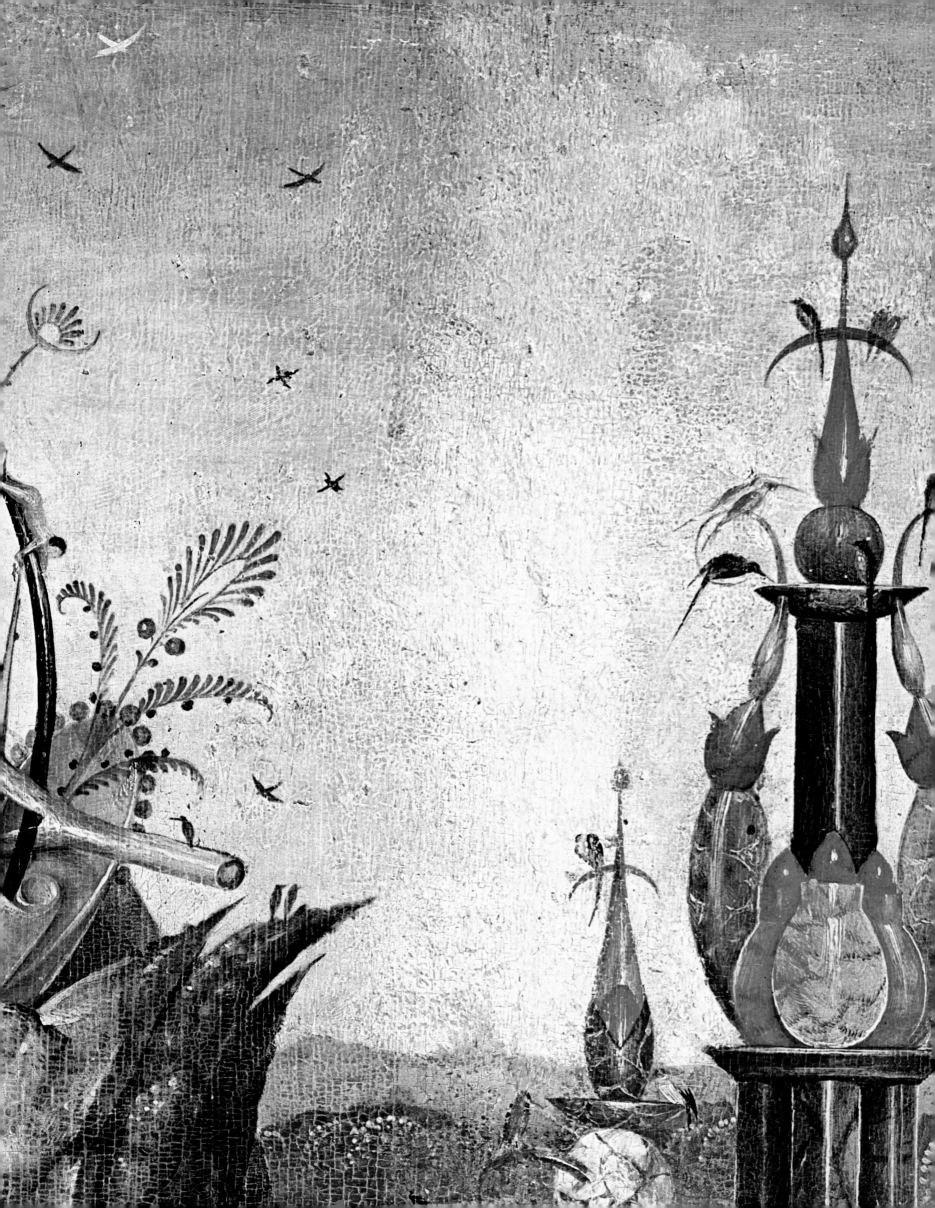

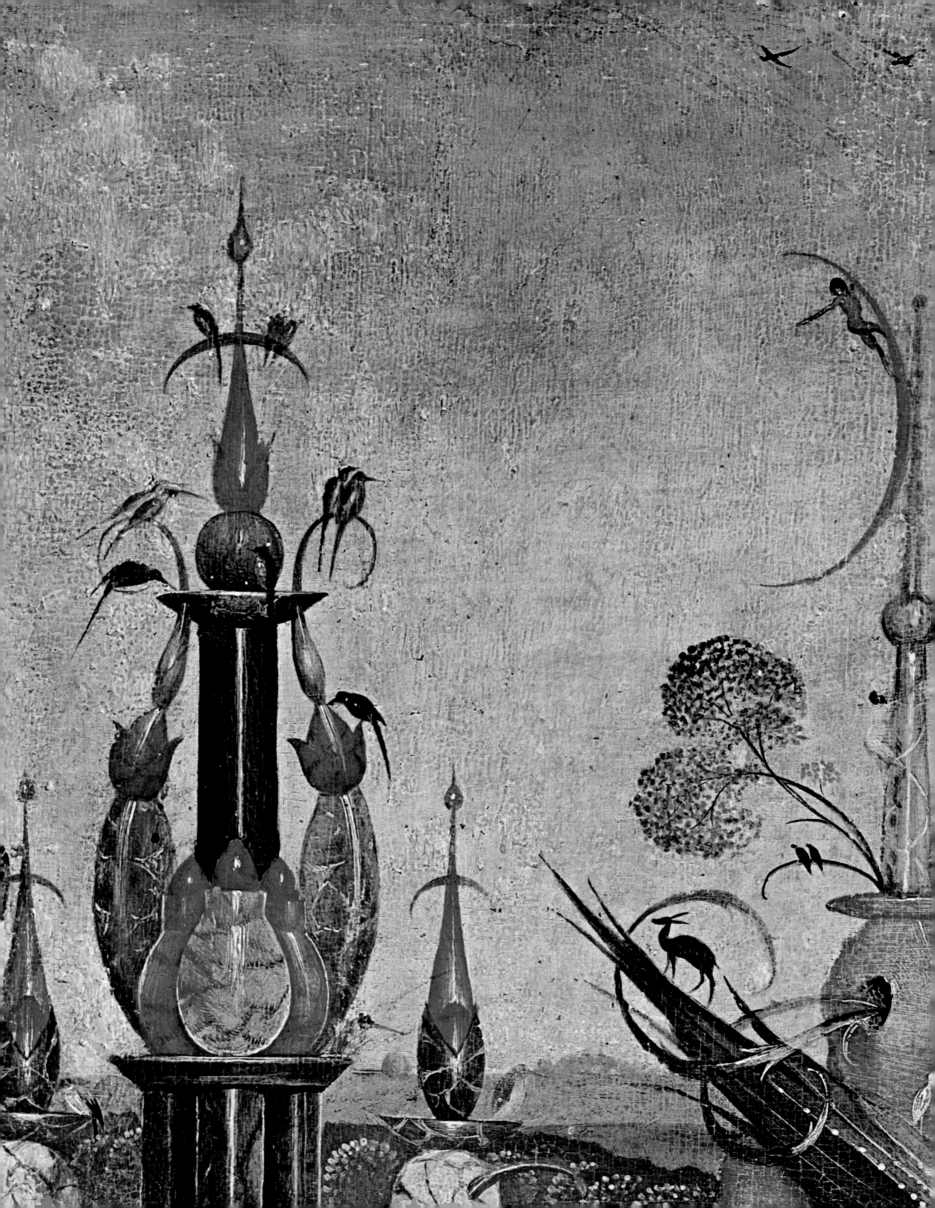

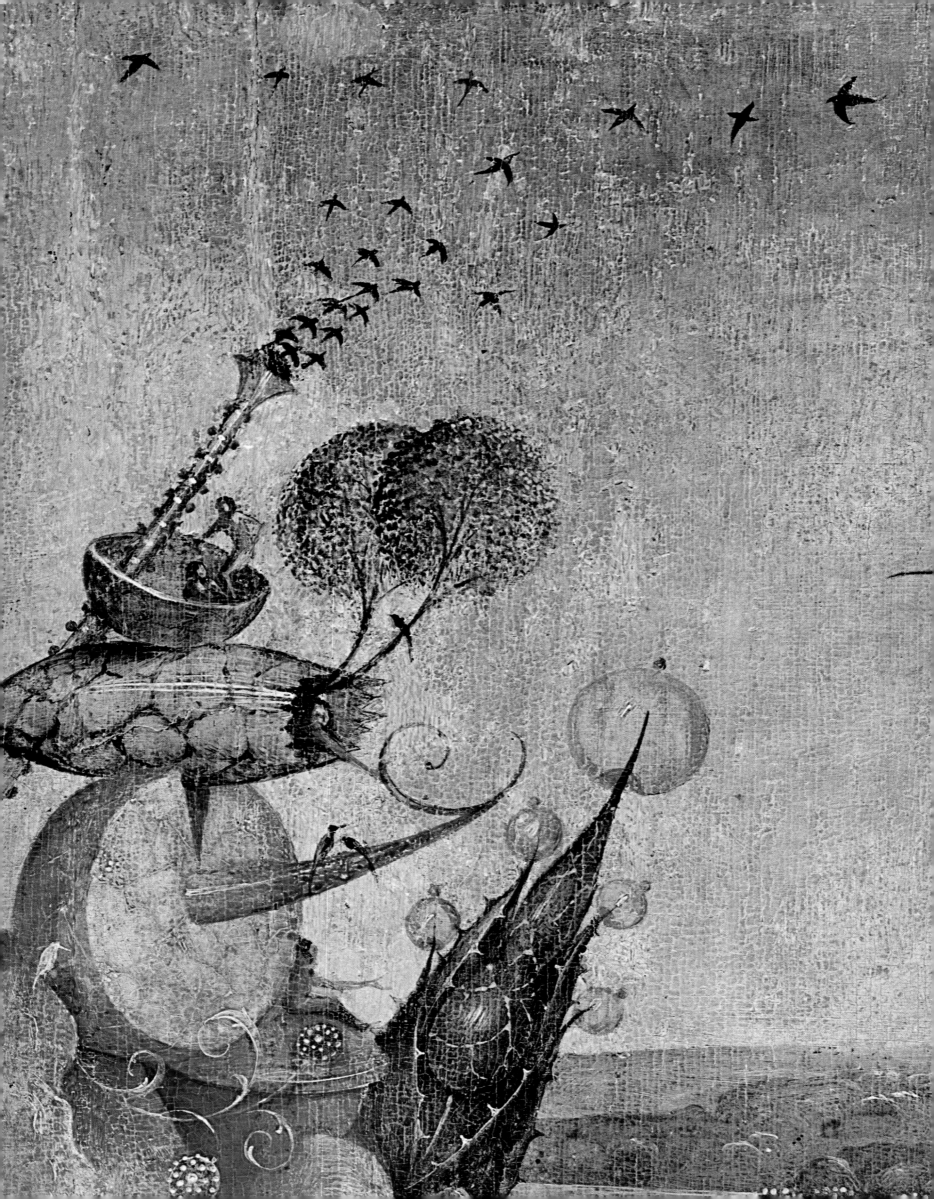

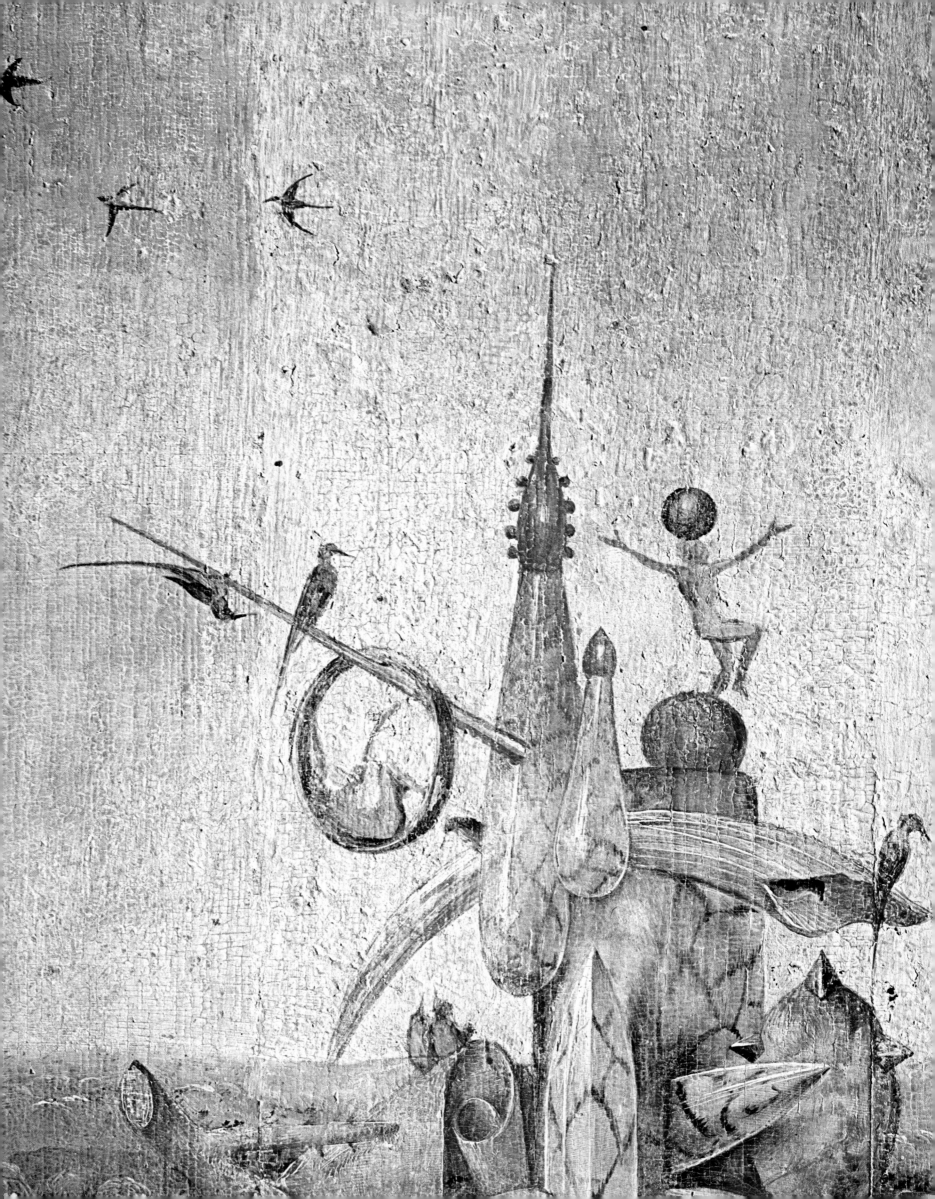

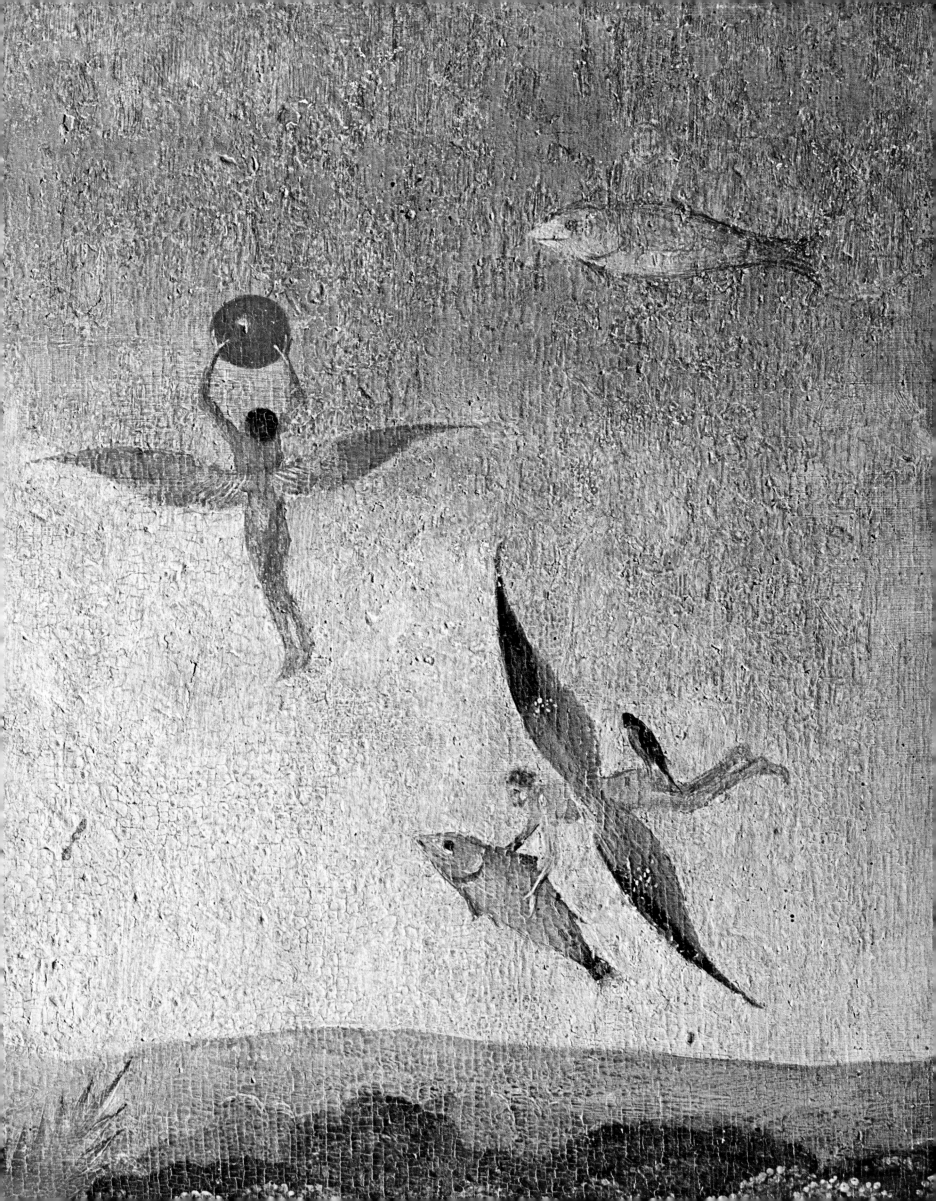

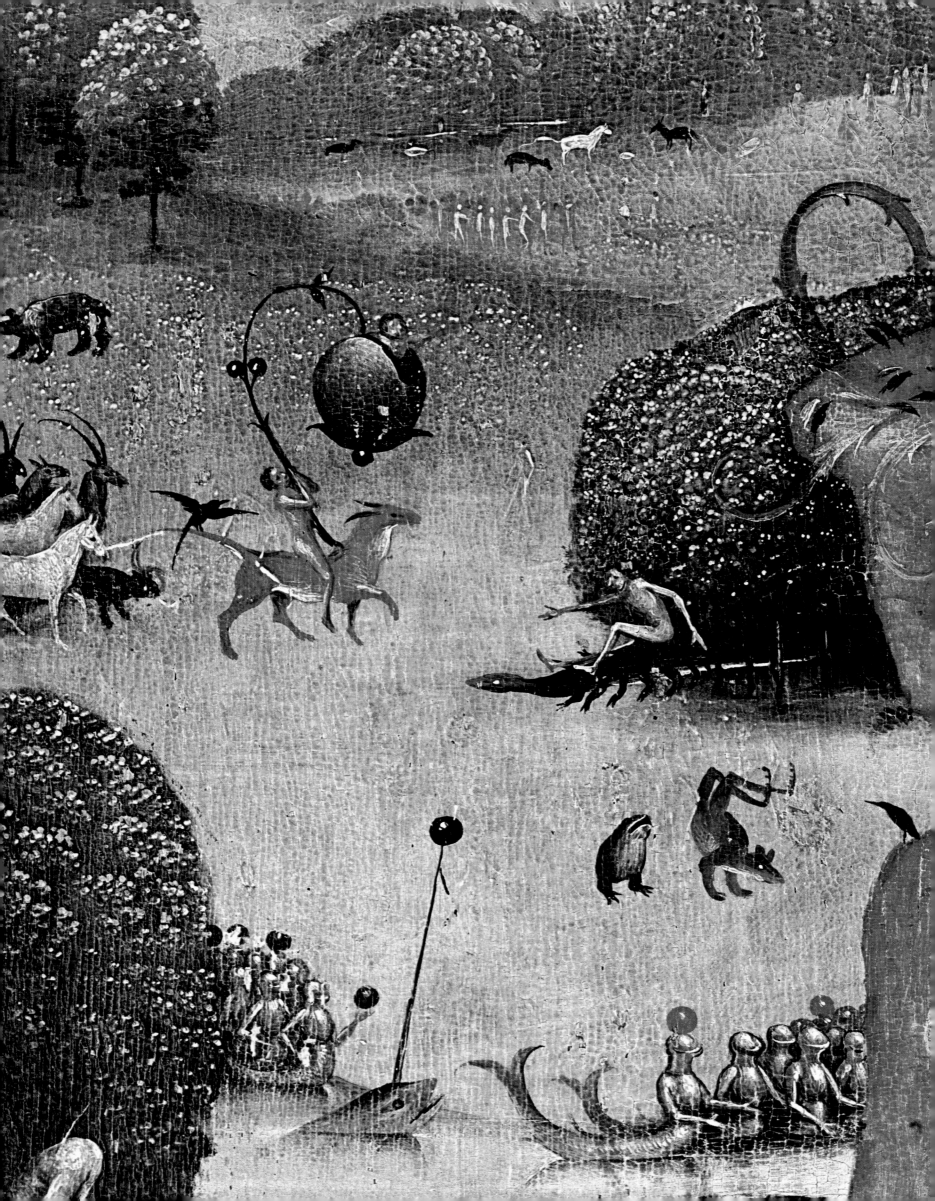

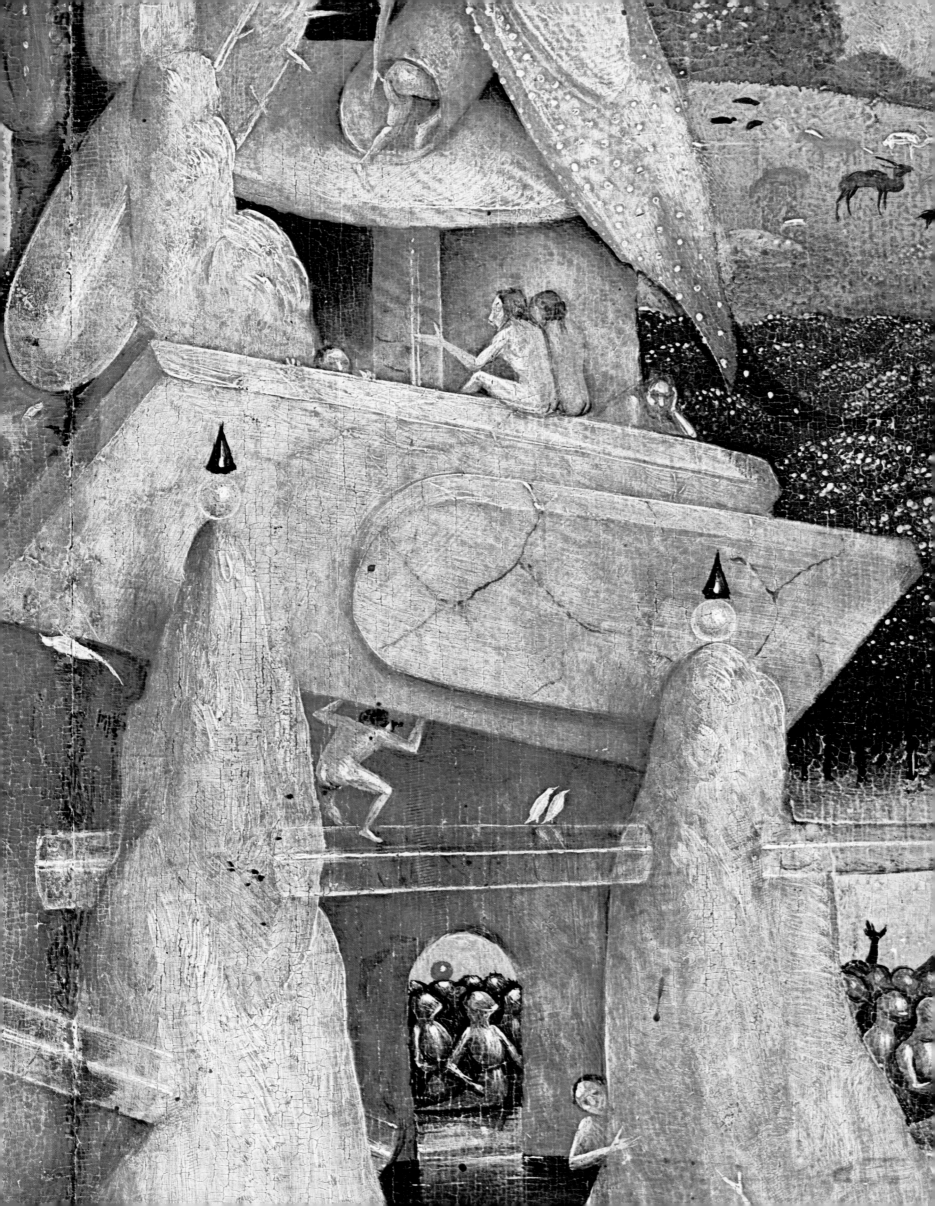

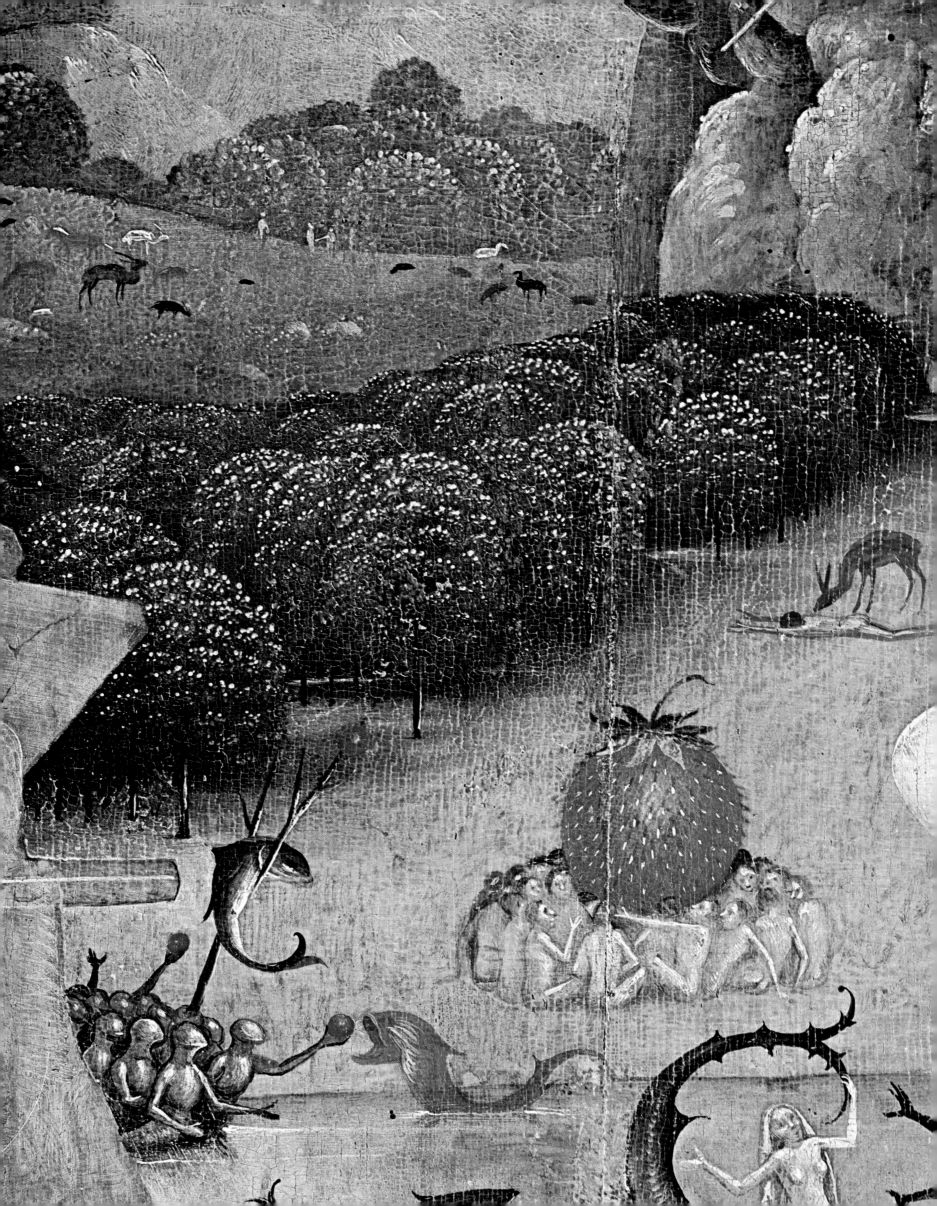

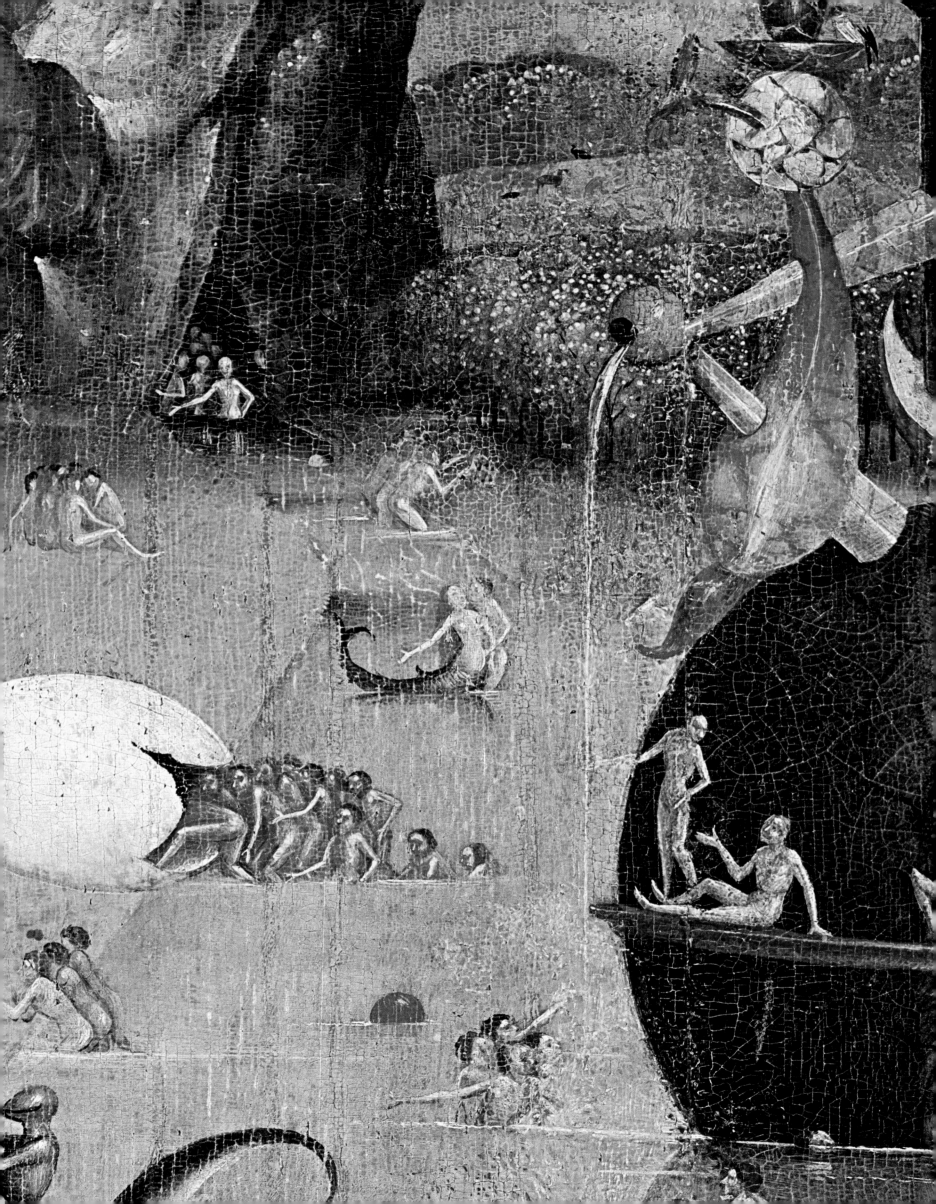

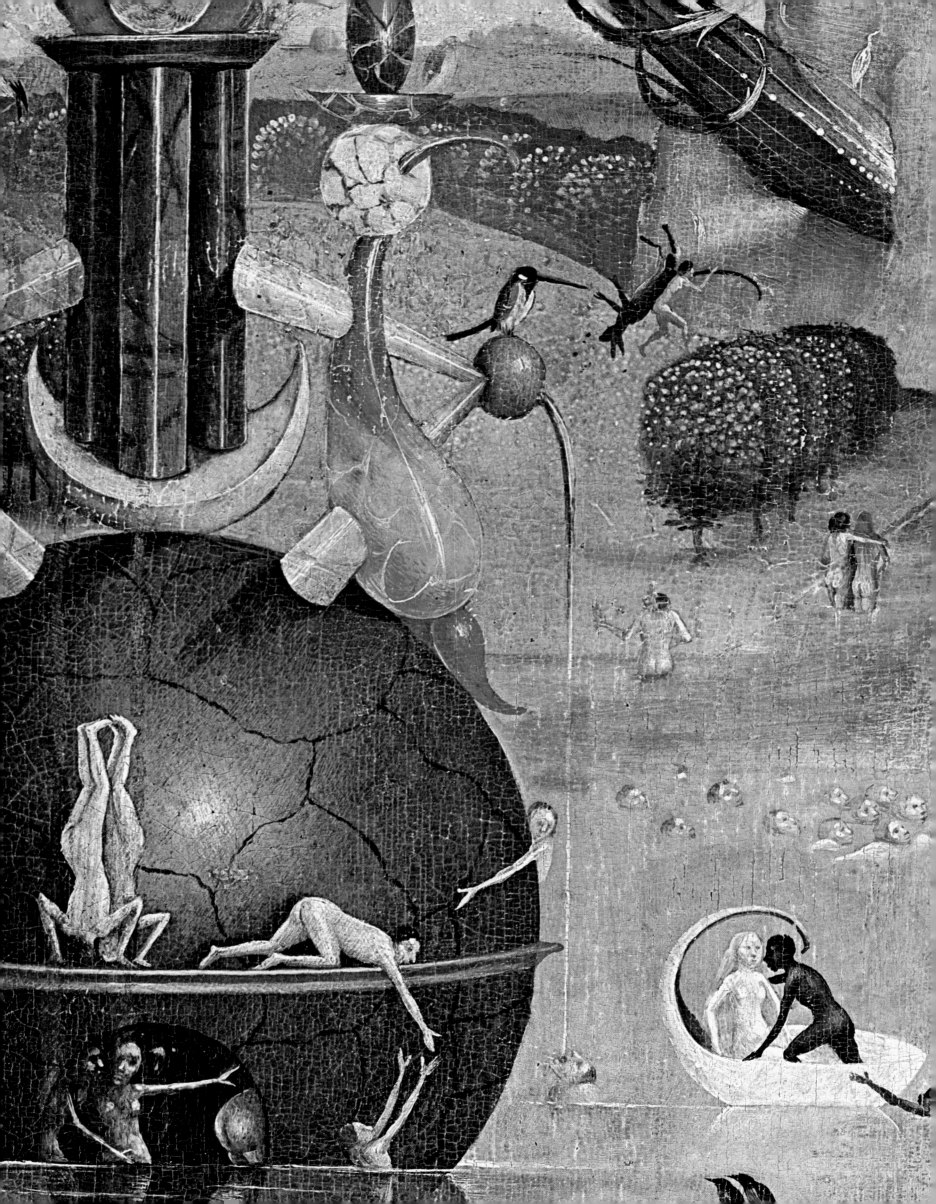

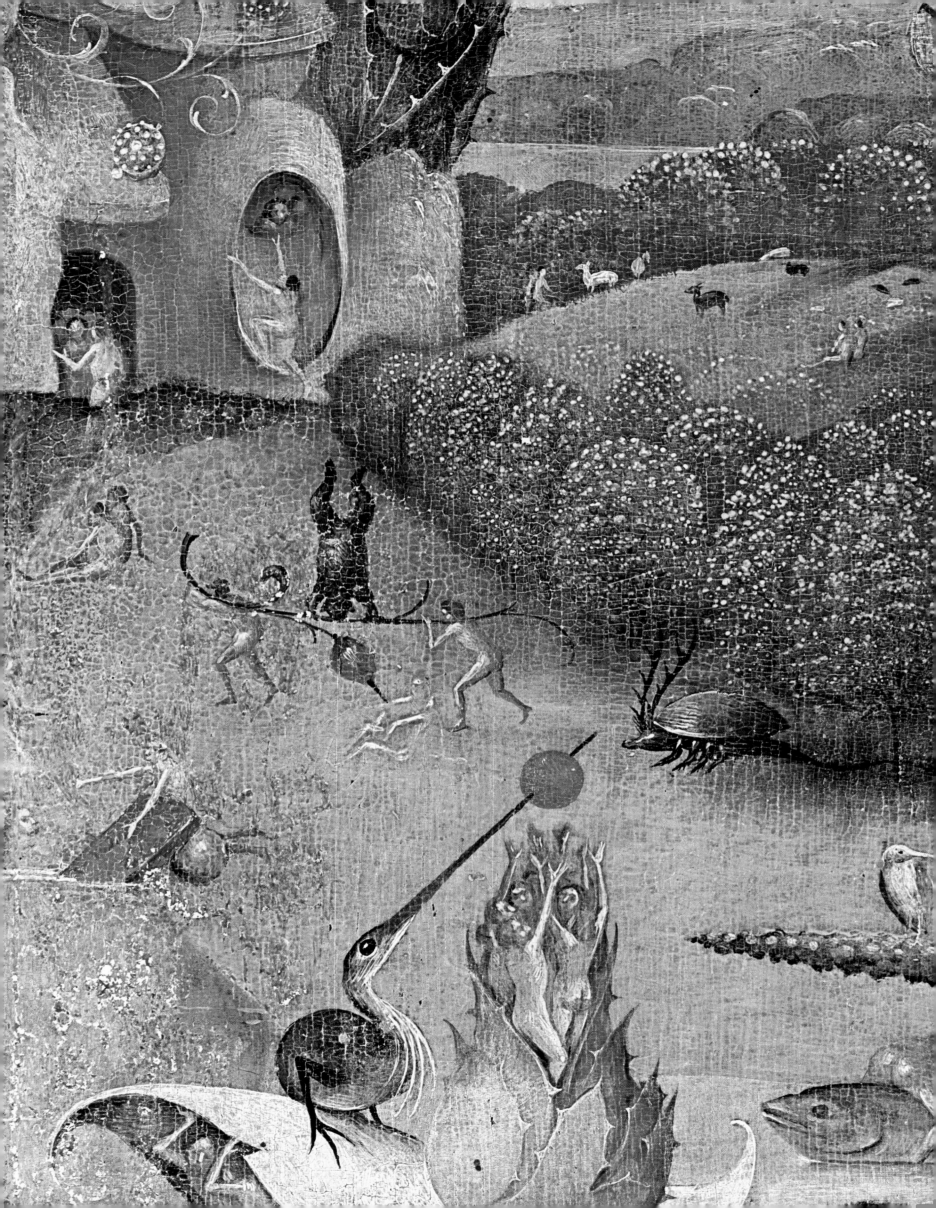

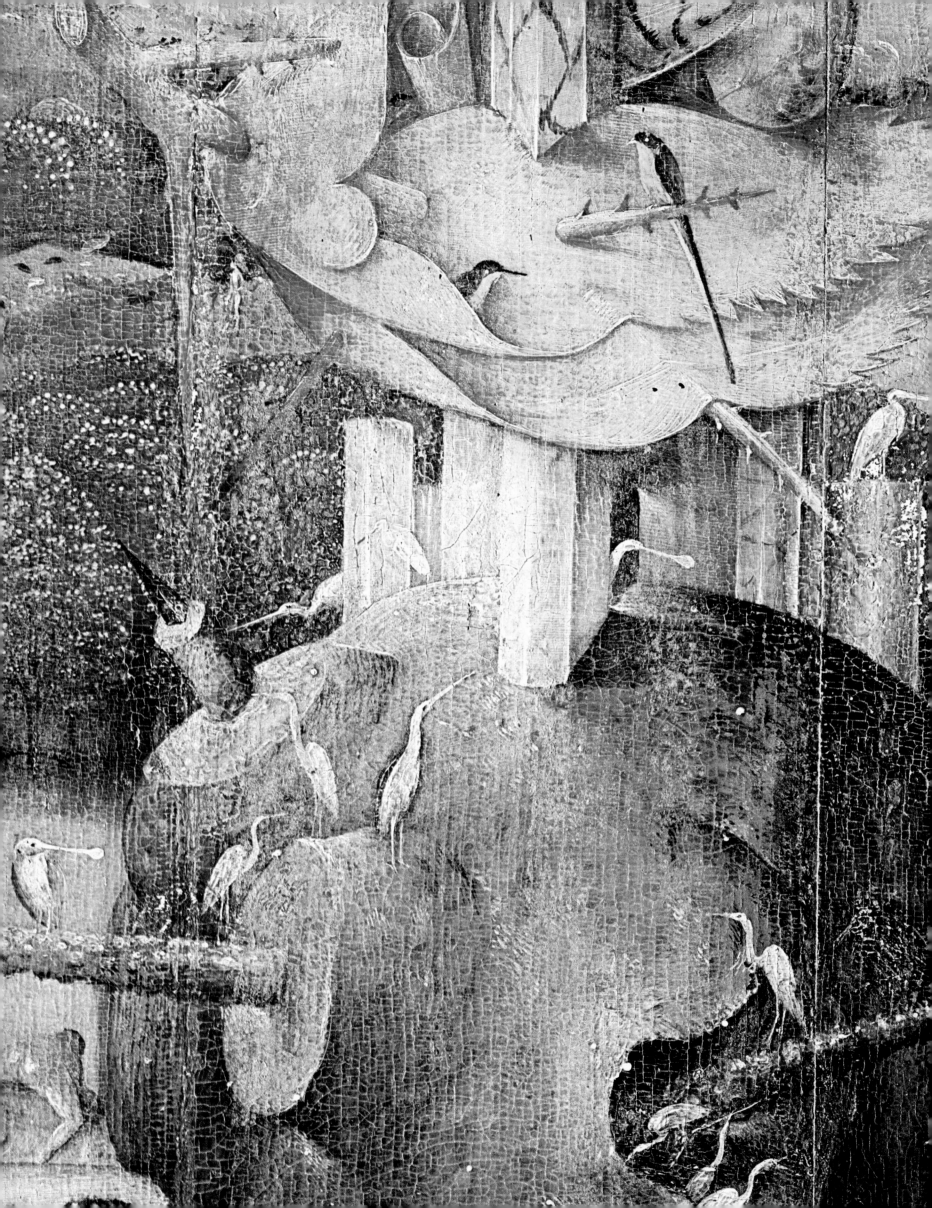

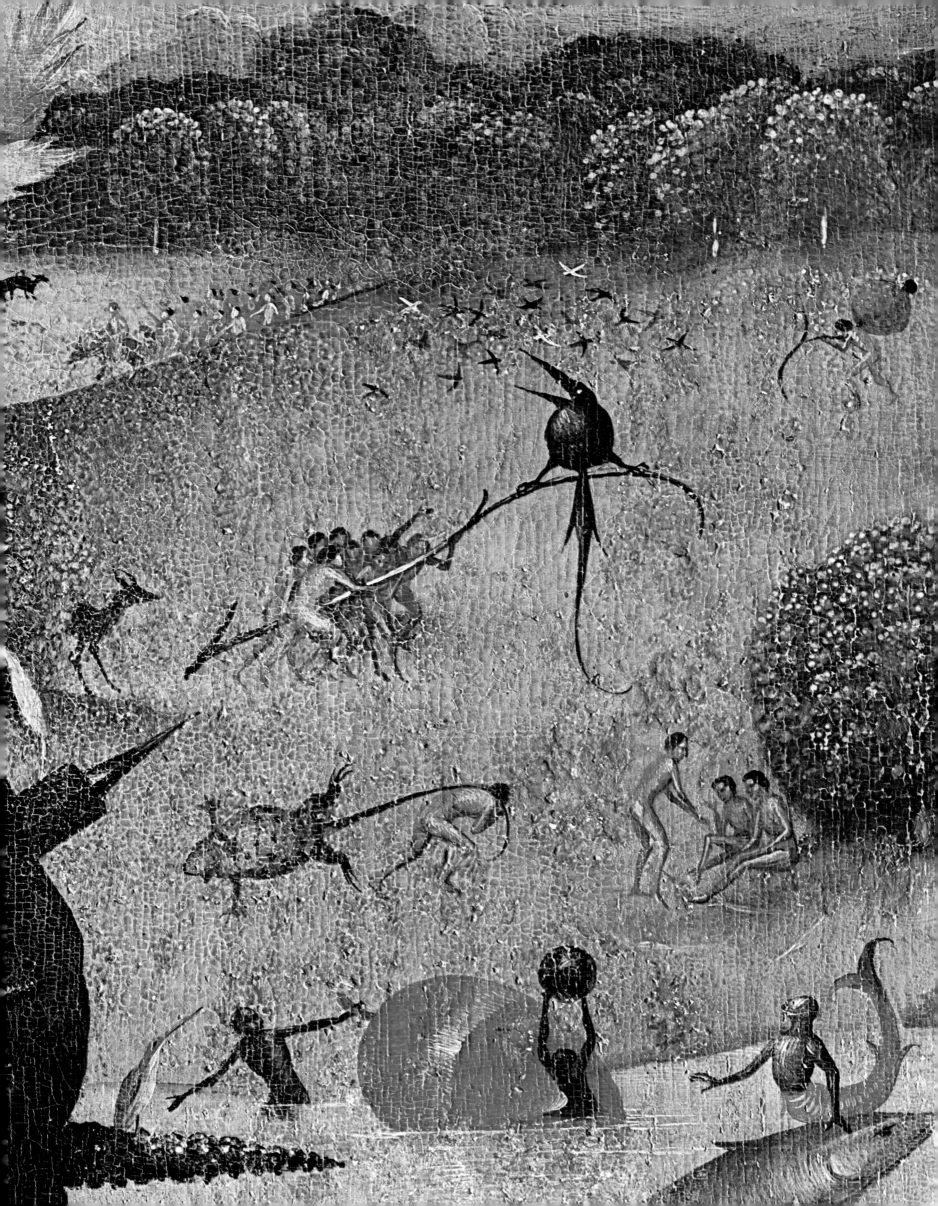

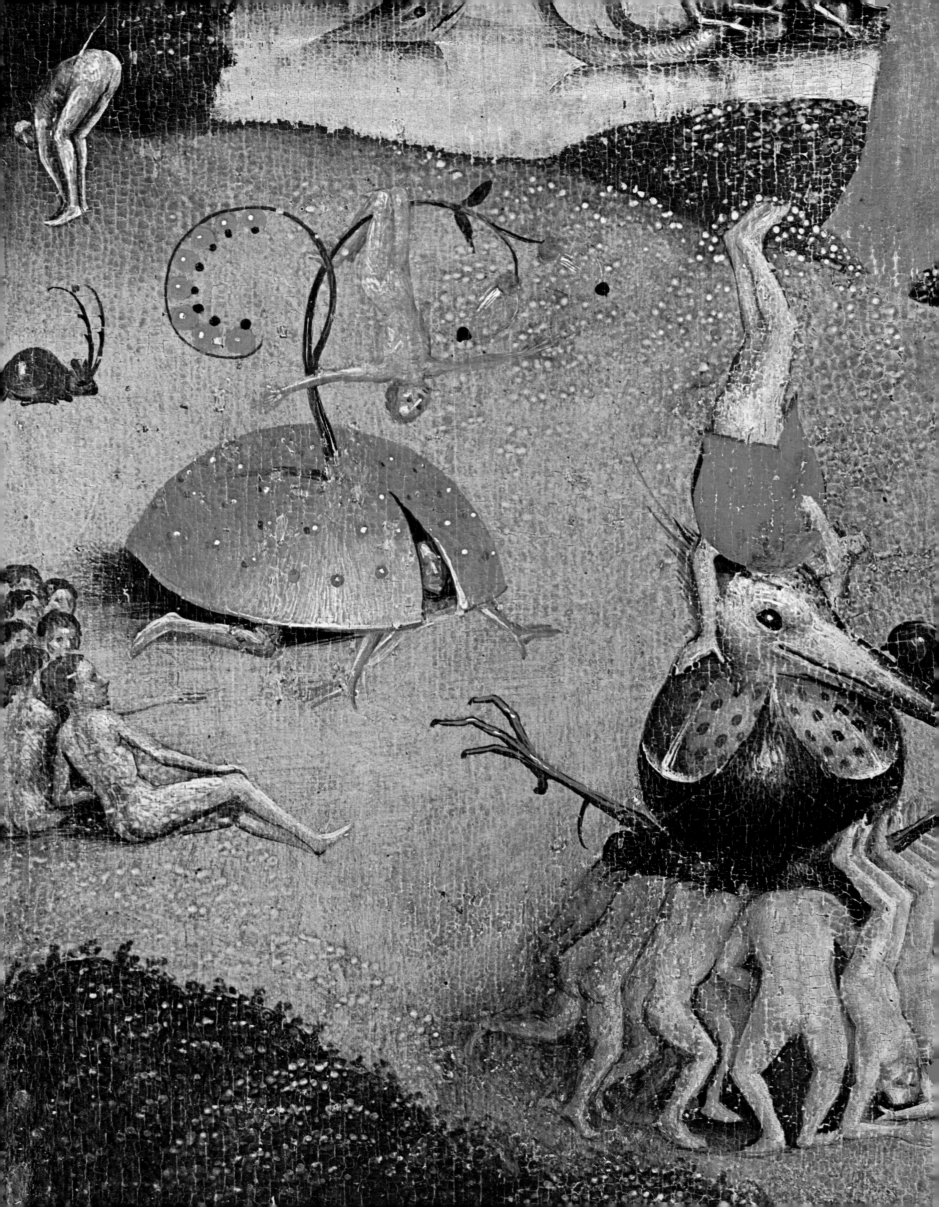

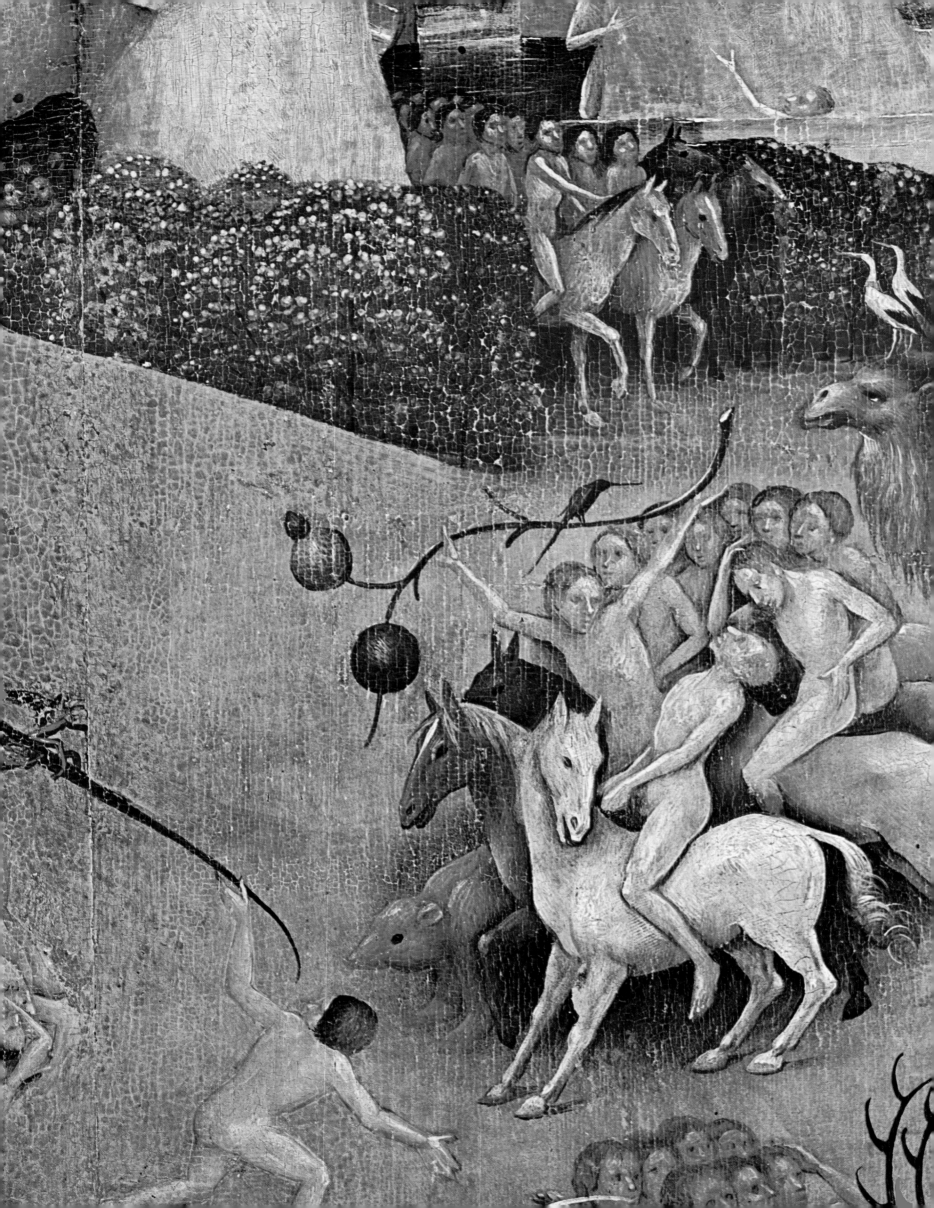

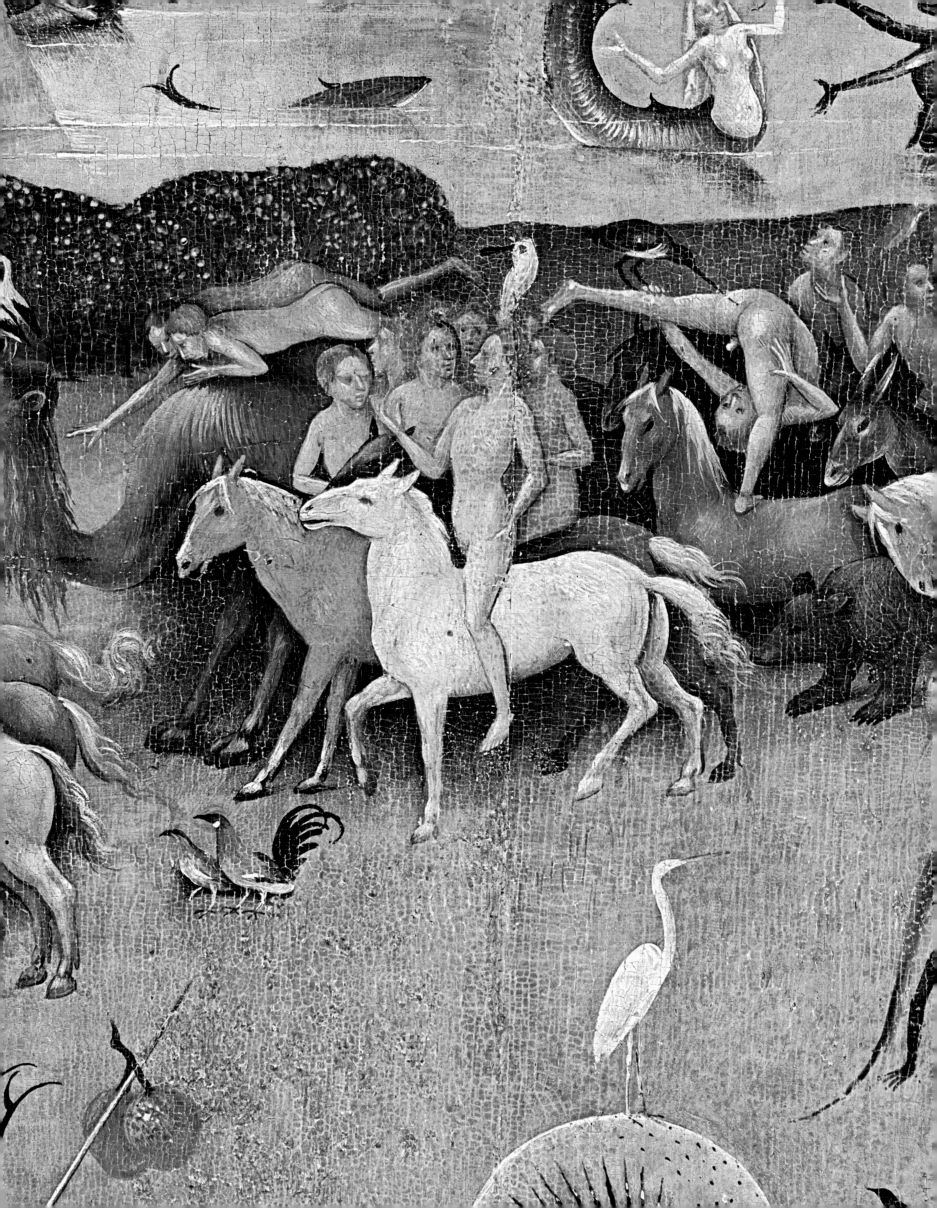

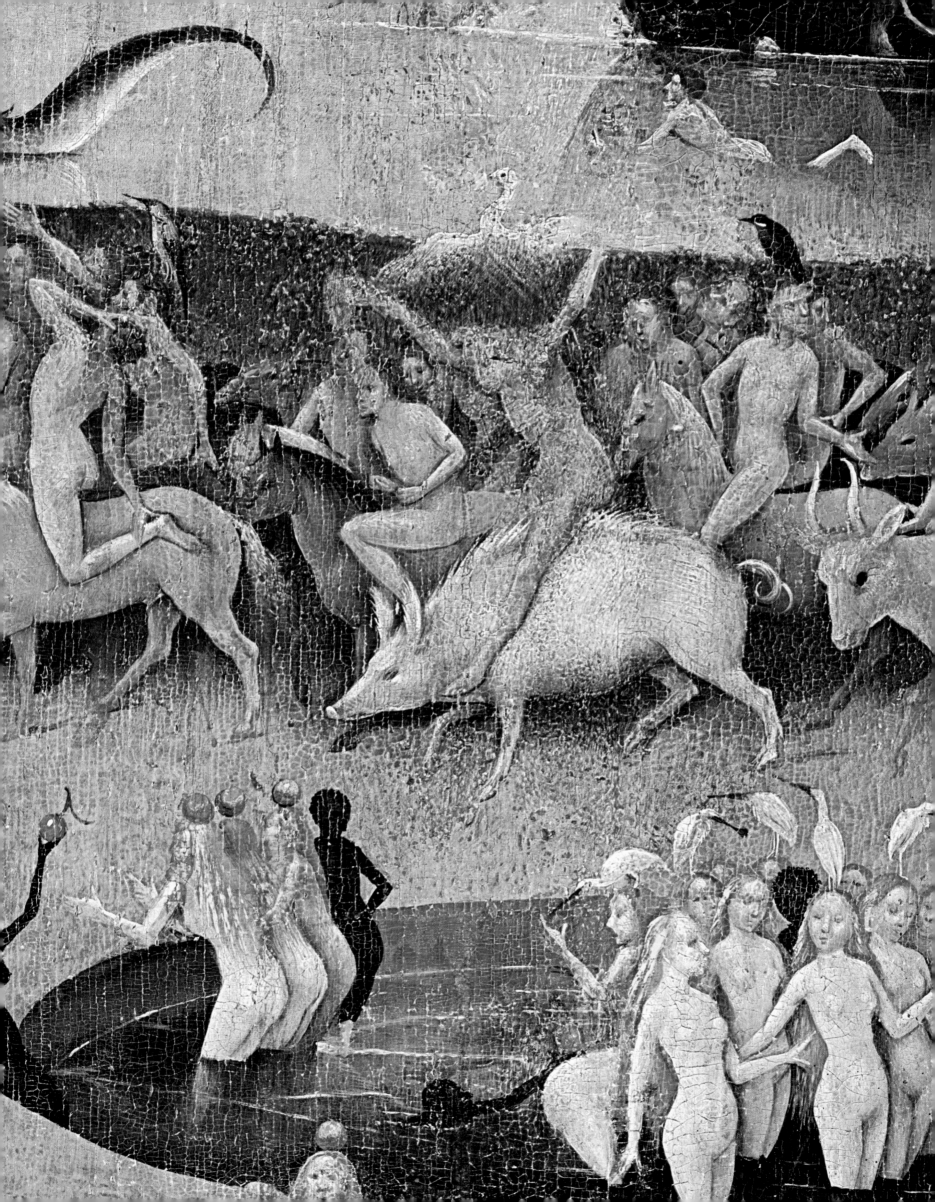

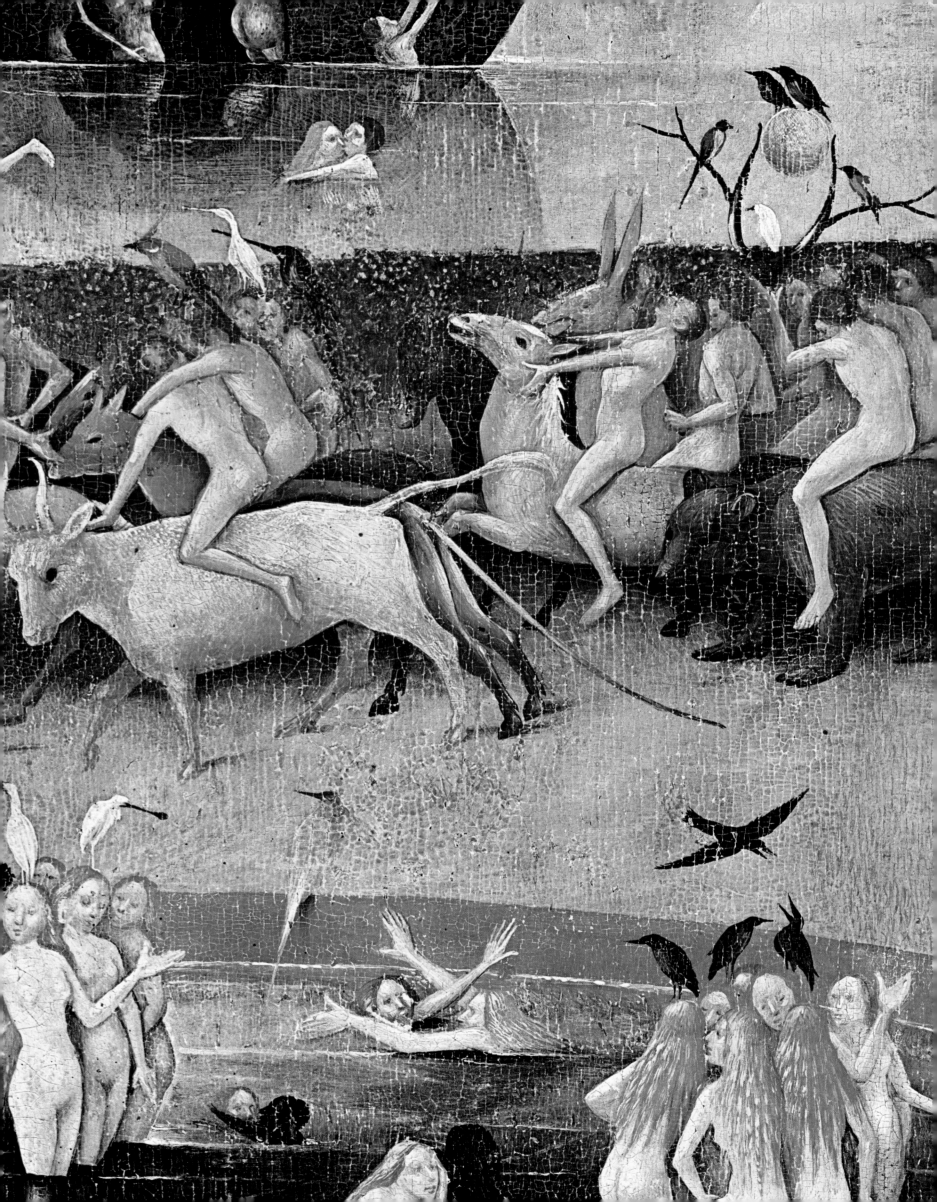

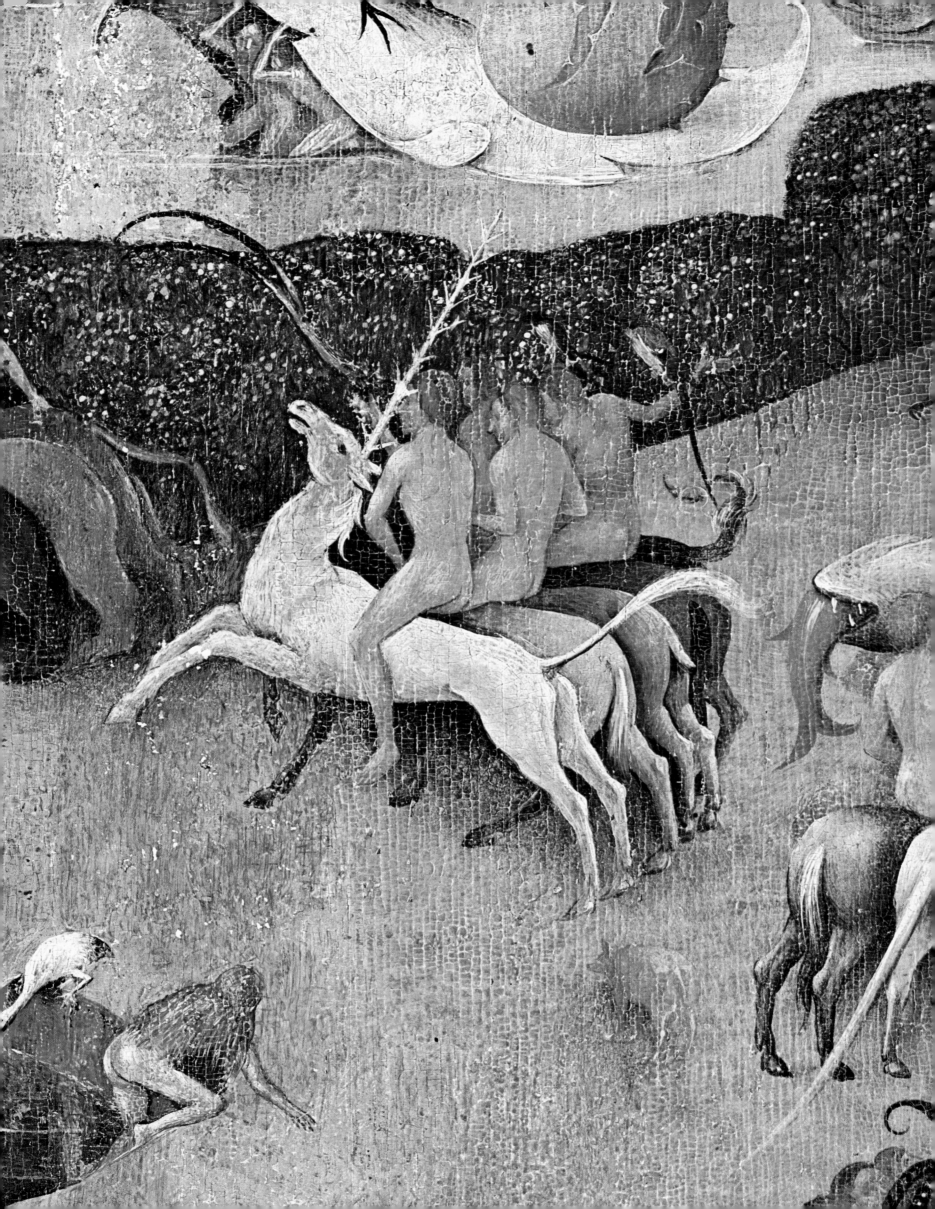

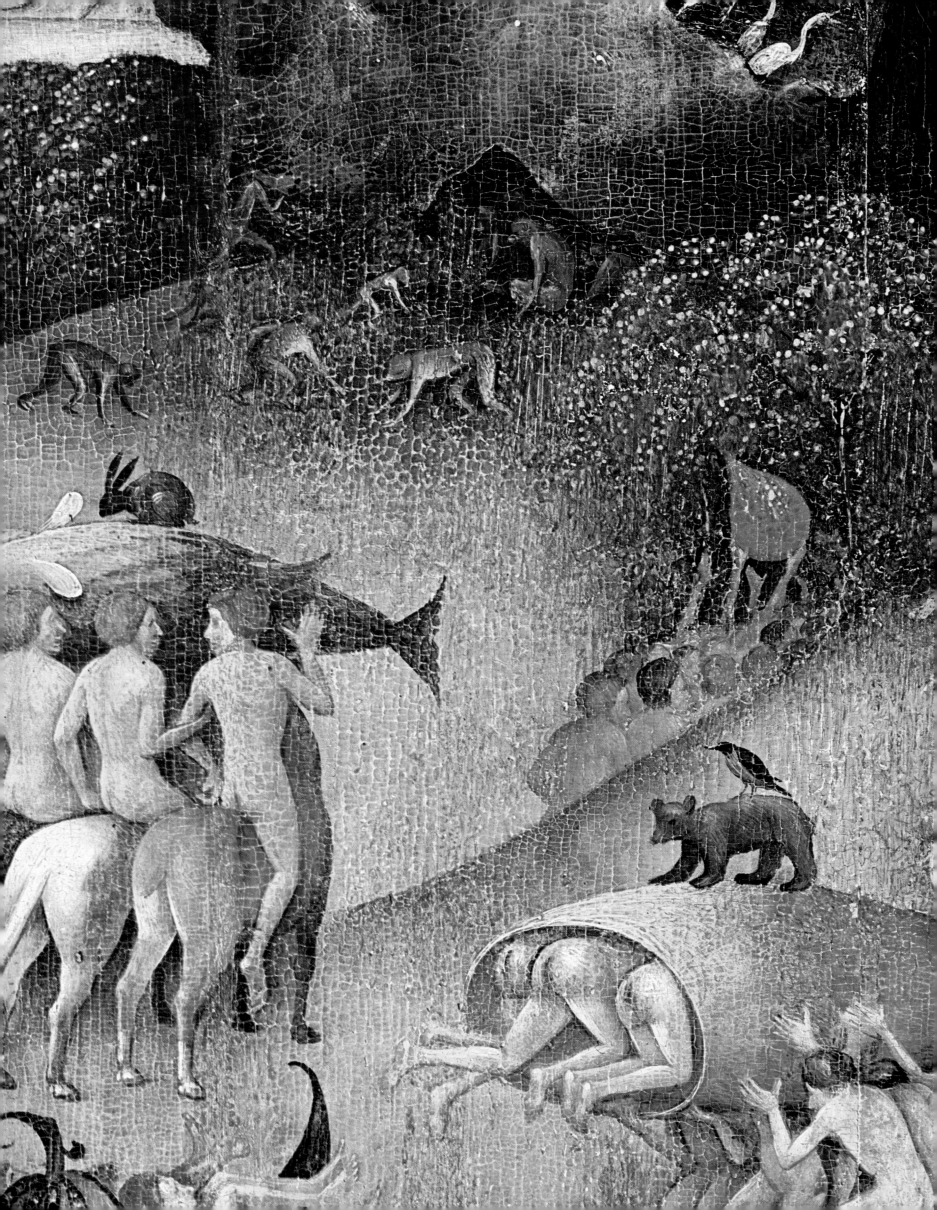

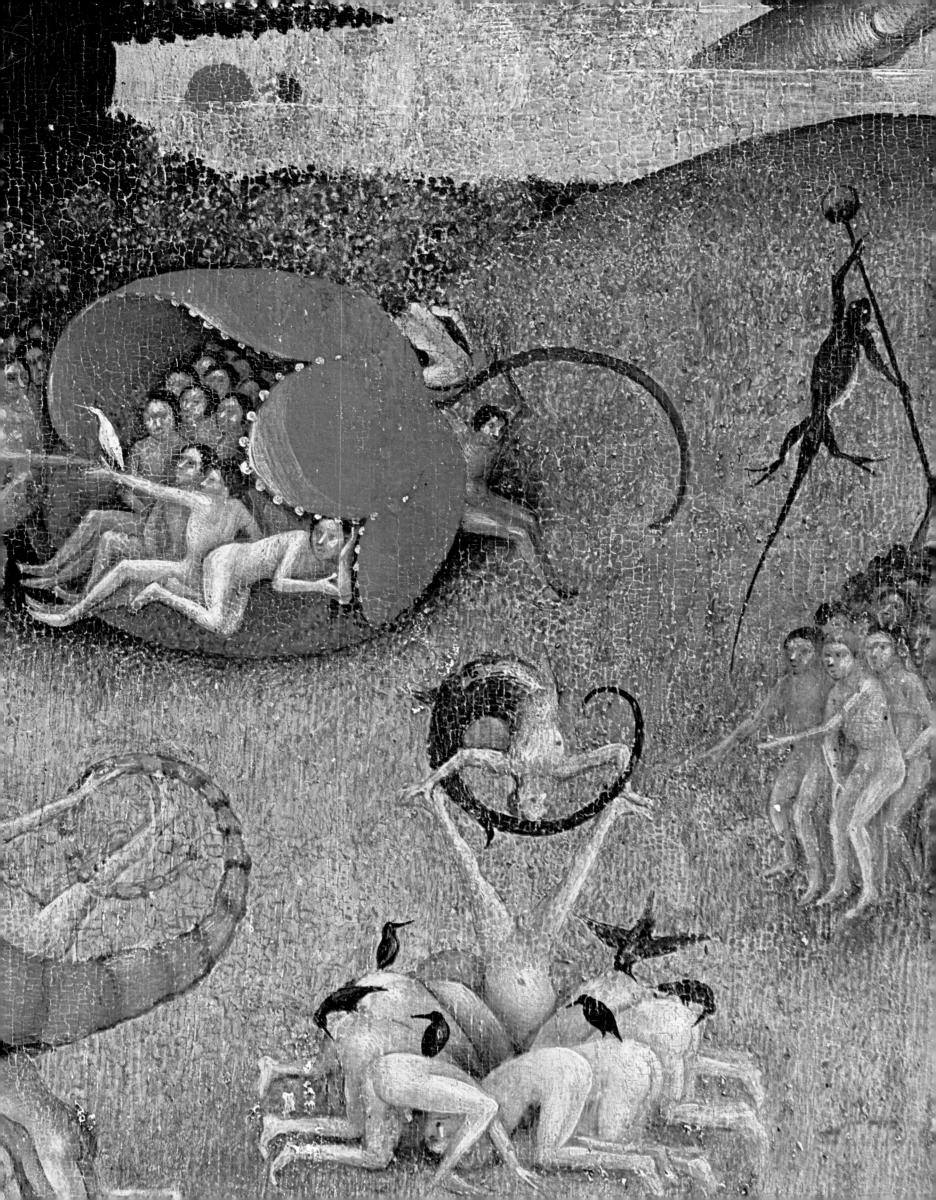

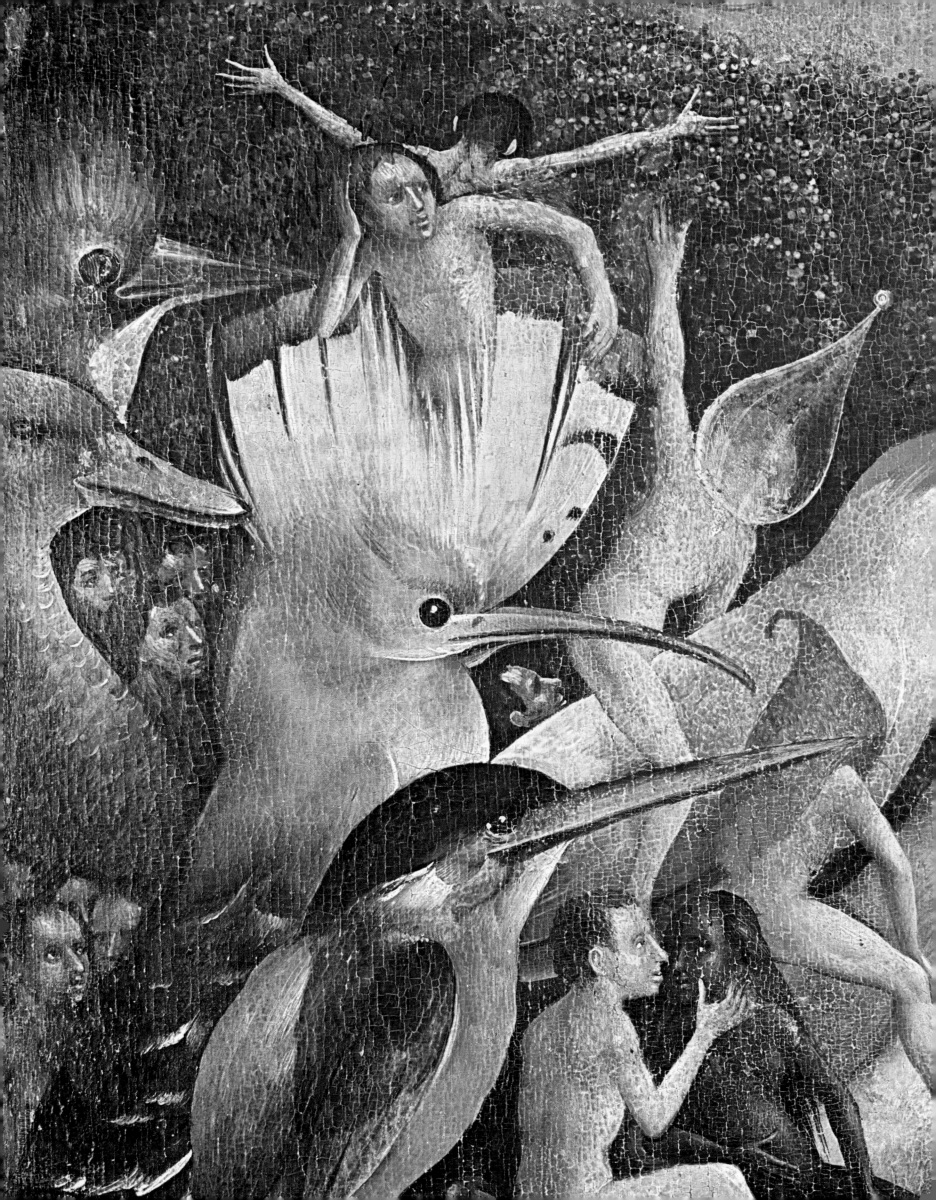

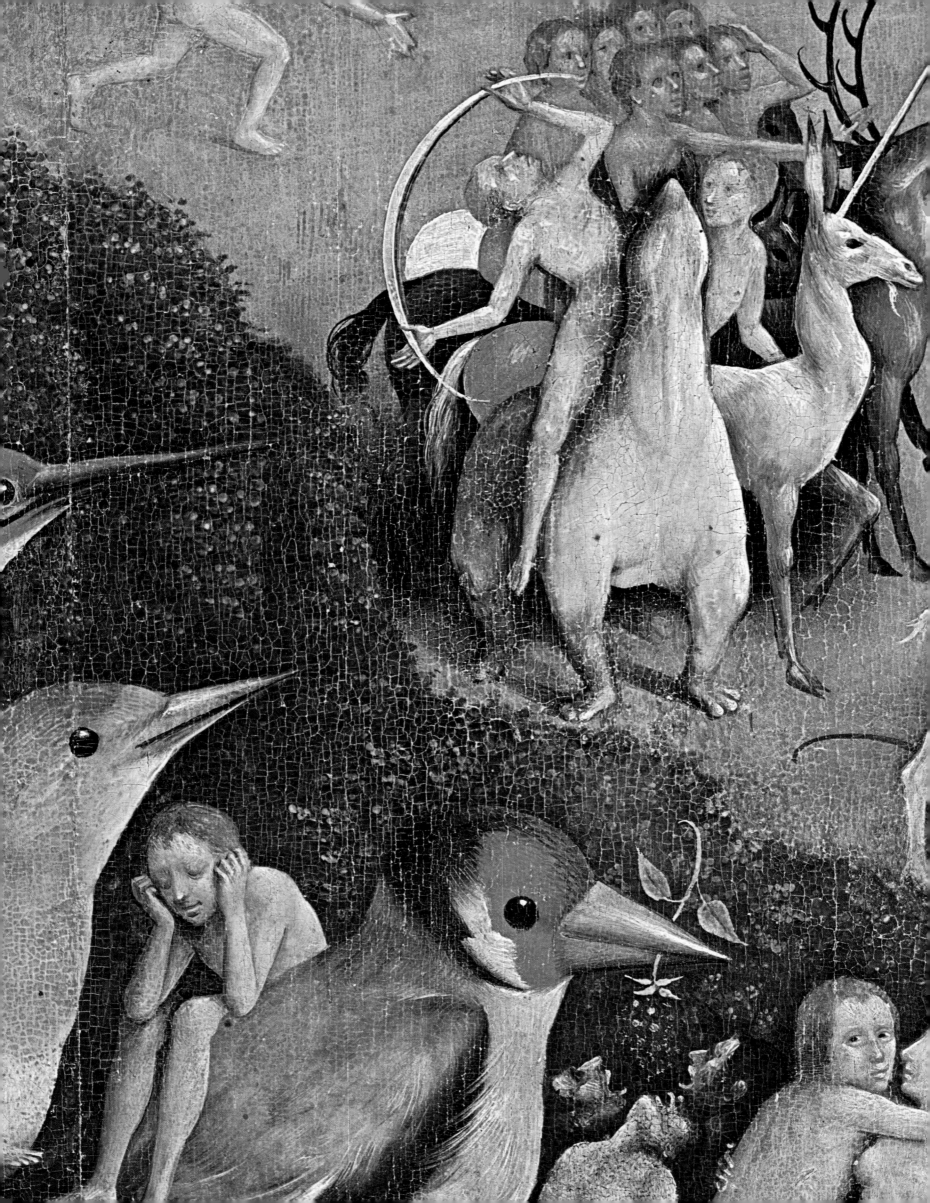

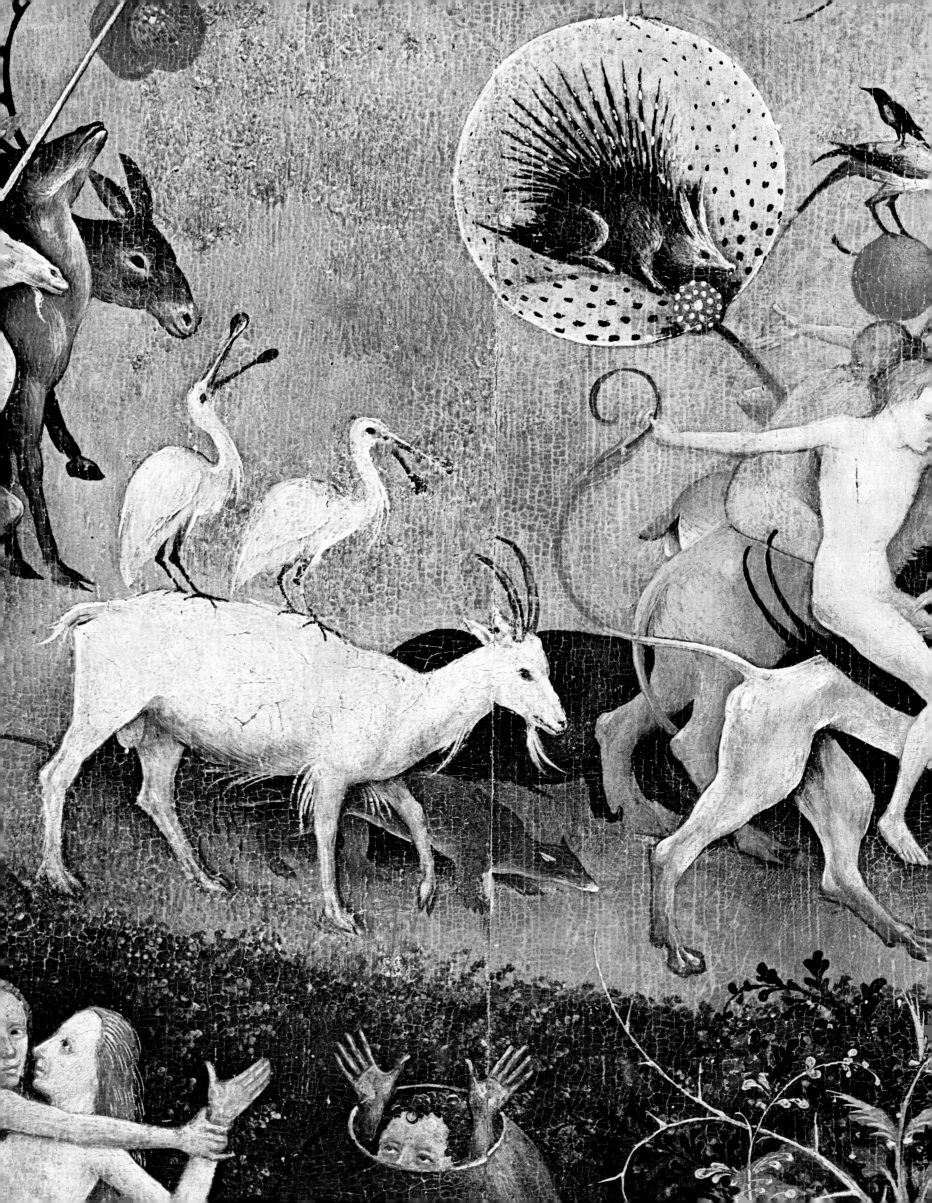

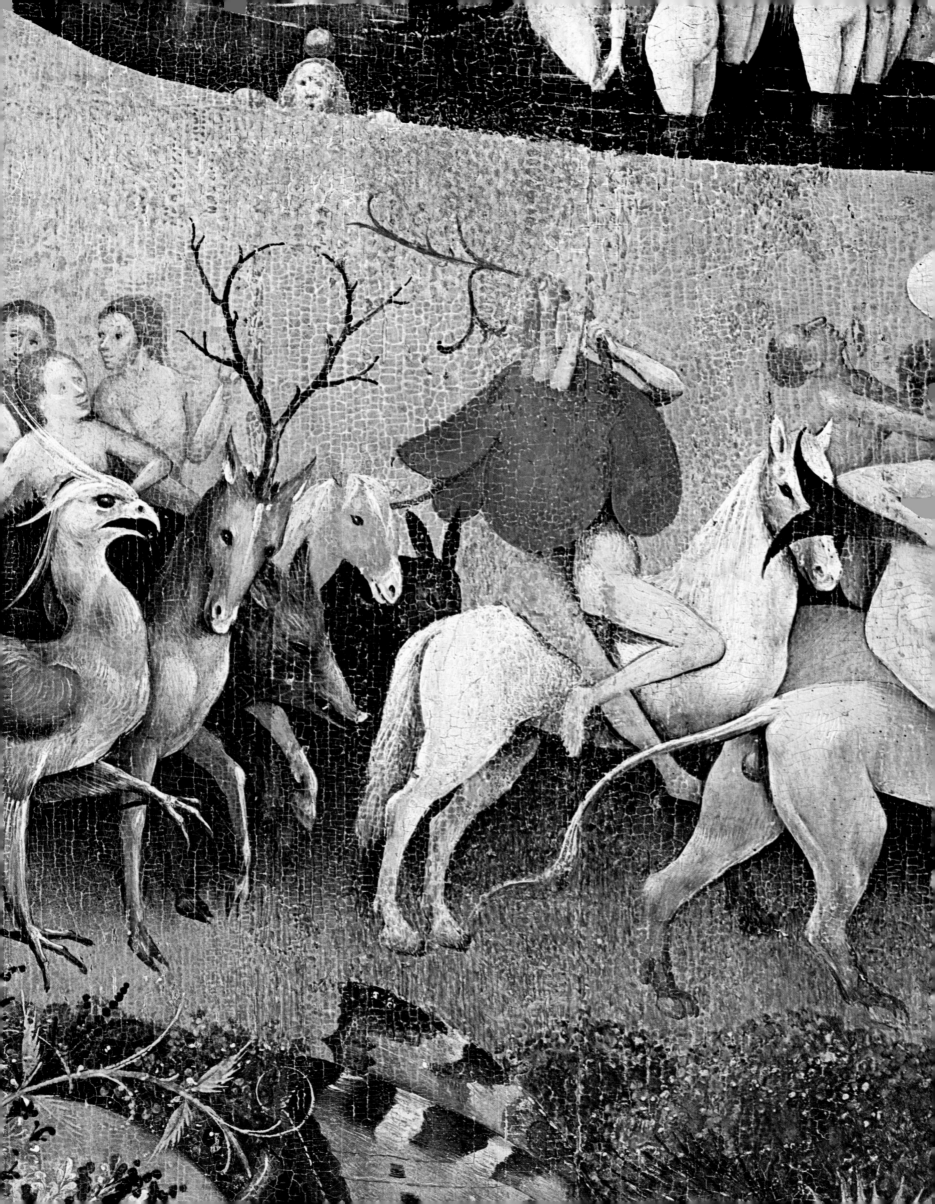

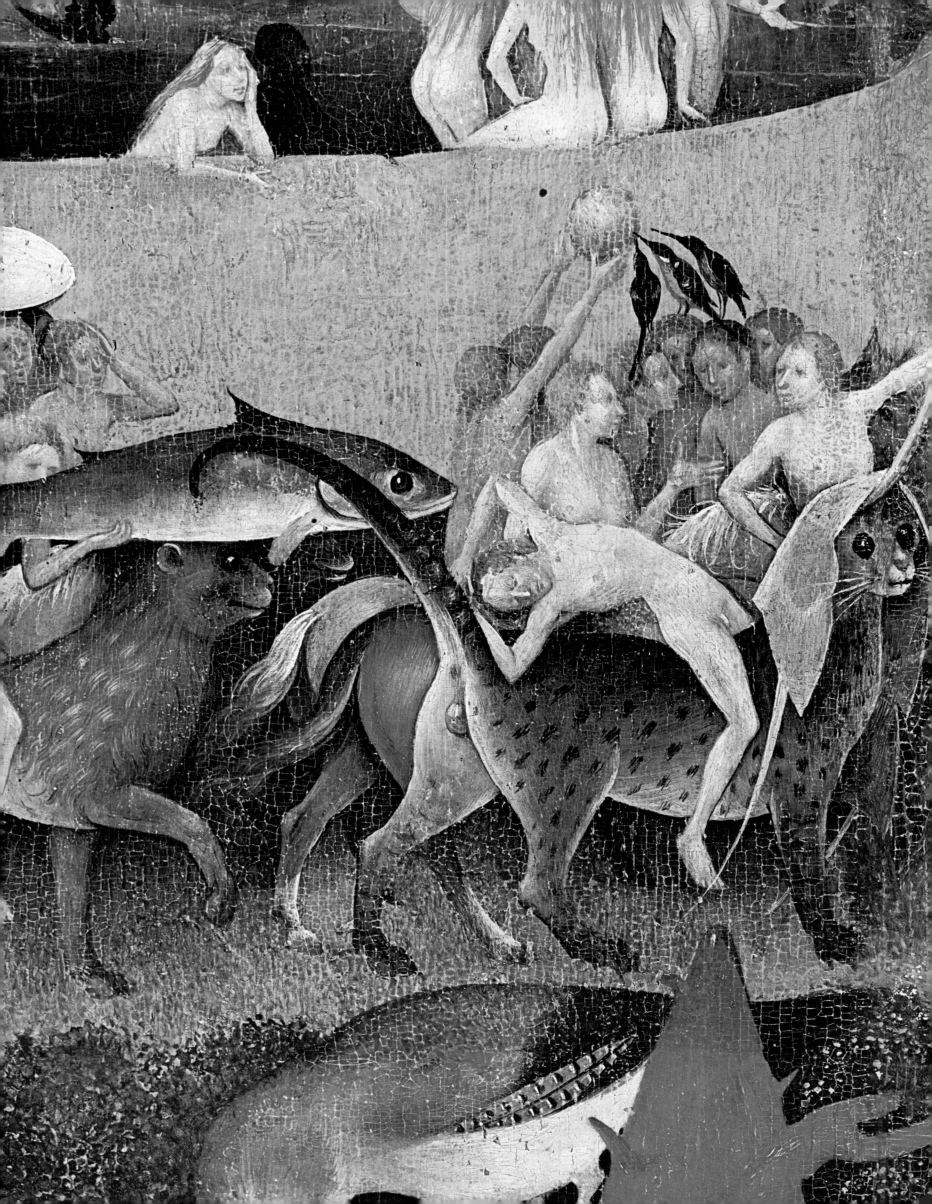

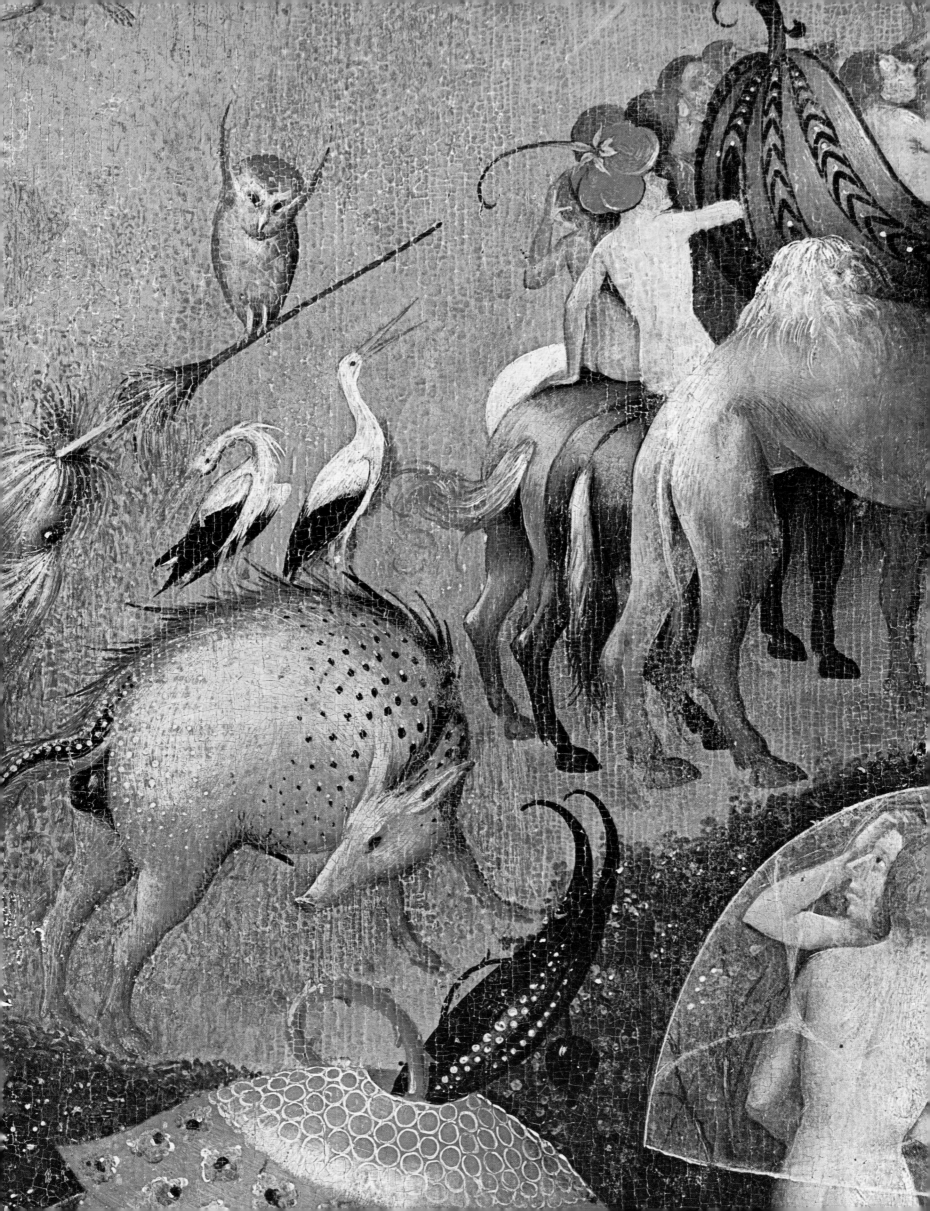

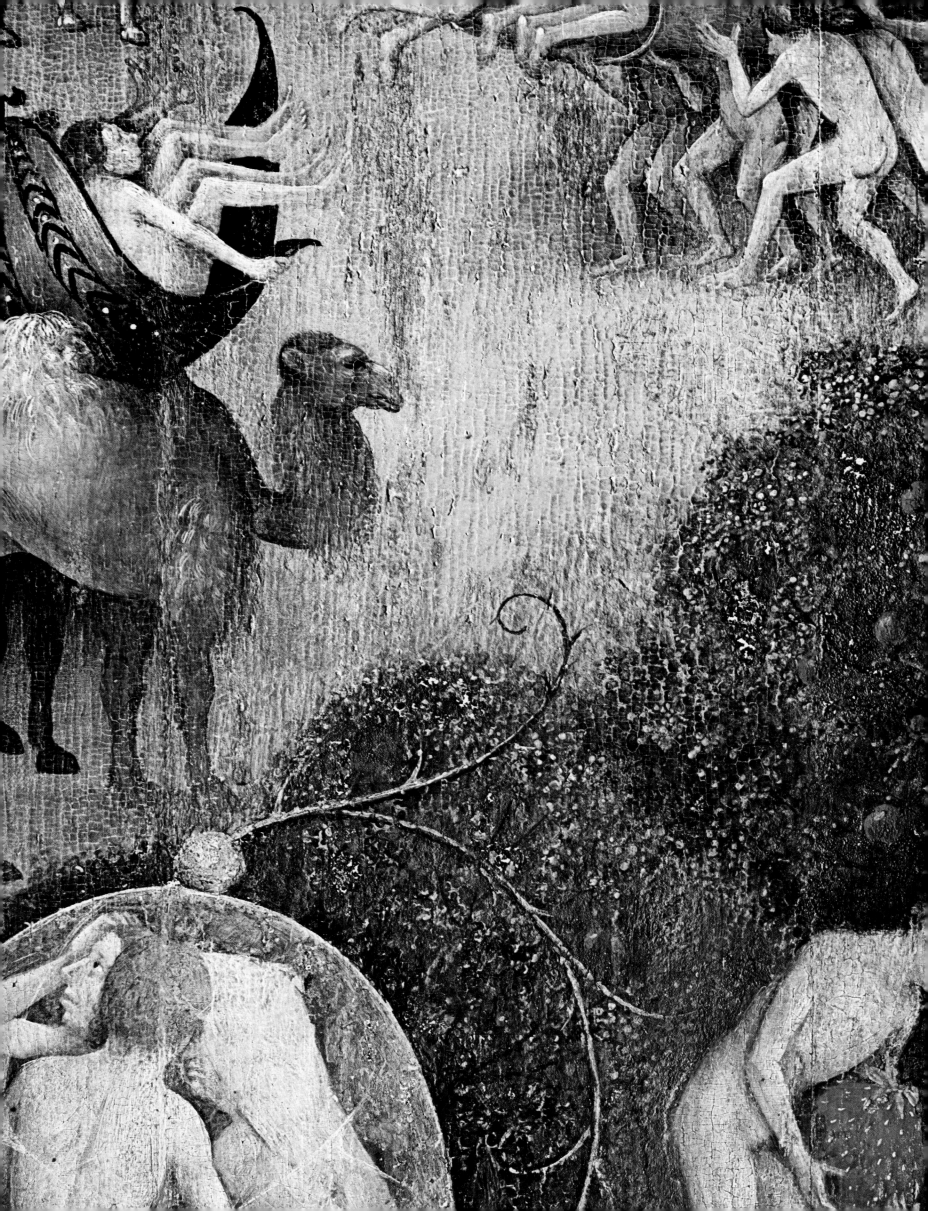

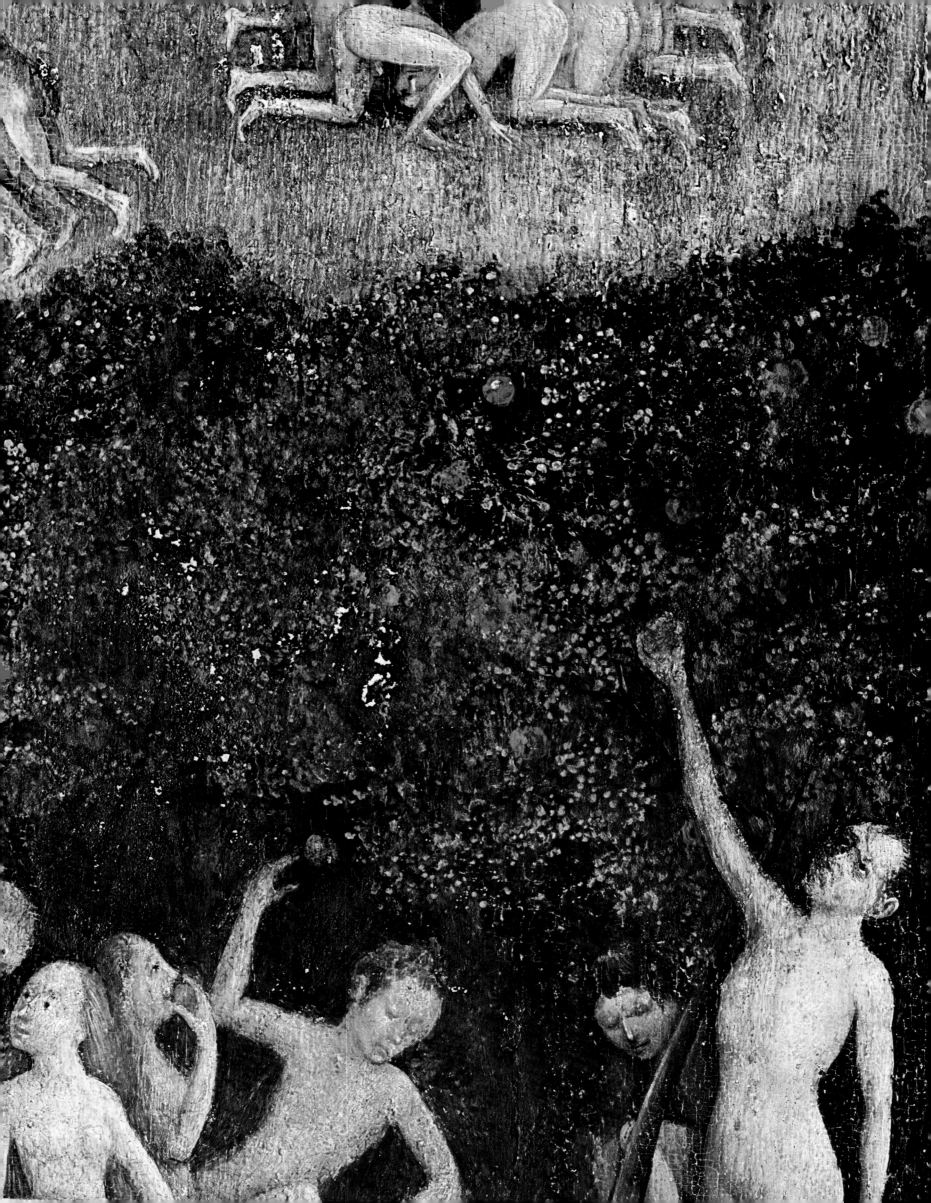

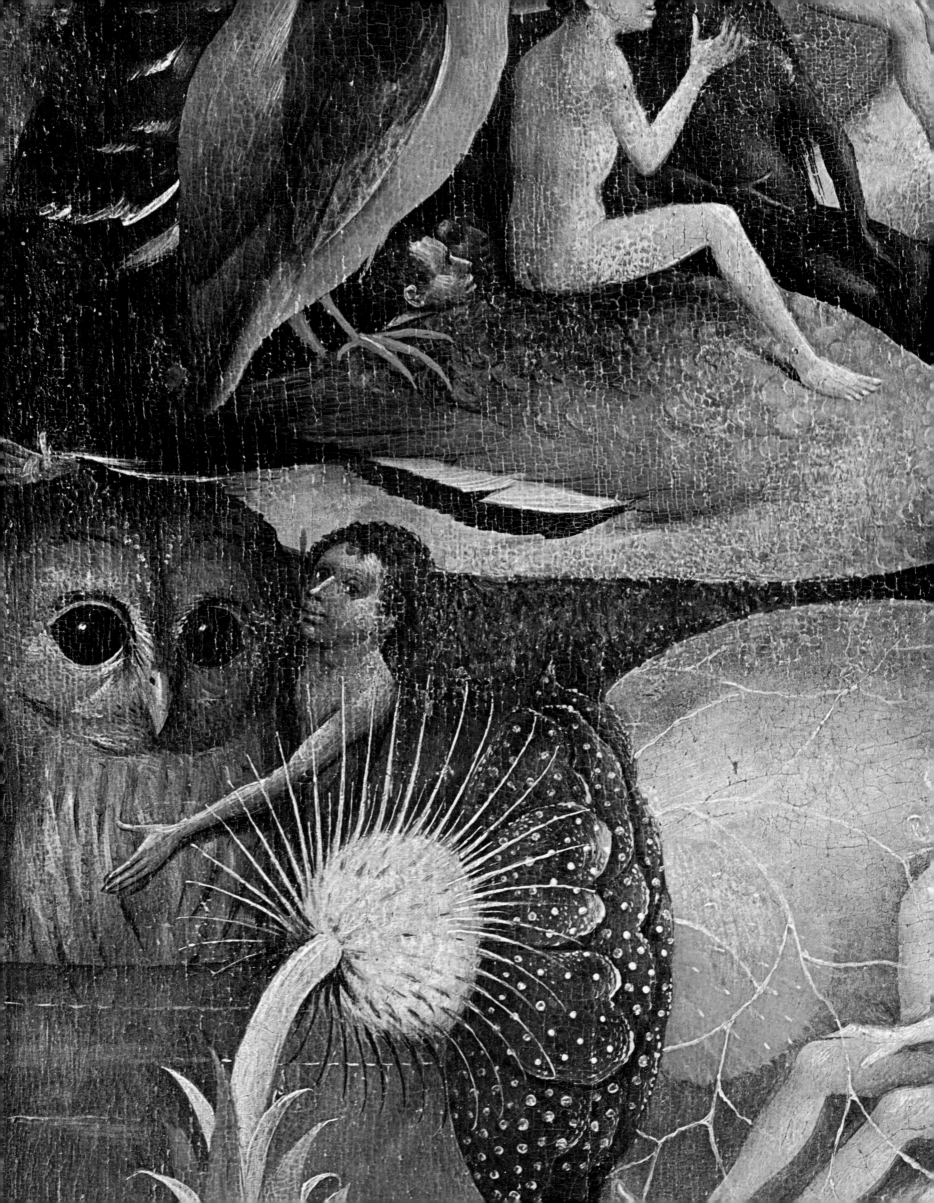

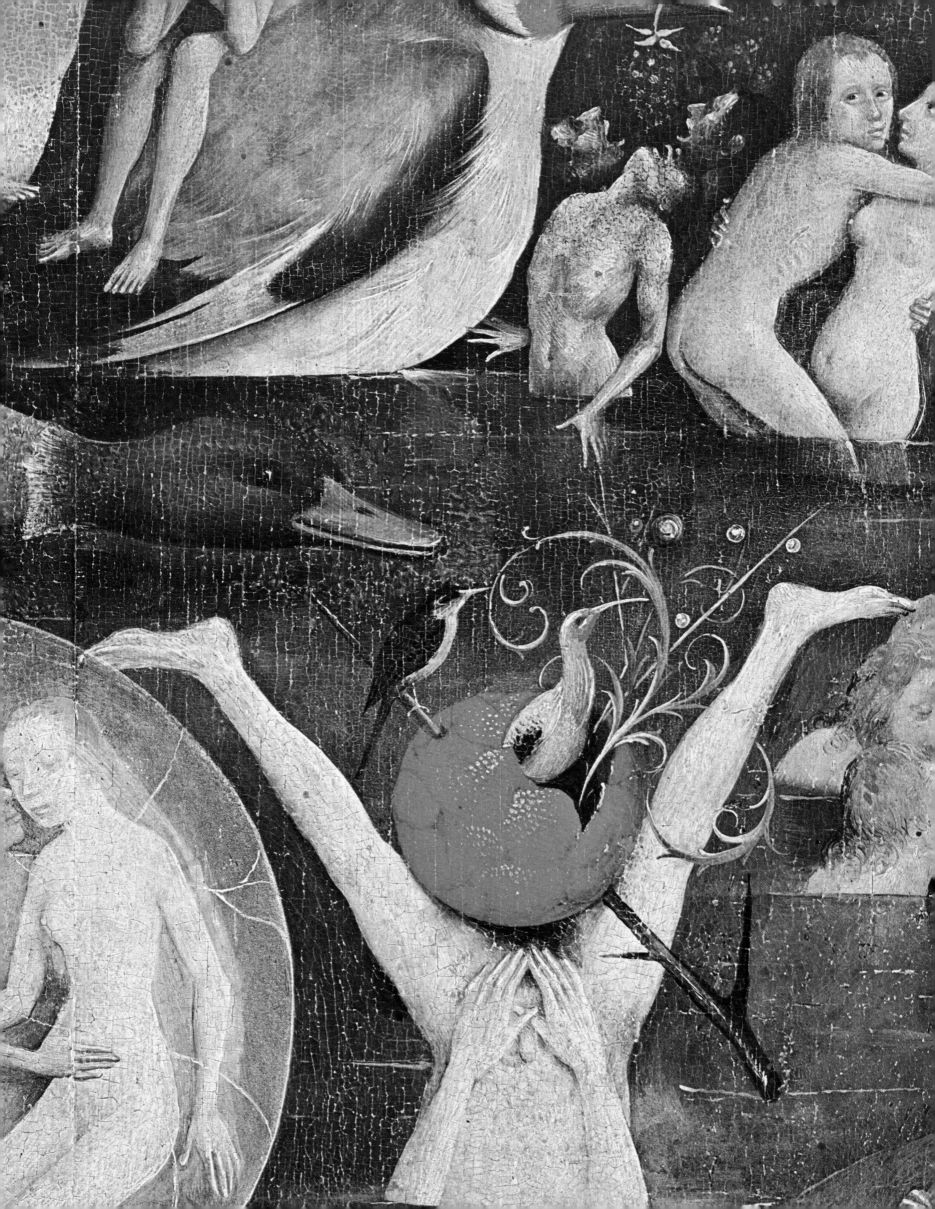

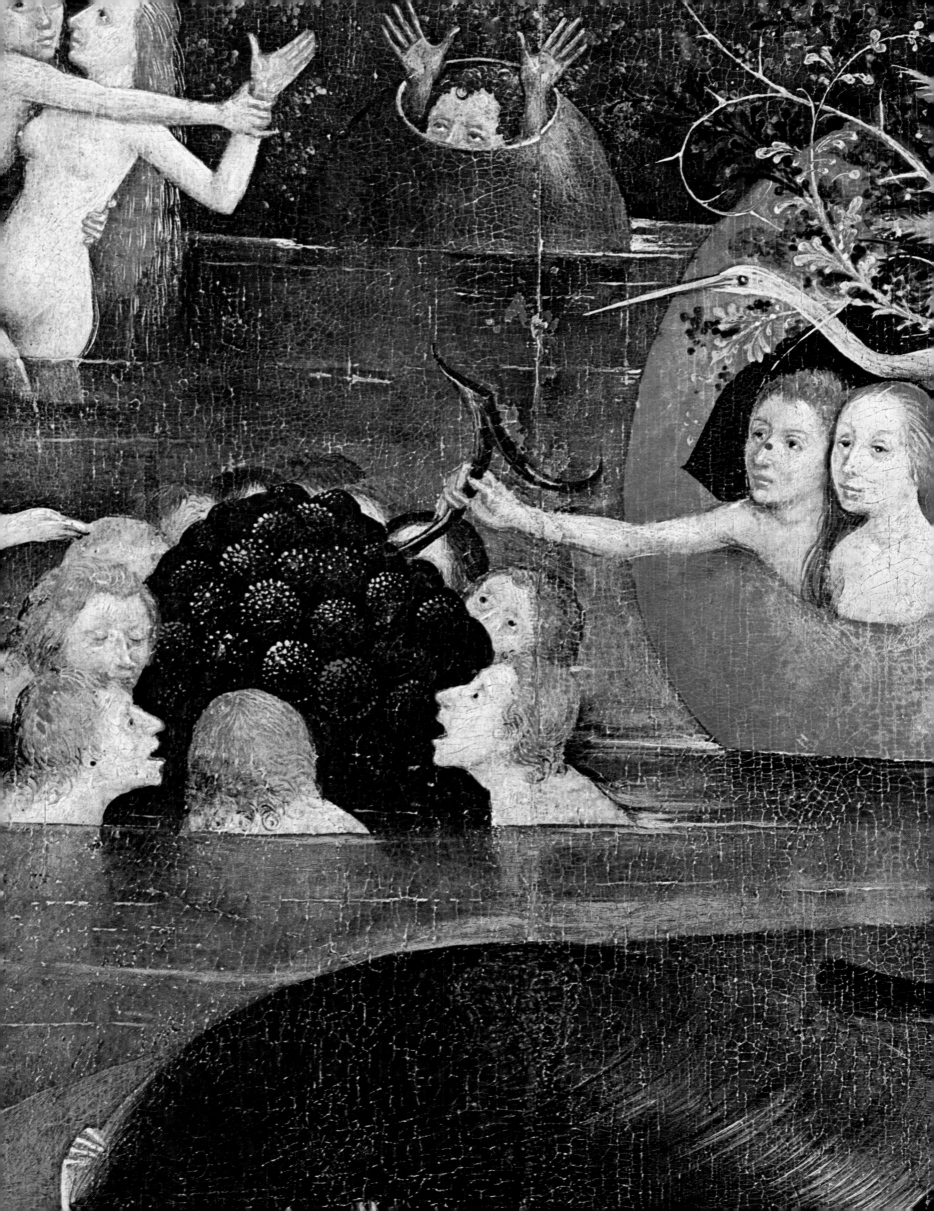

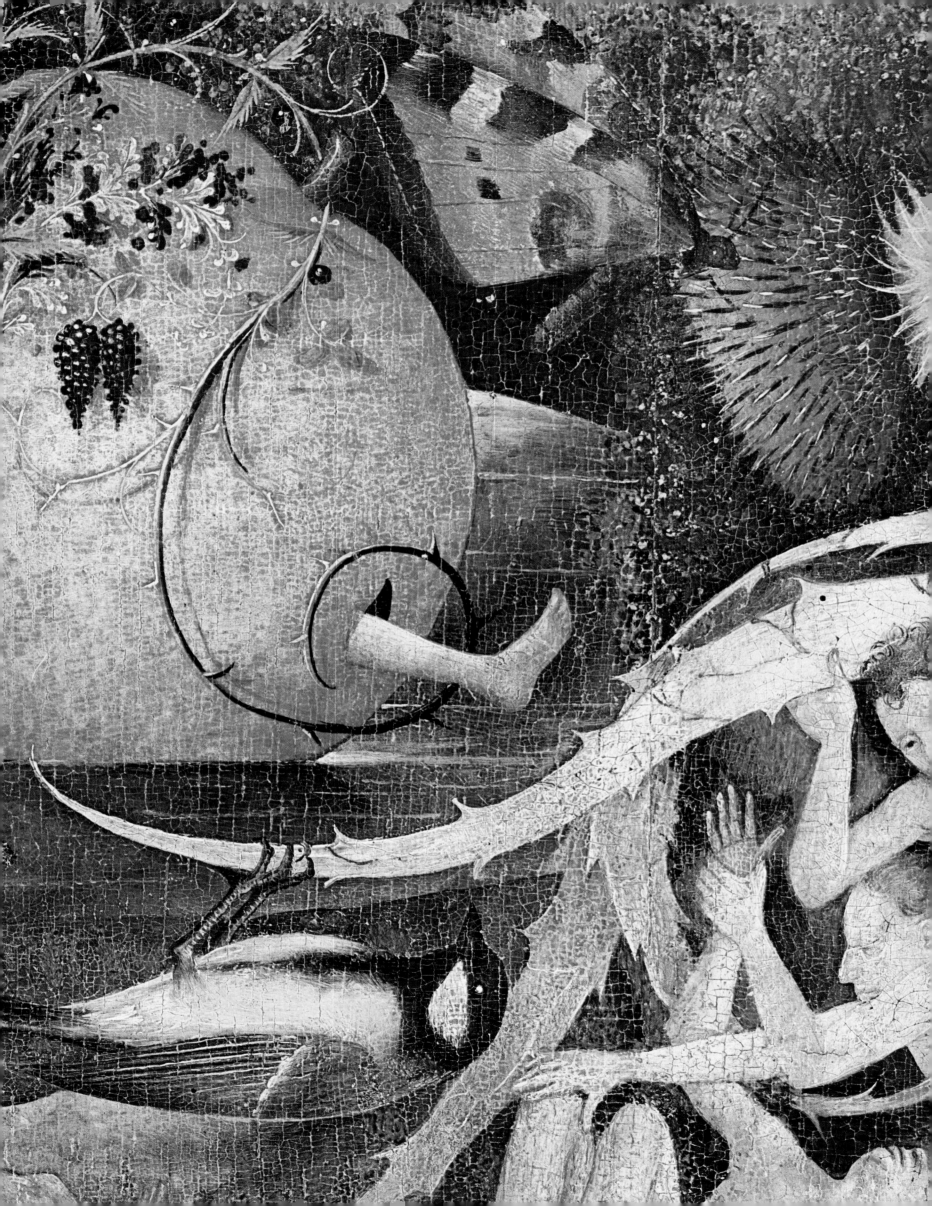

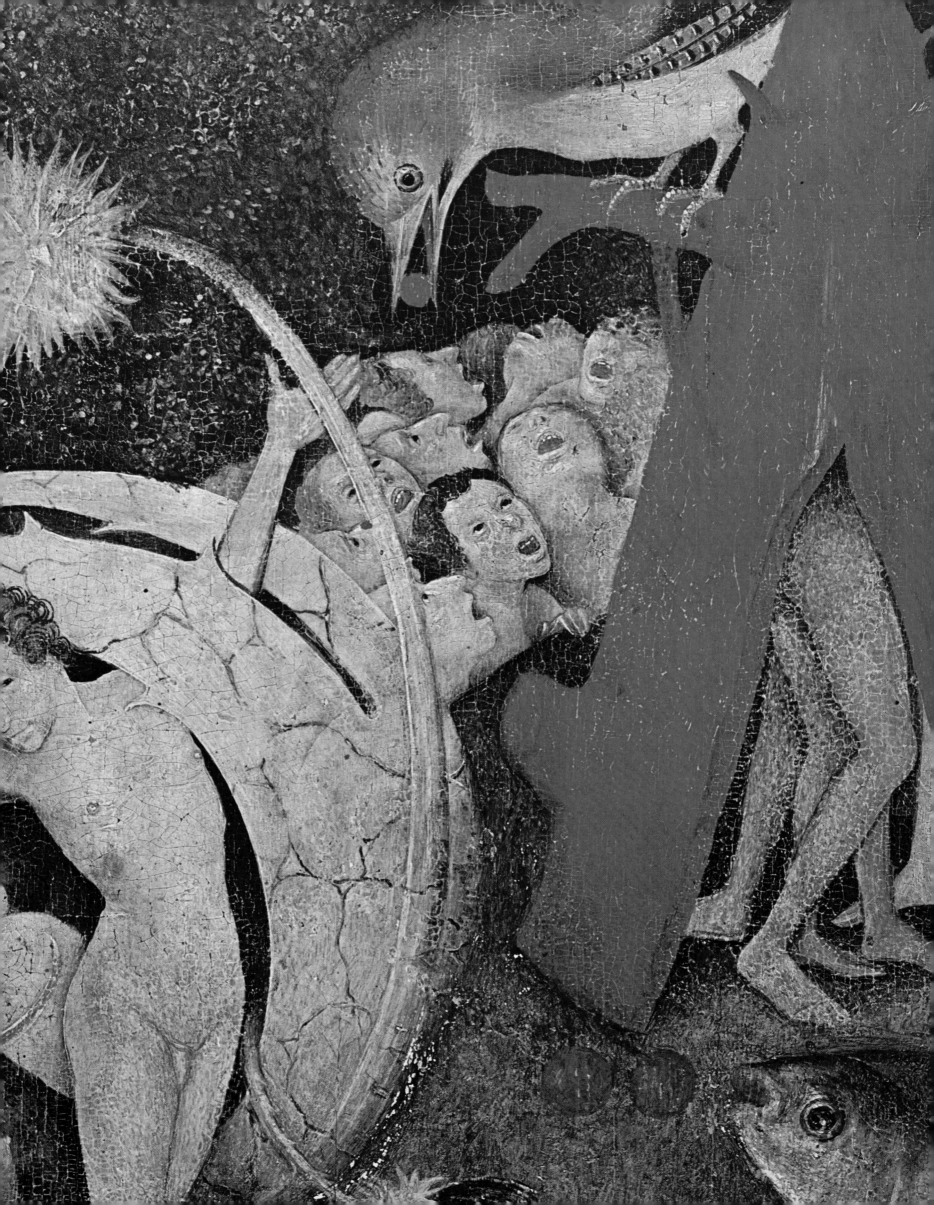

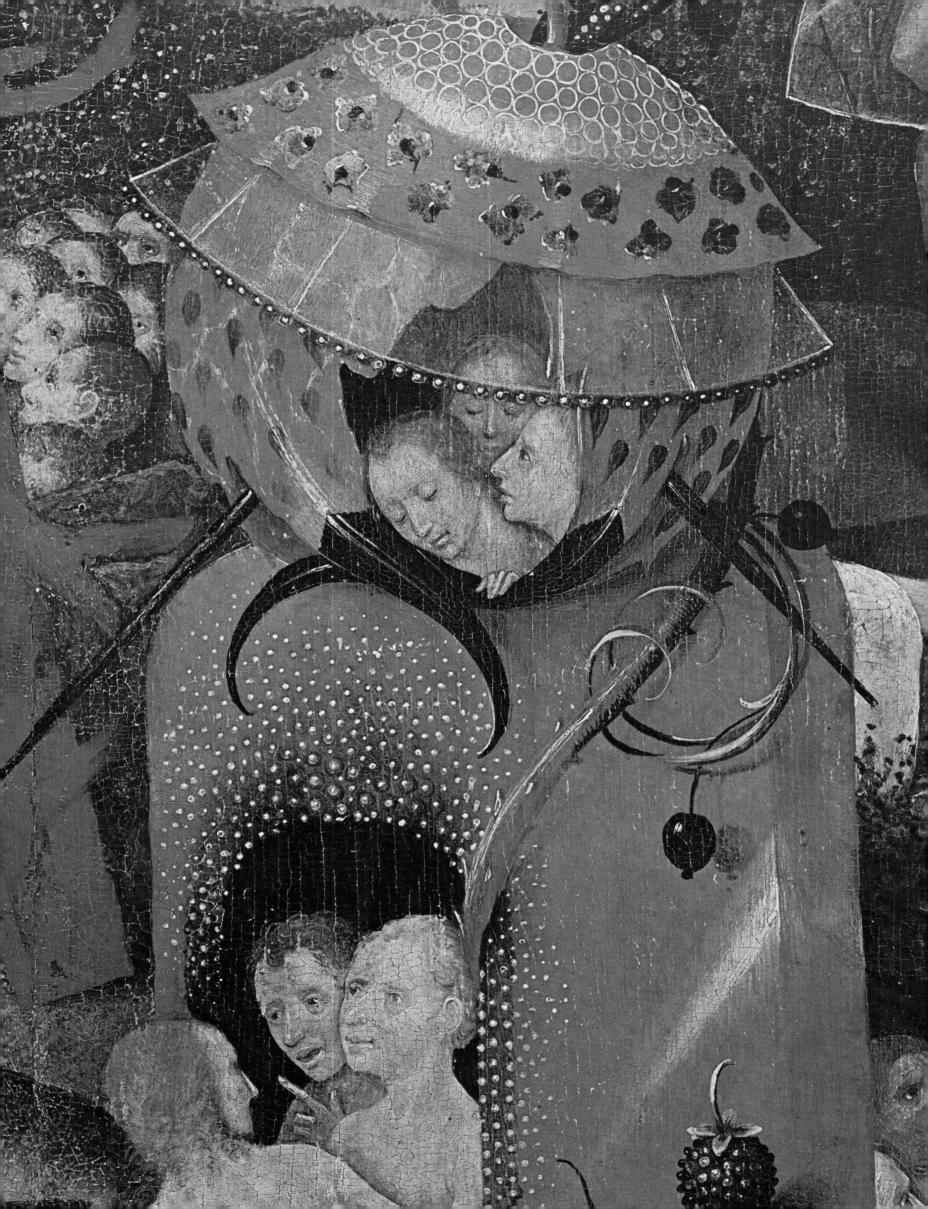

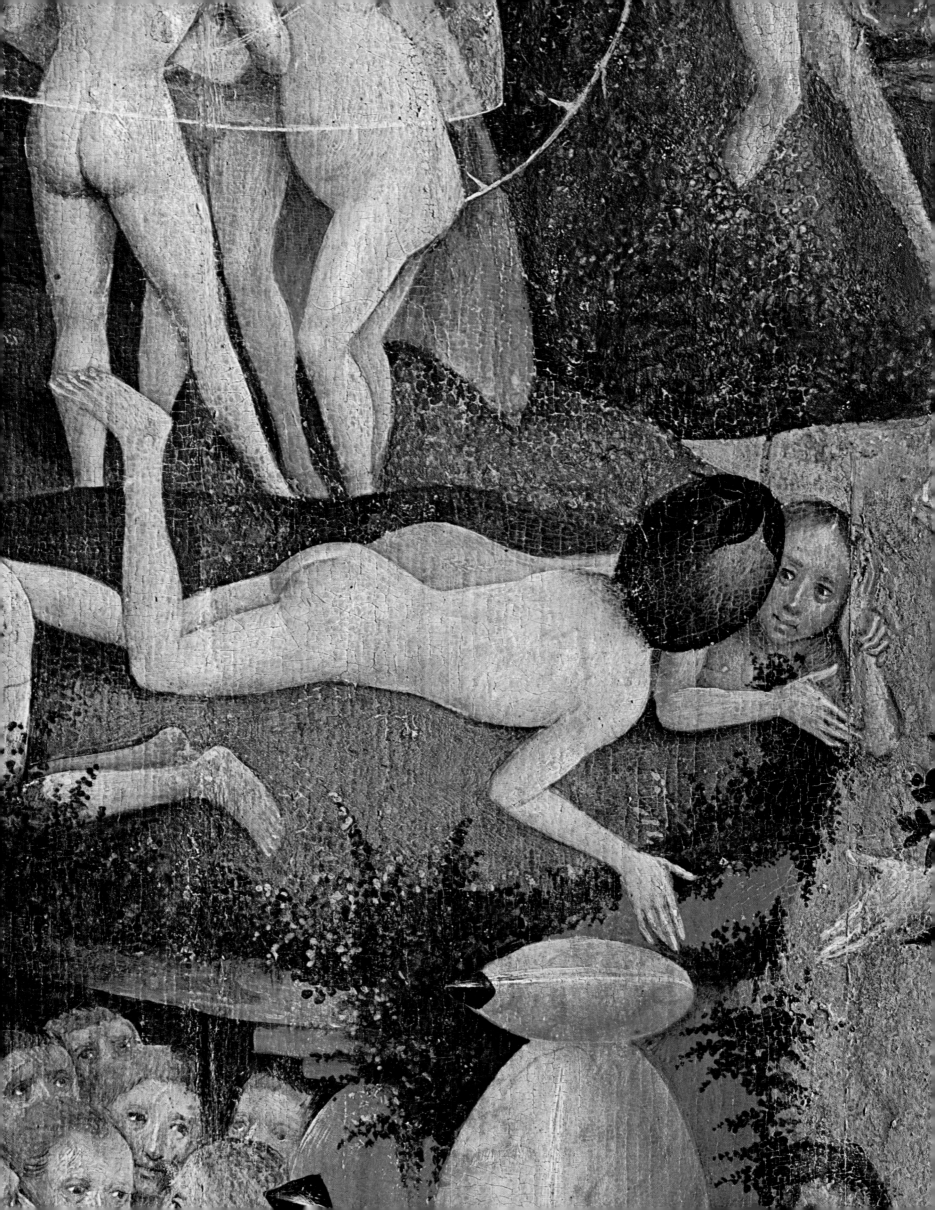

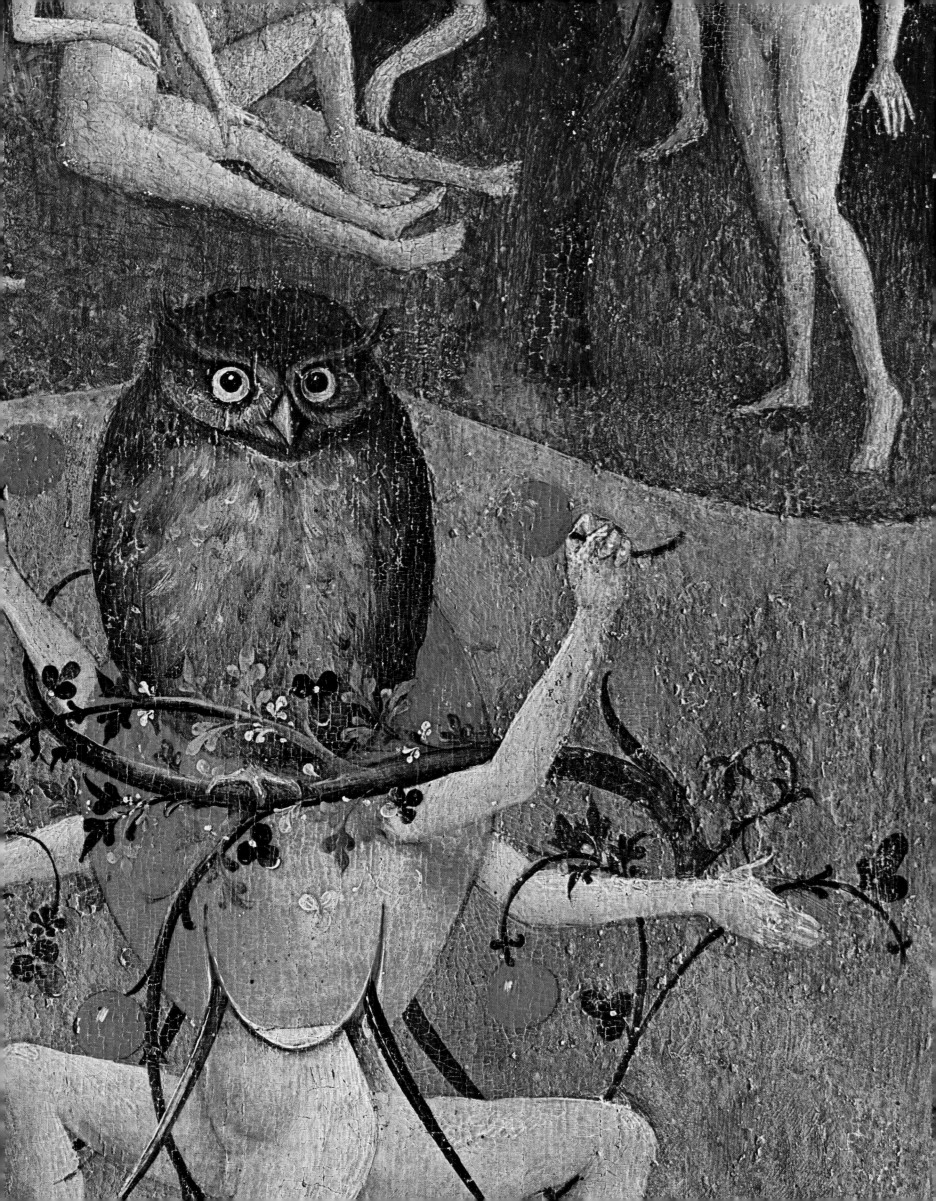

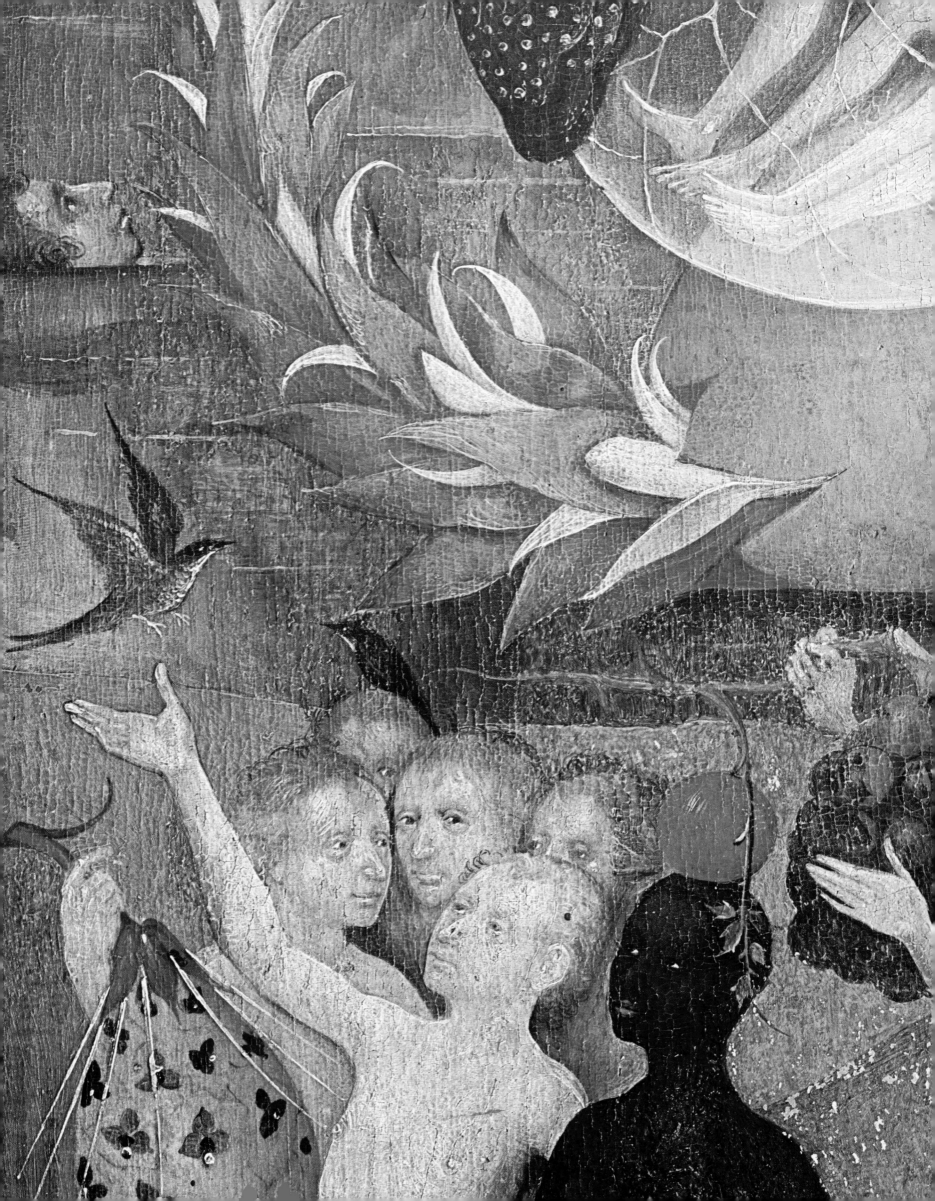

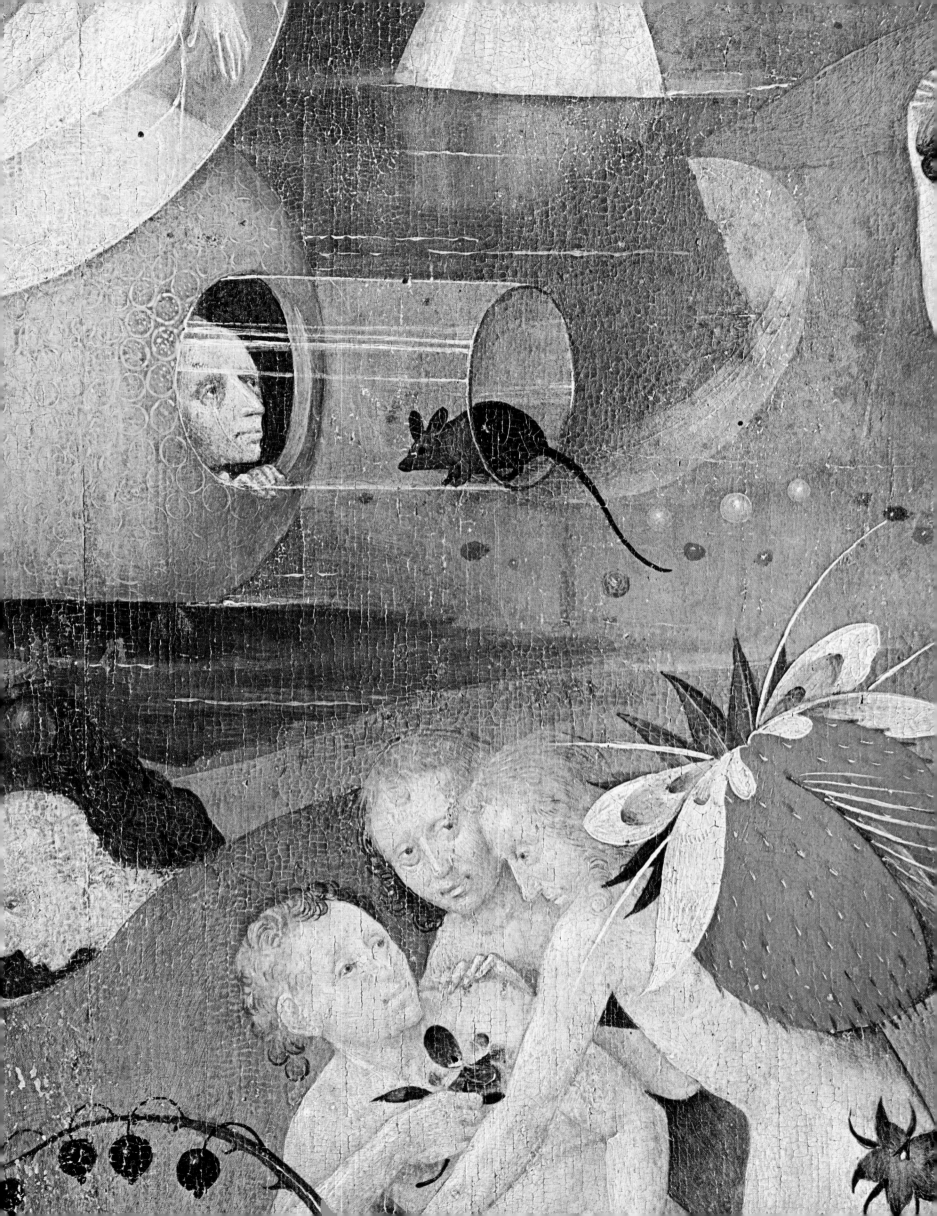

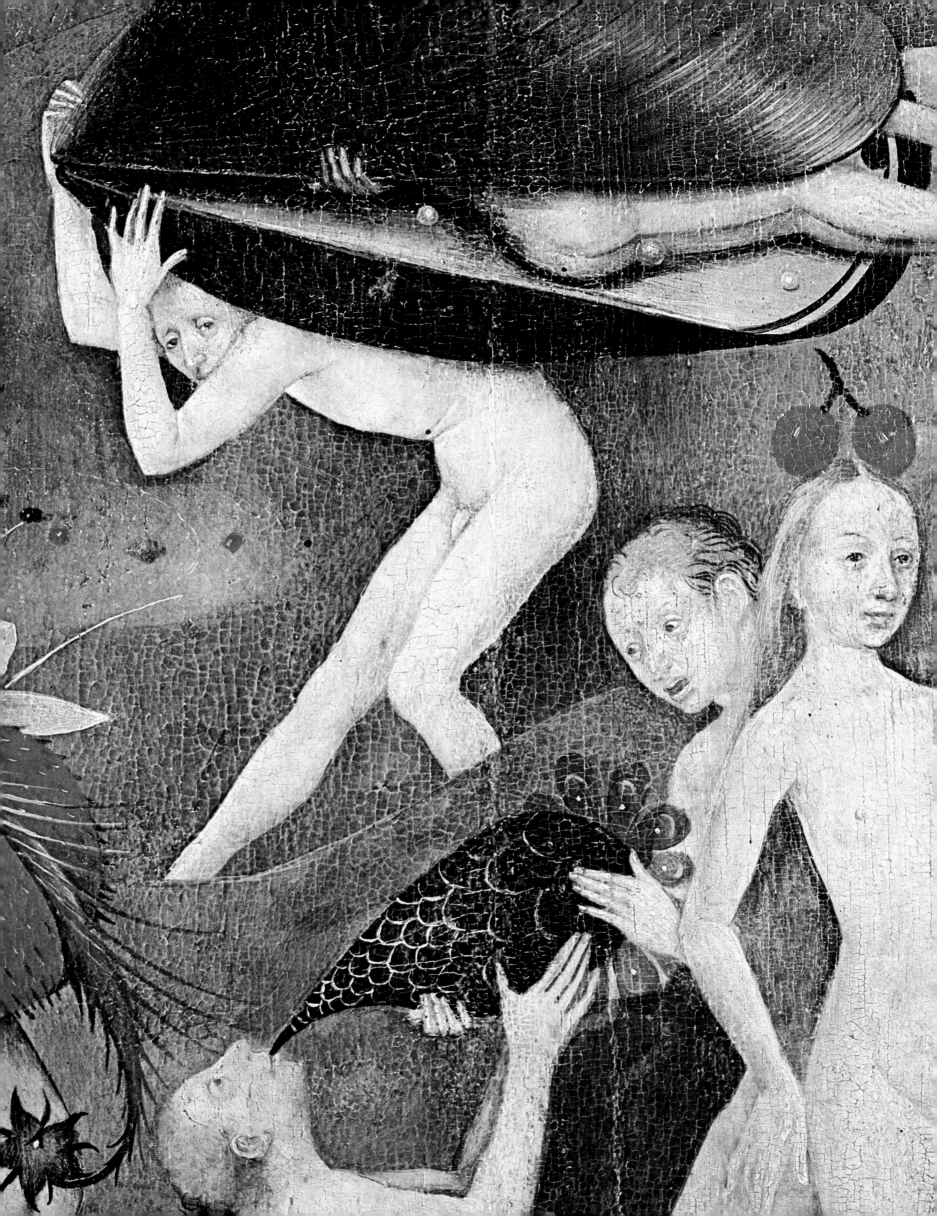

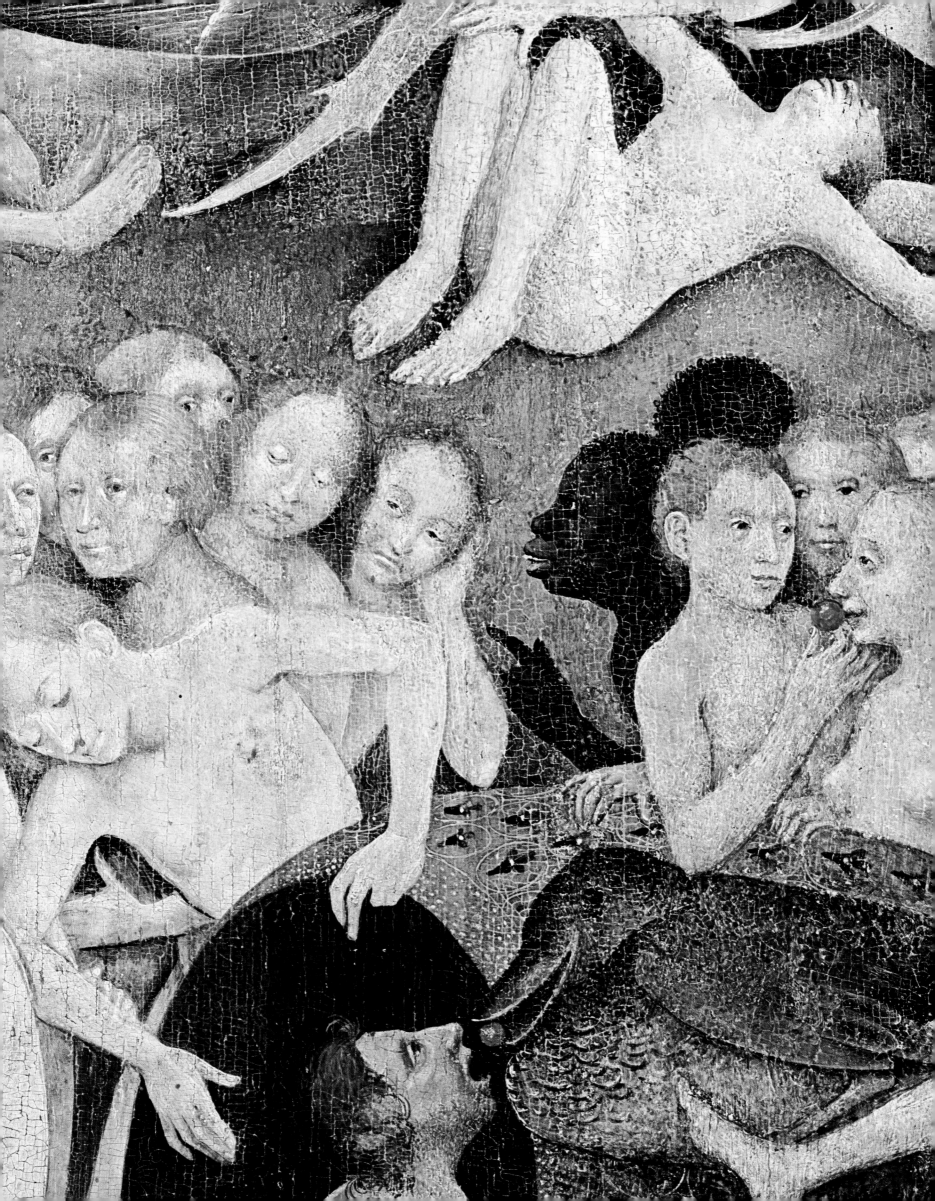

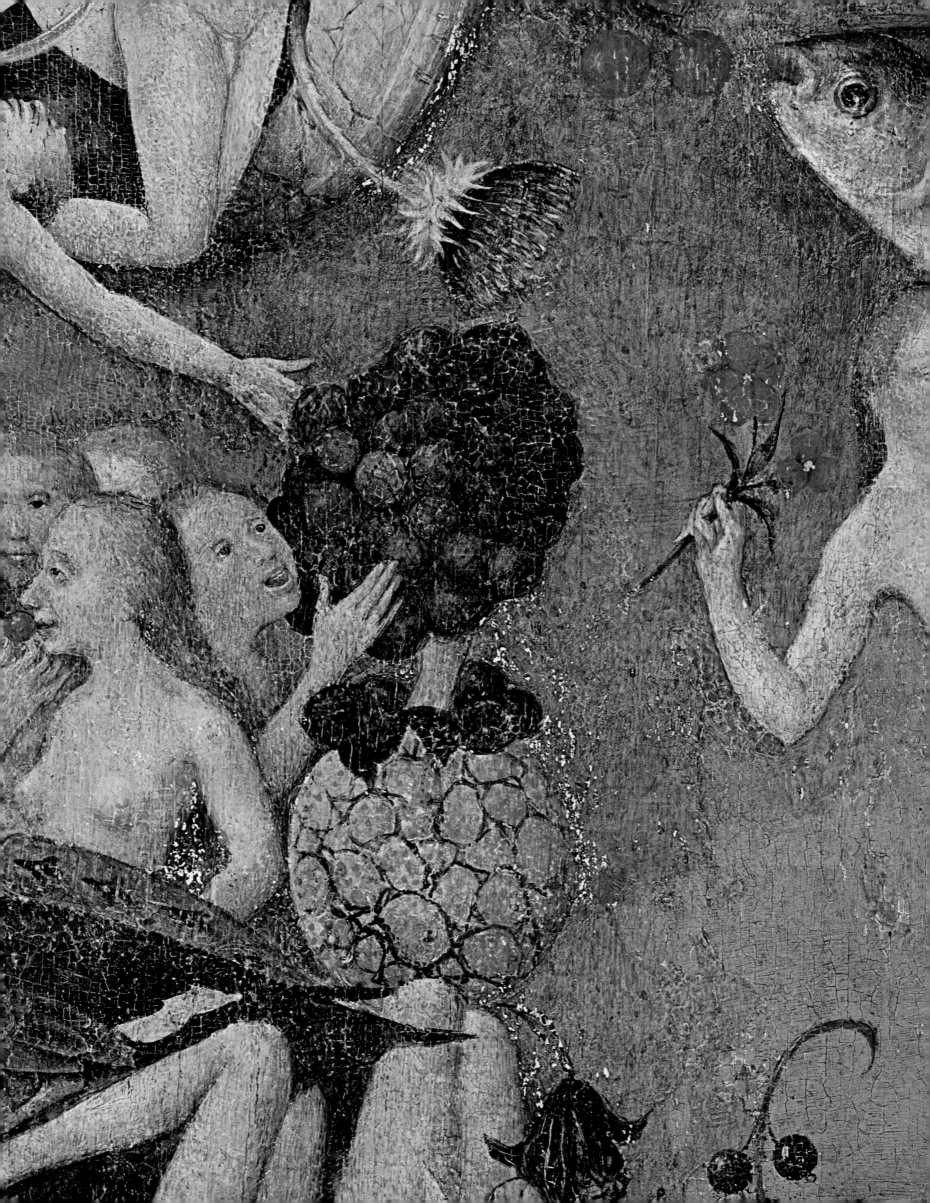

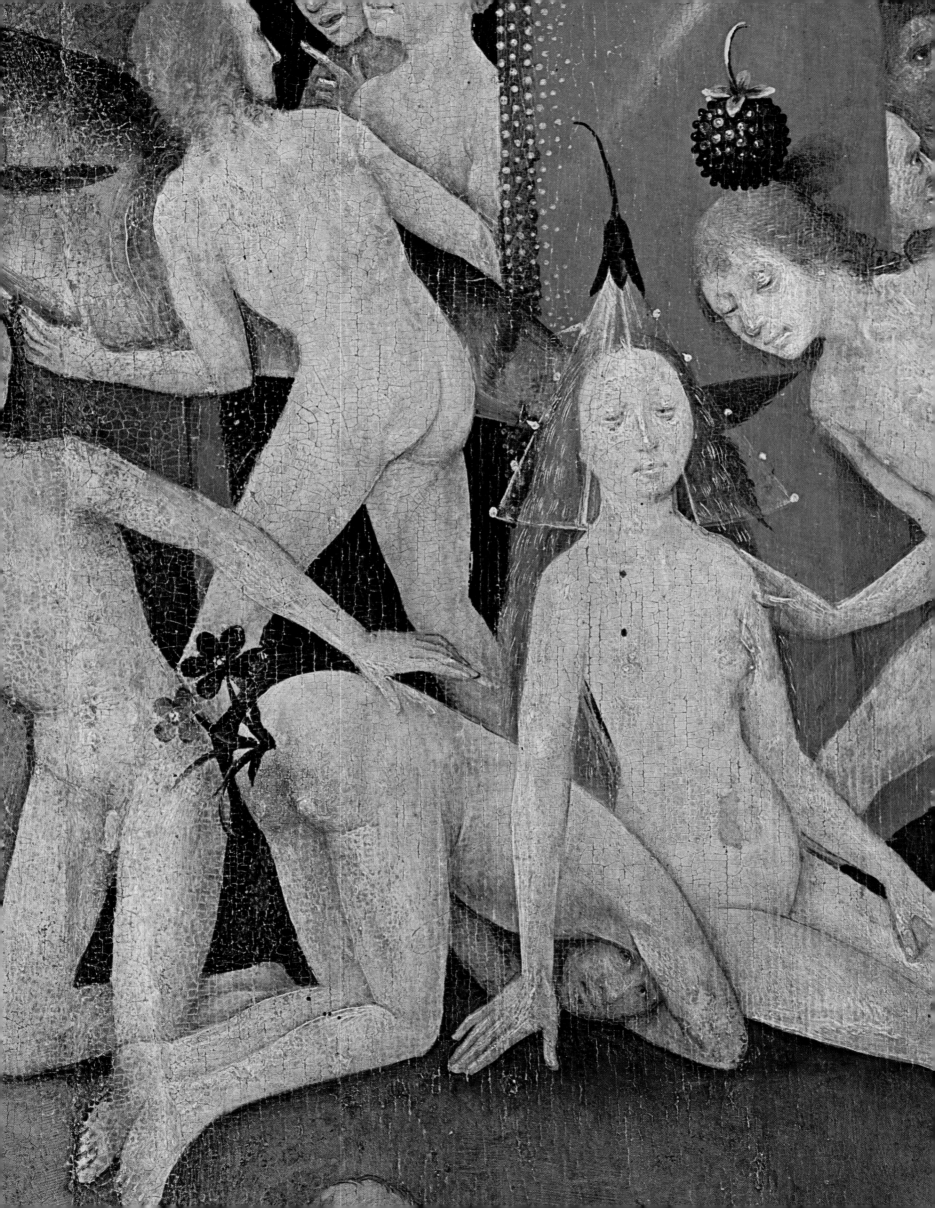

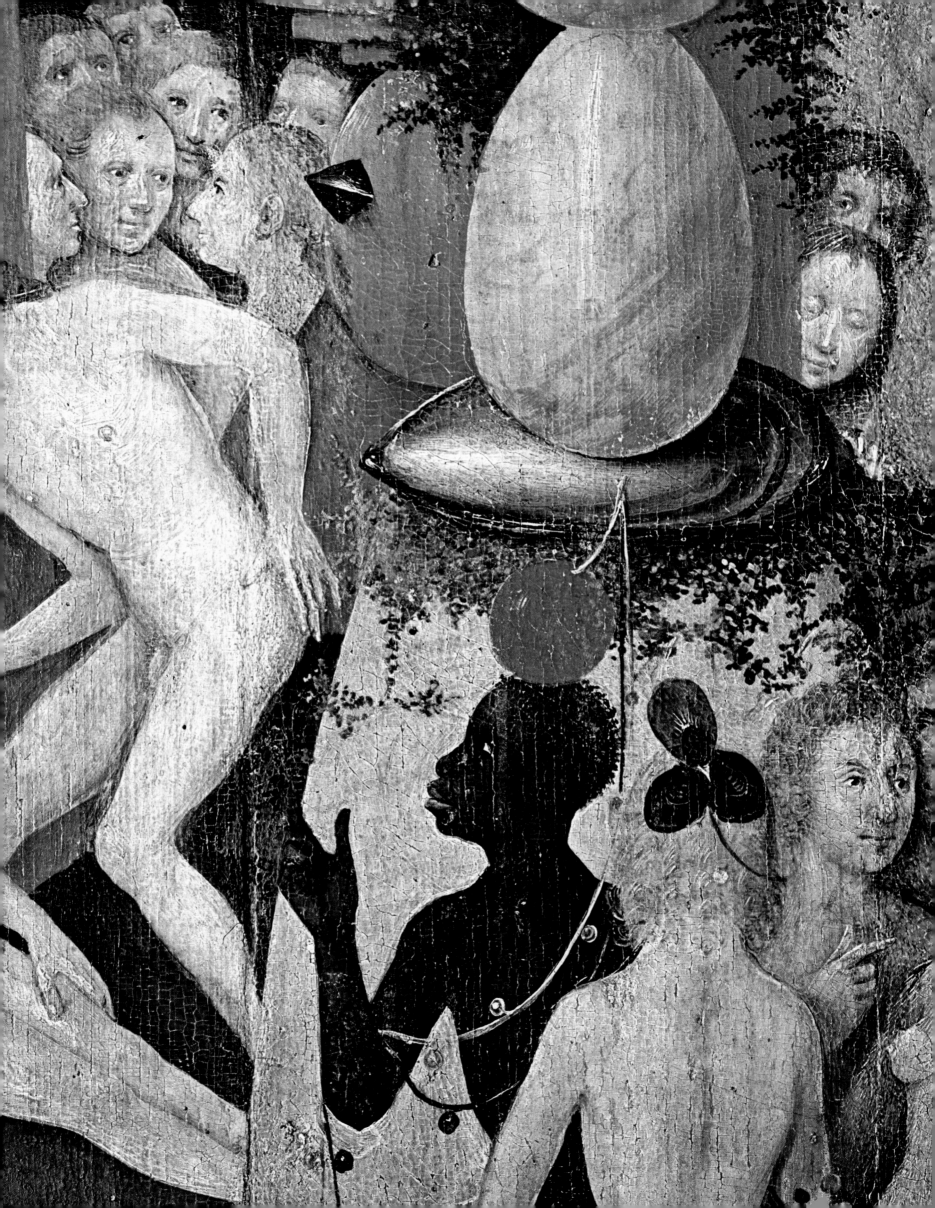

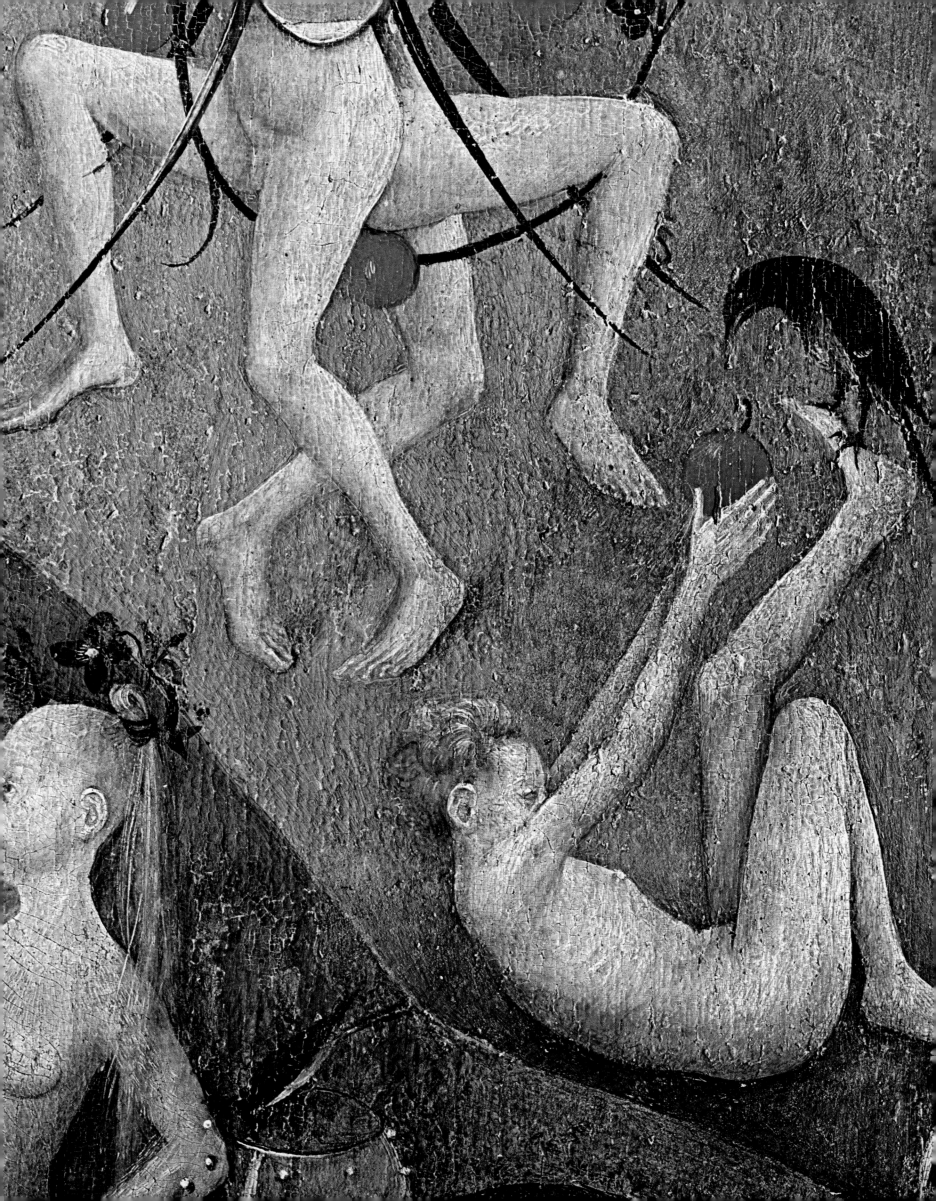

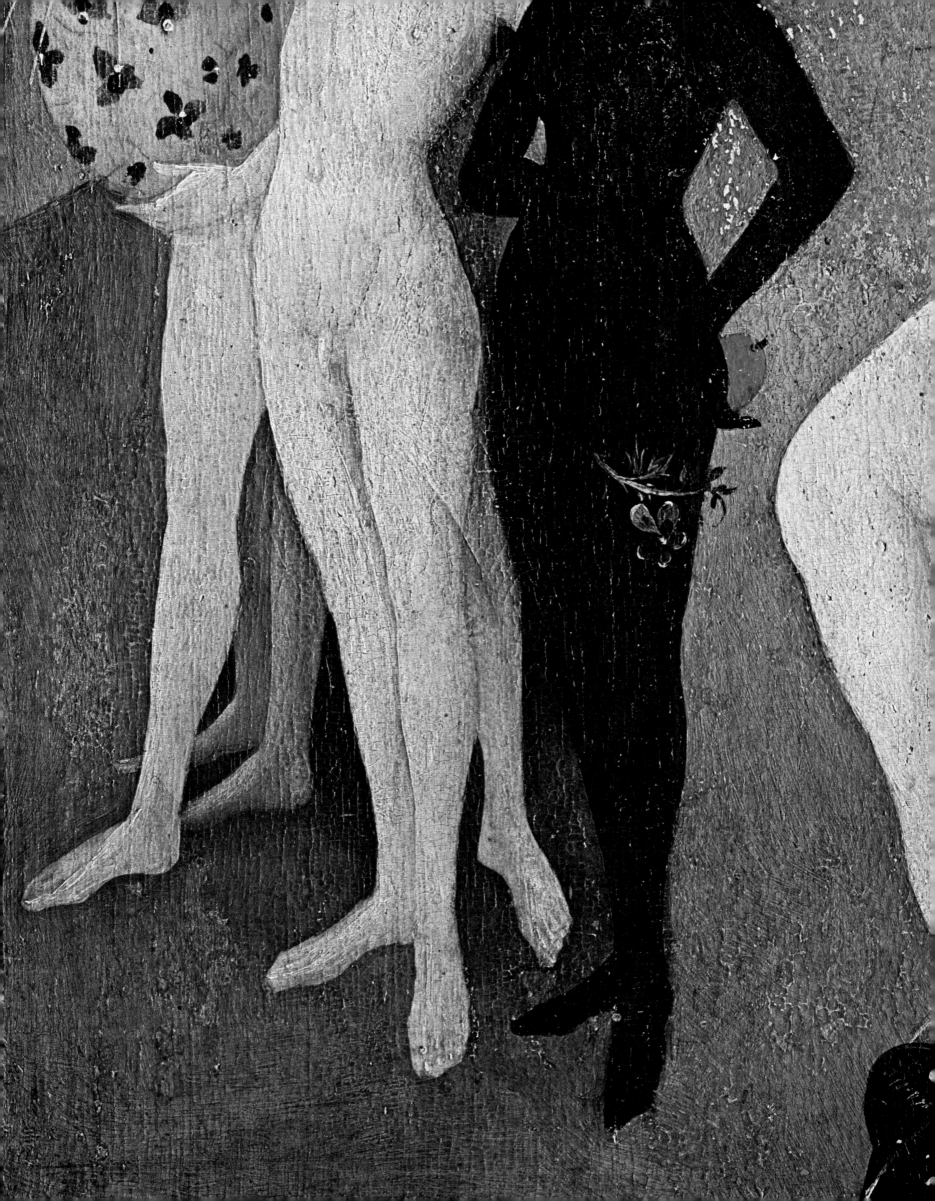

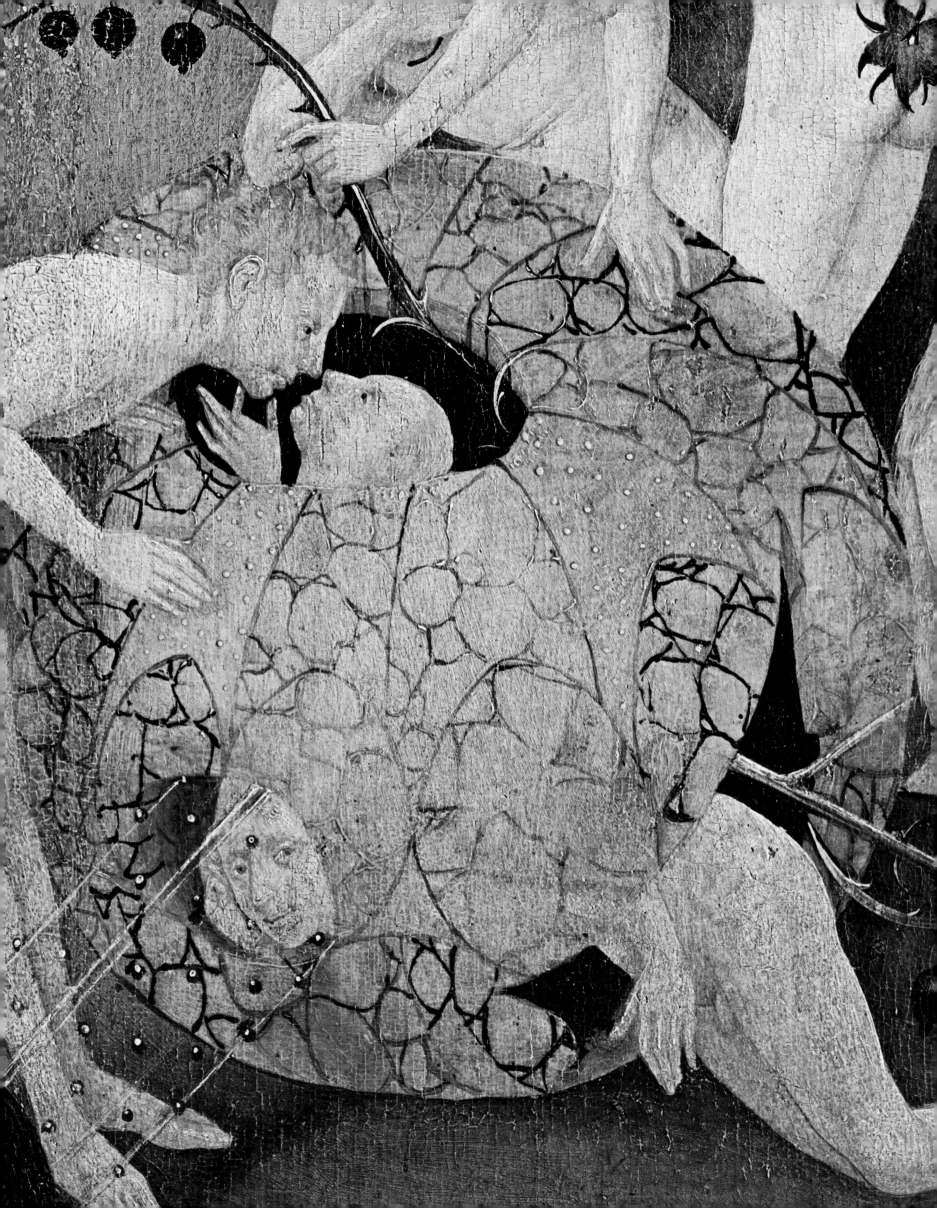

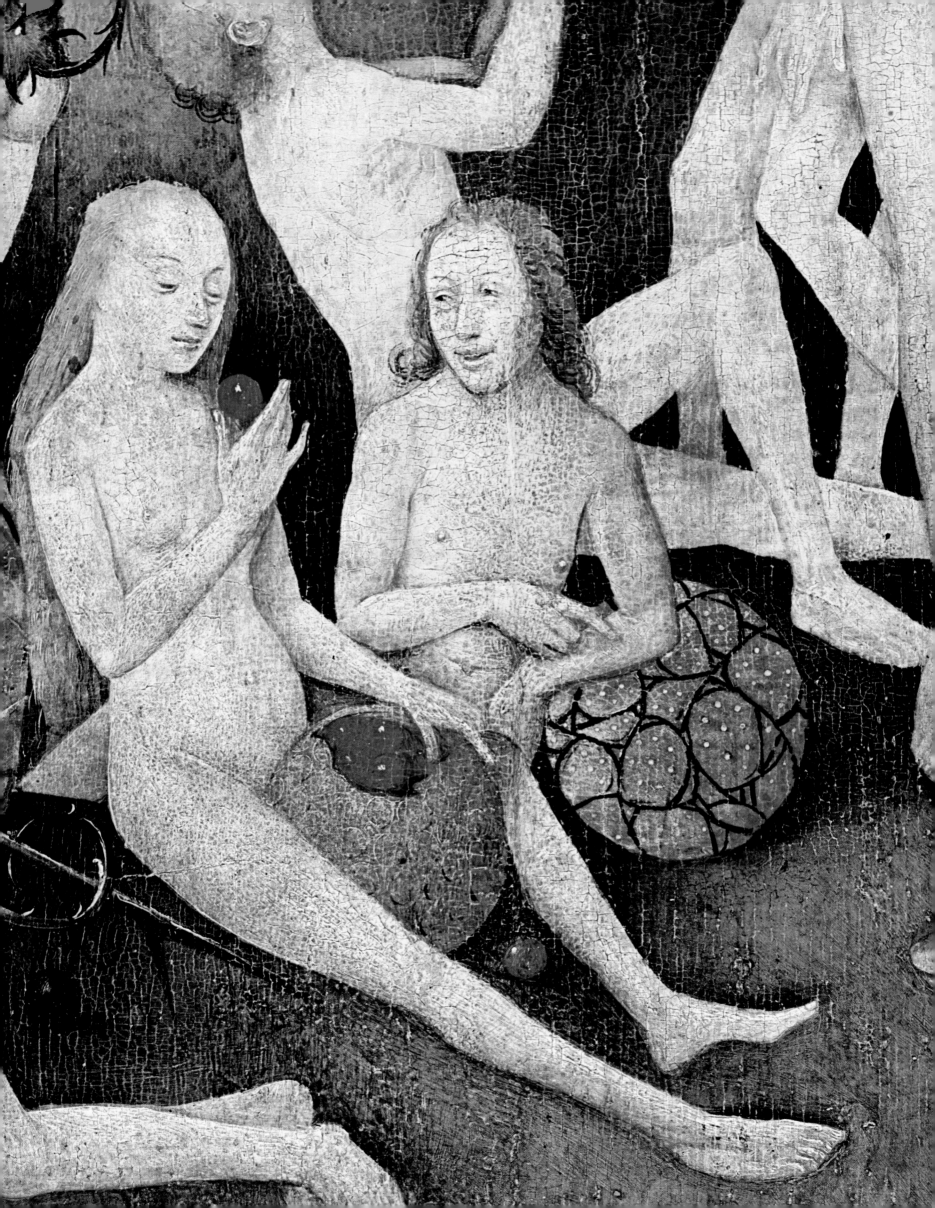

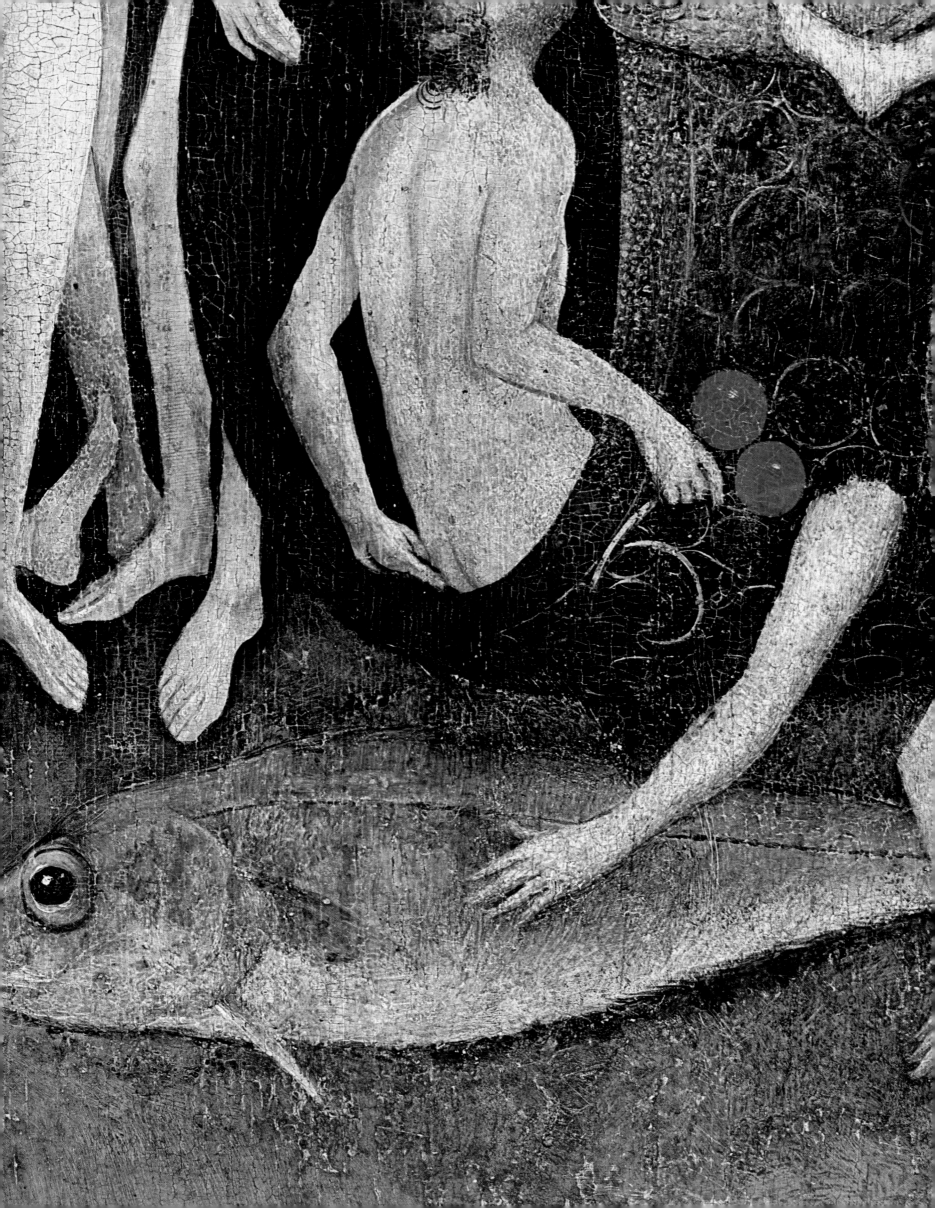

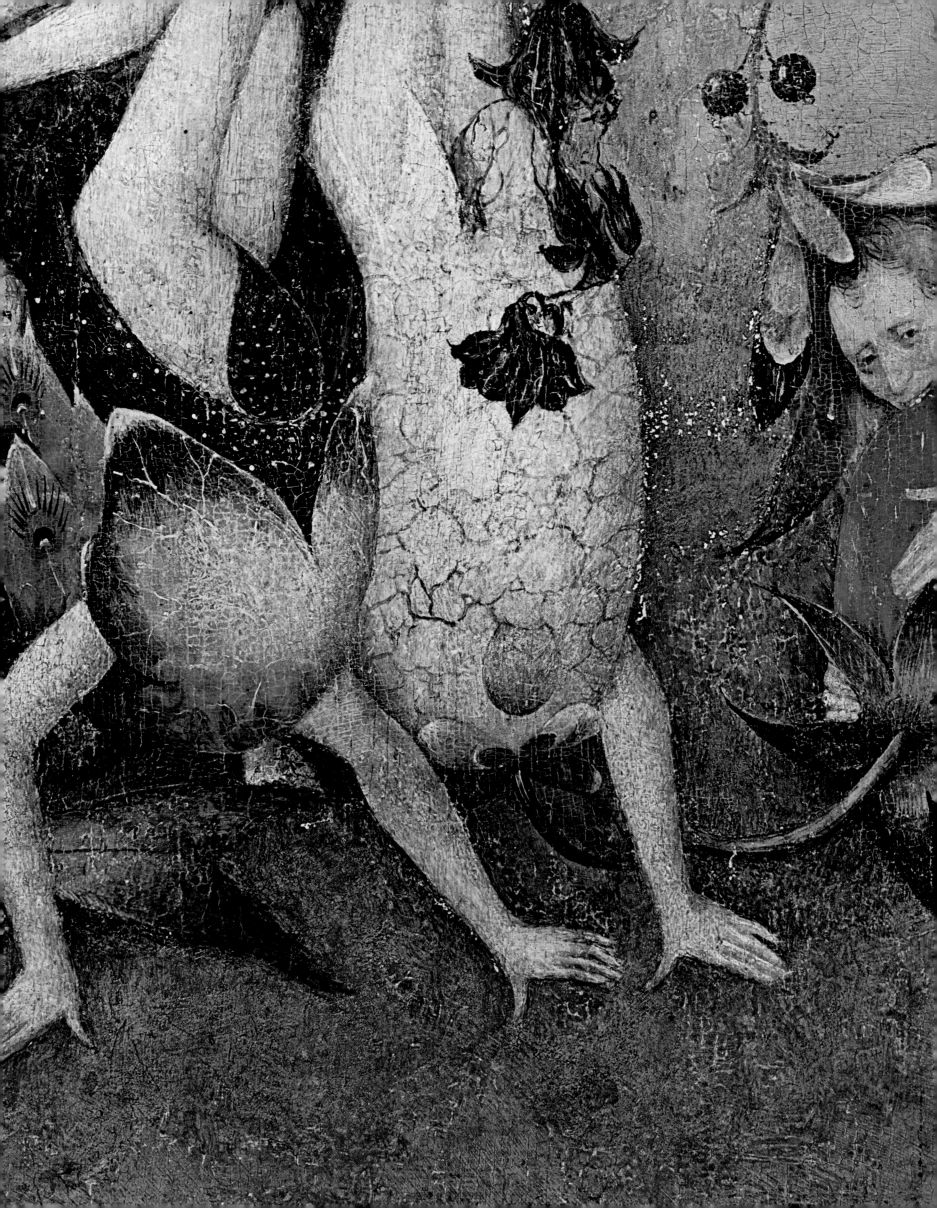

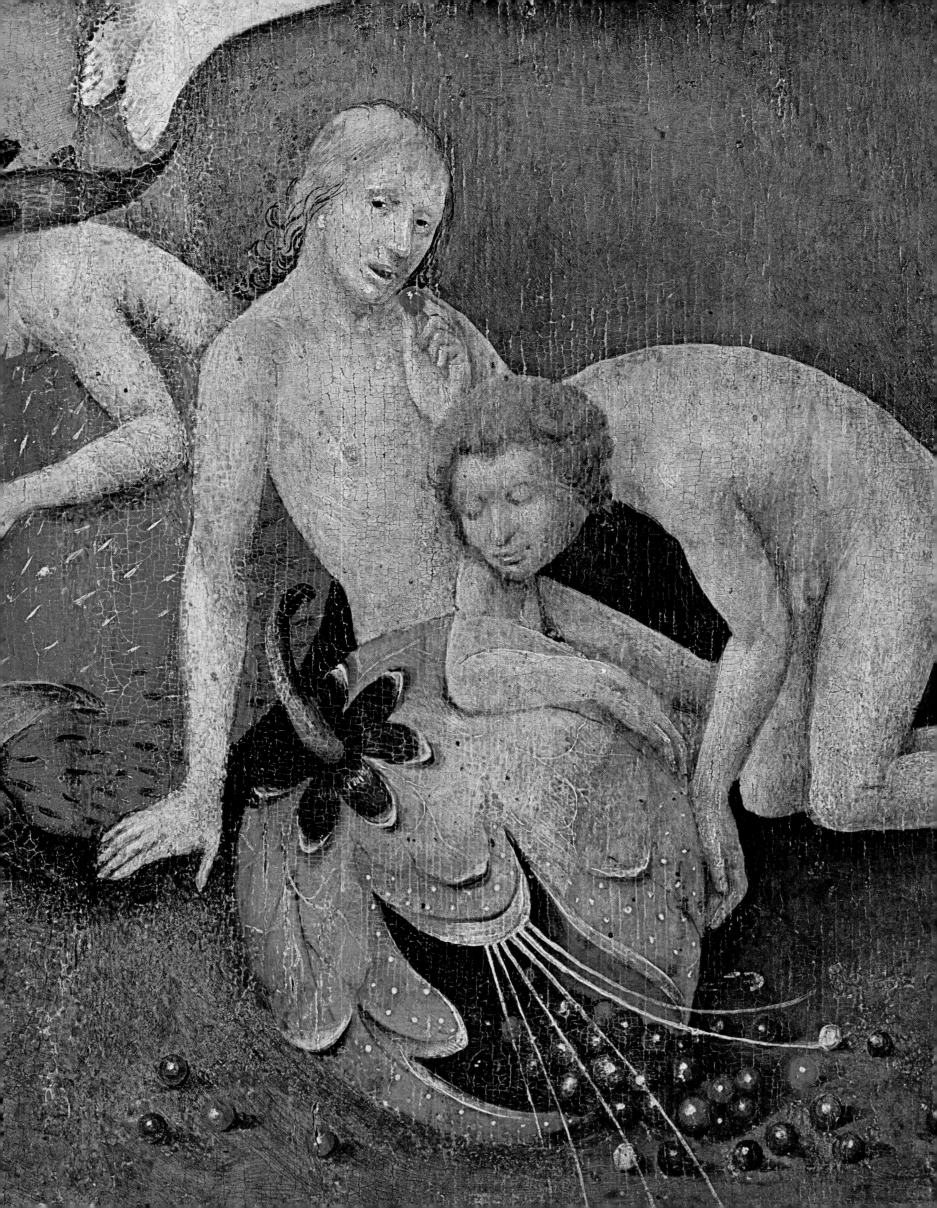

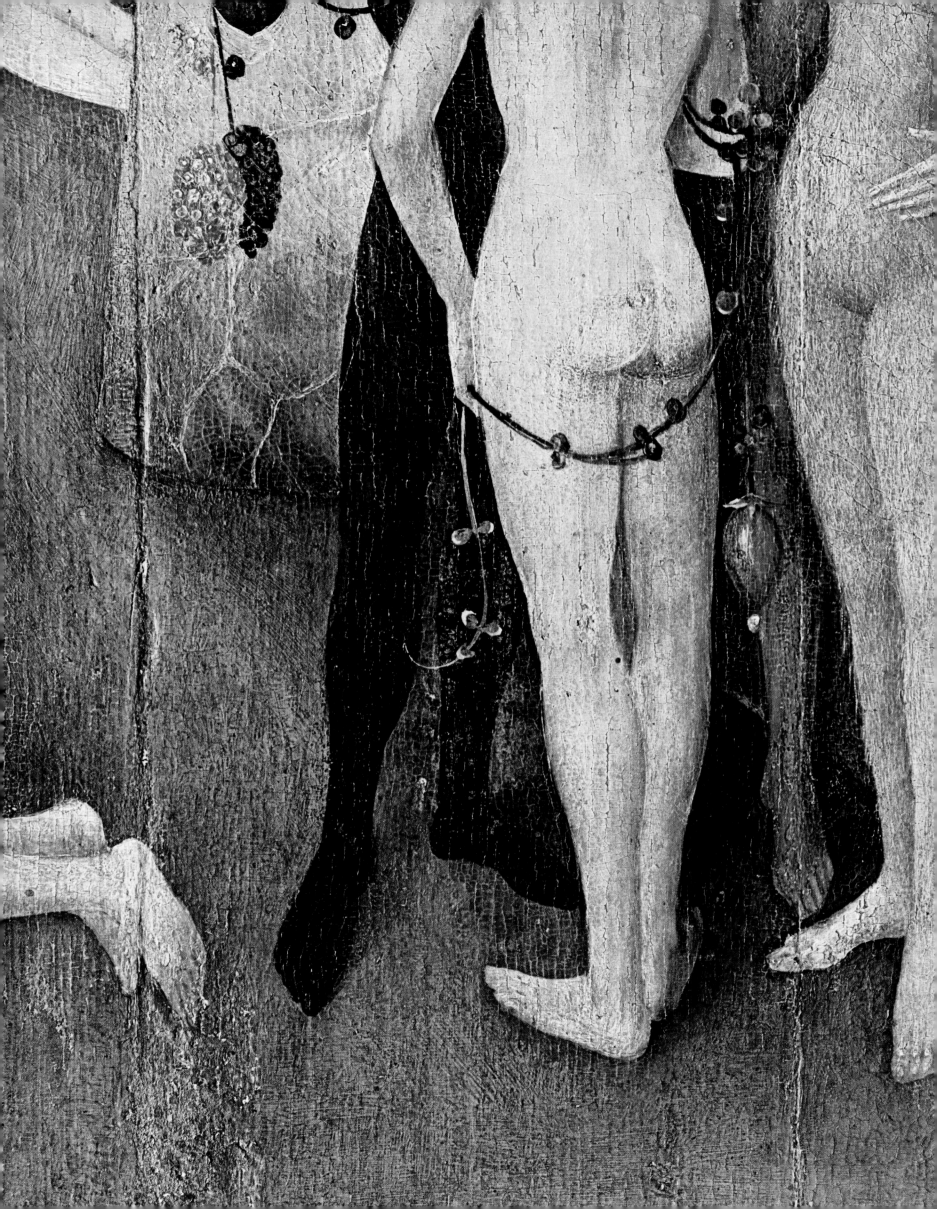

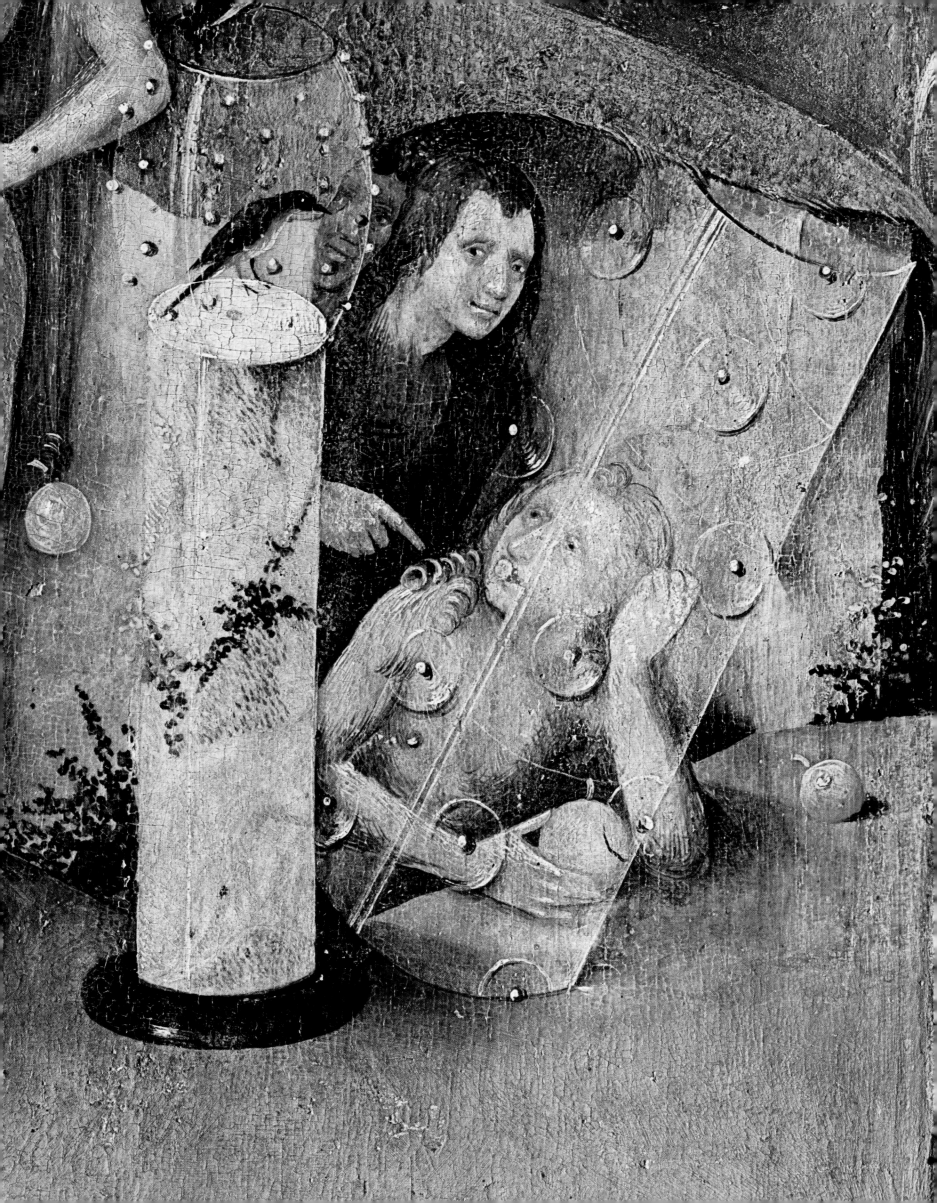

HELL

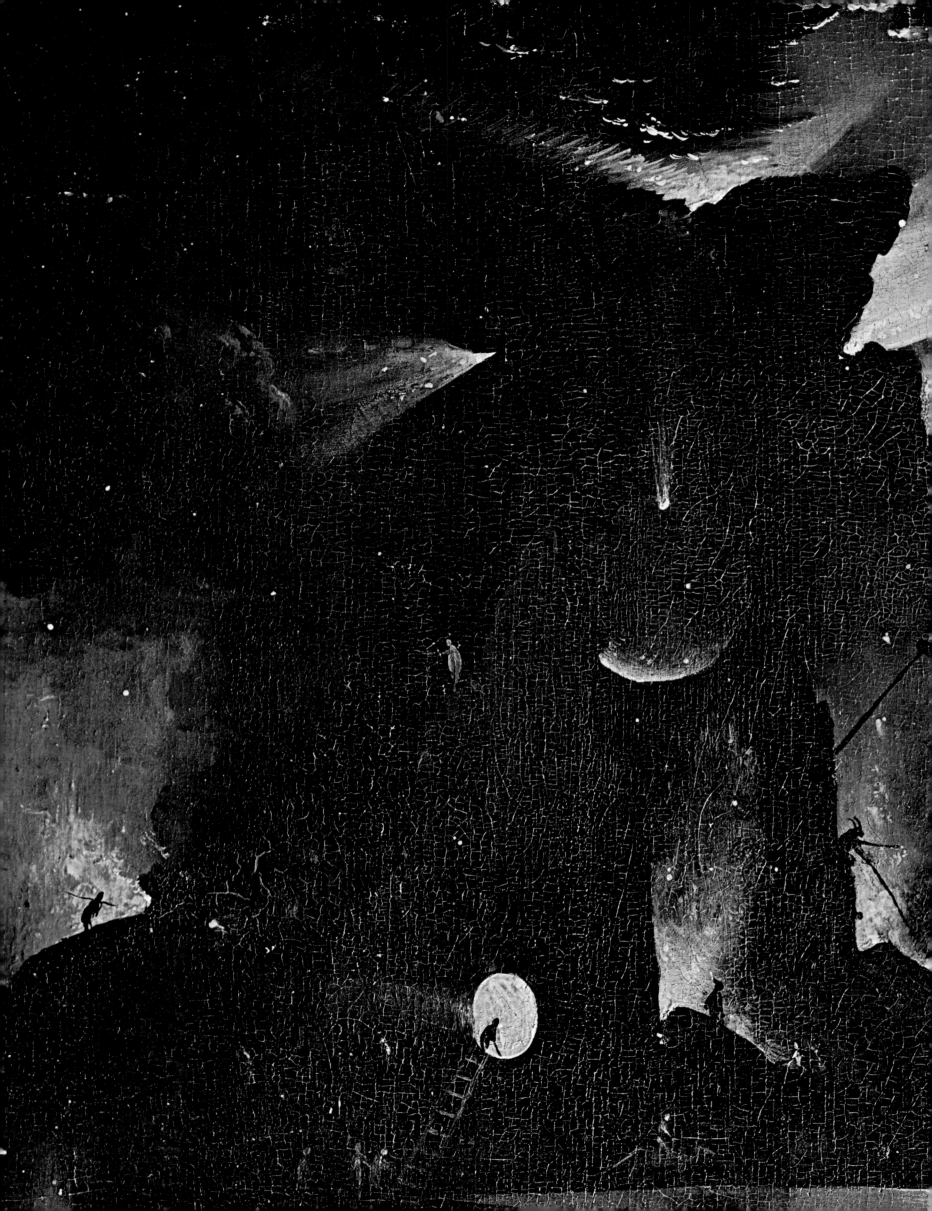

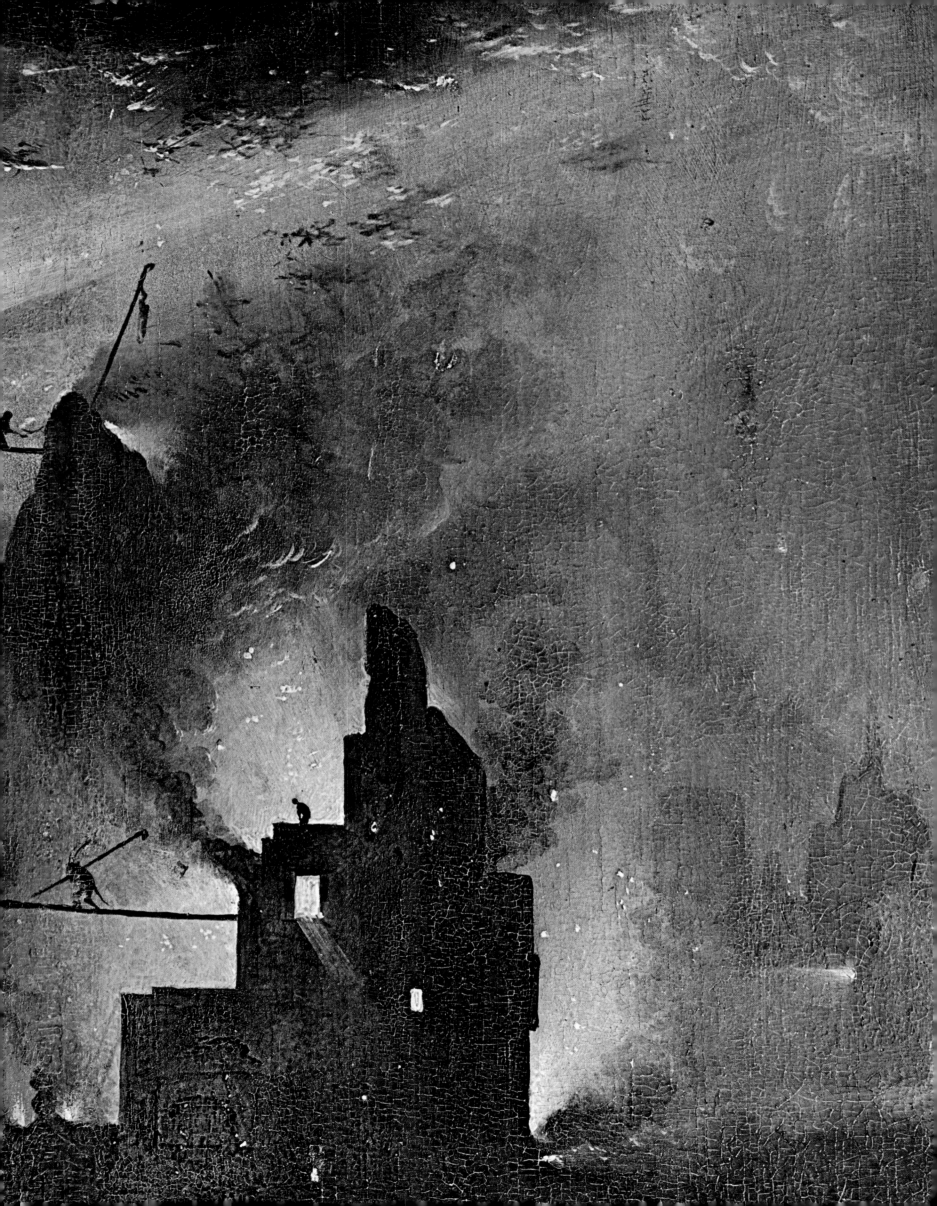

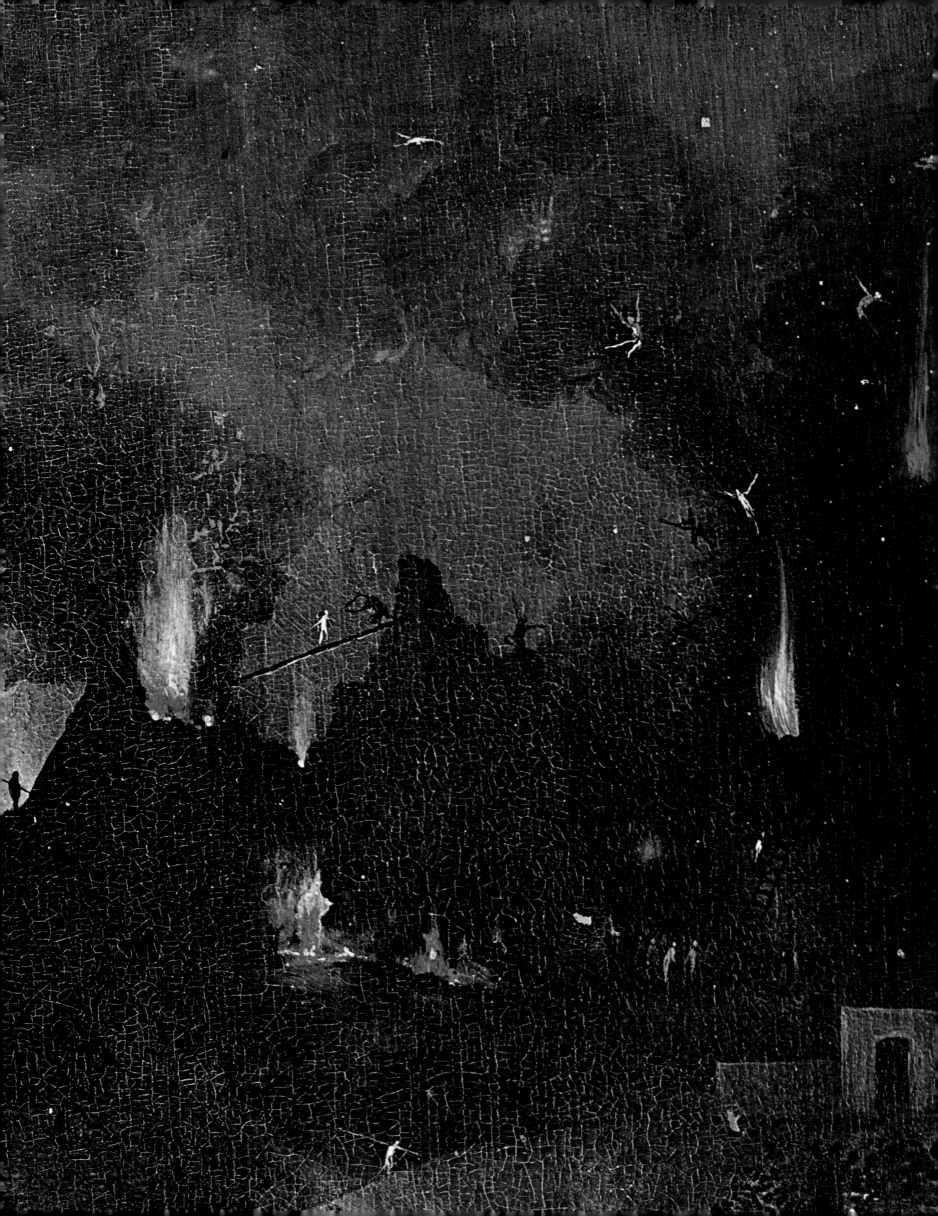

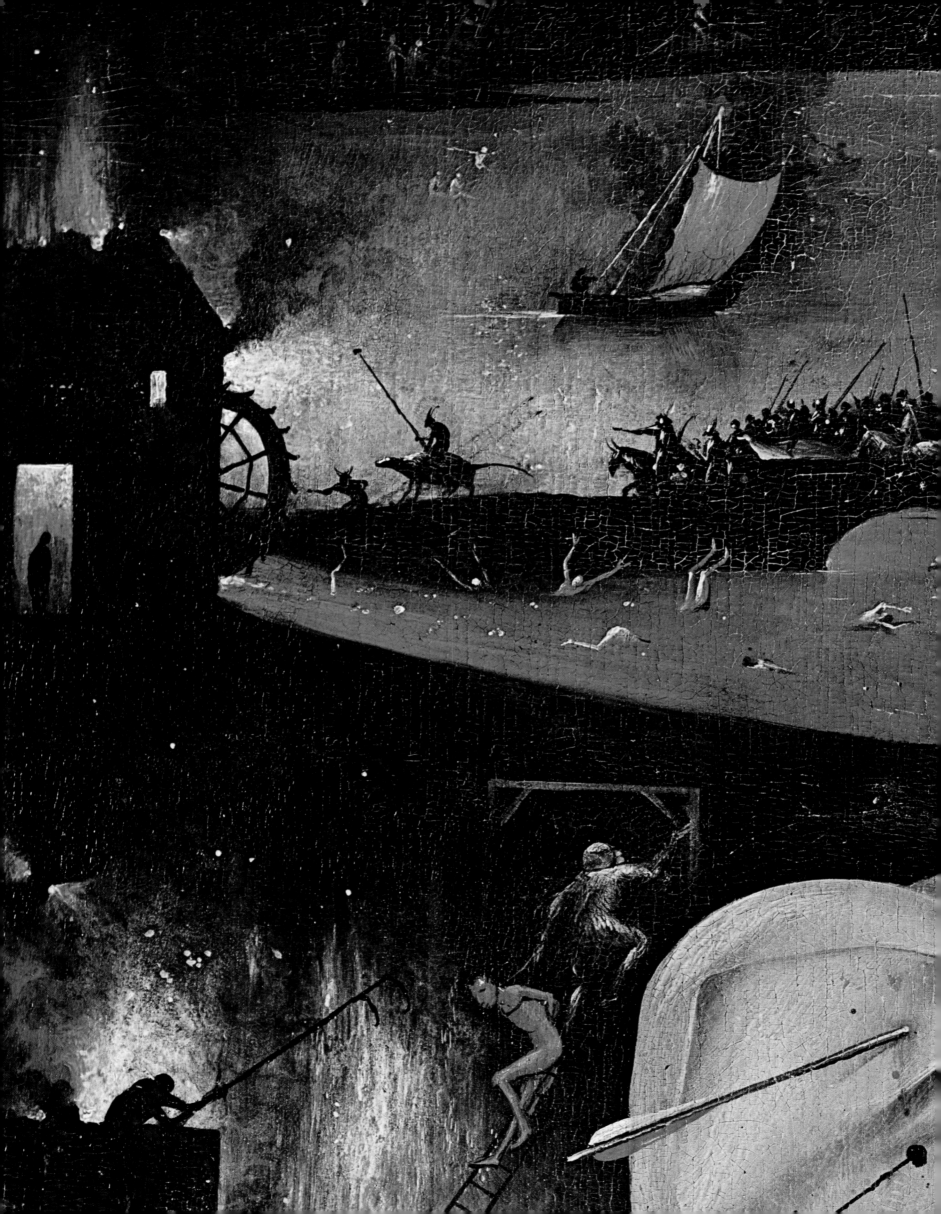

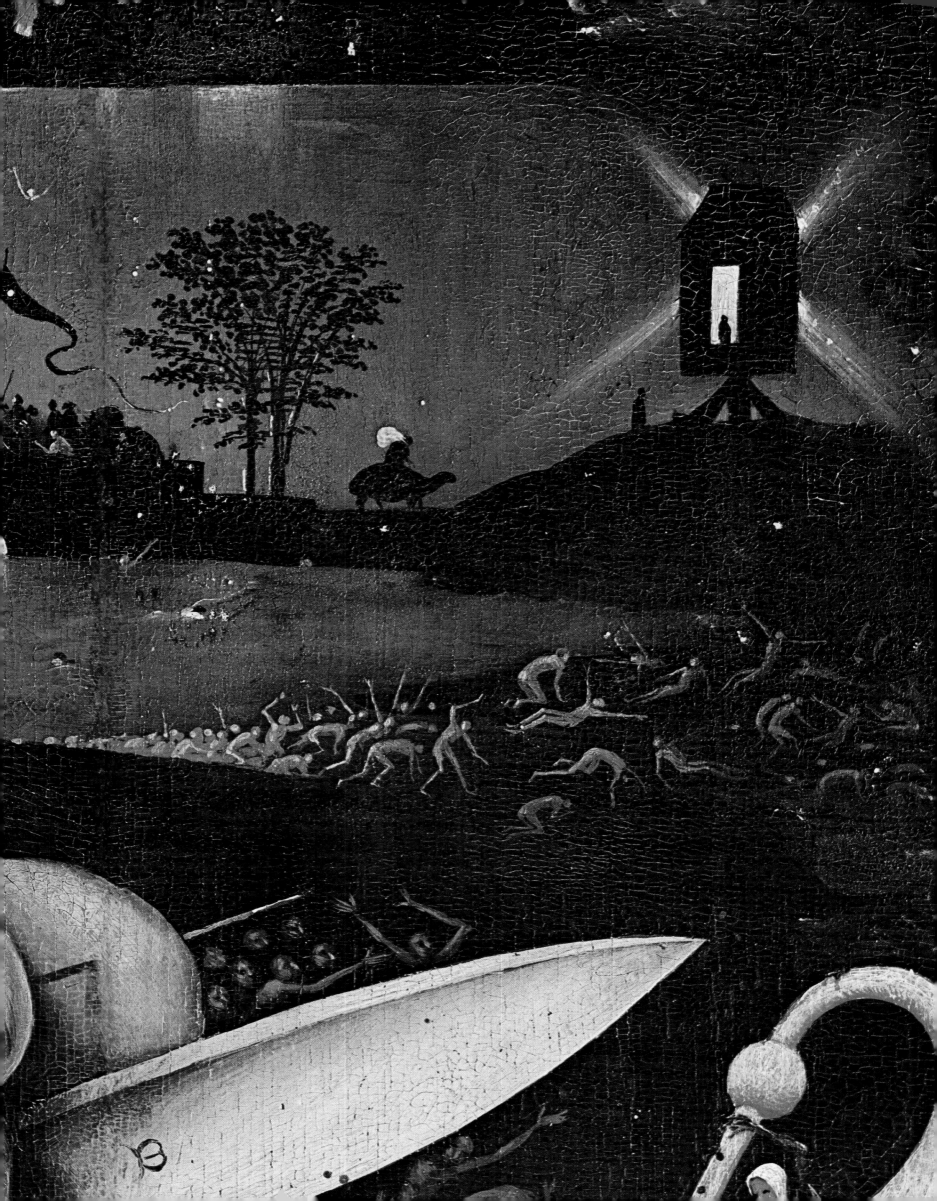

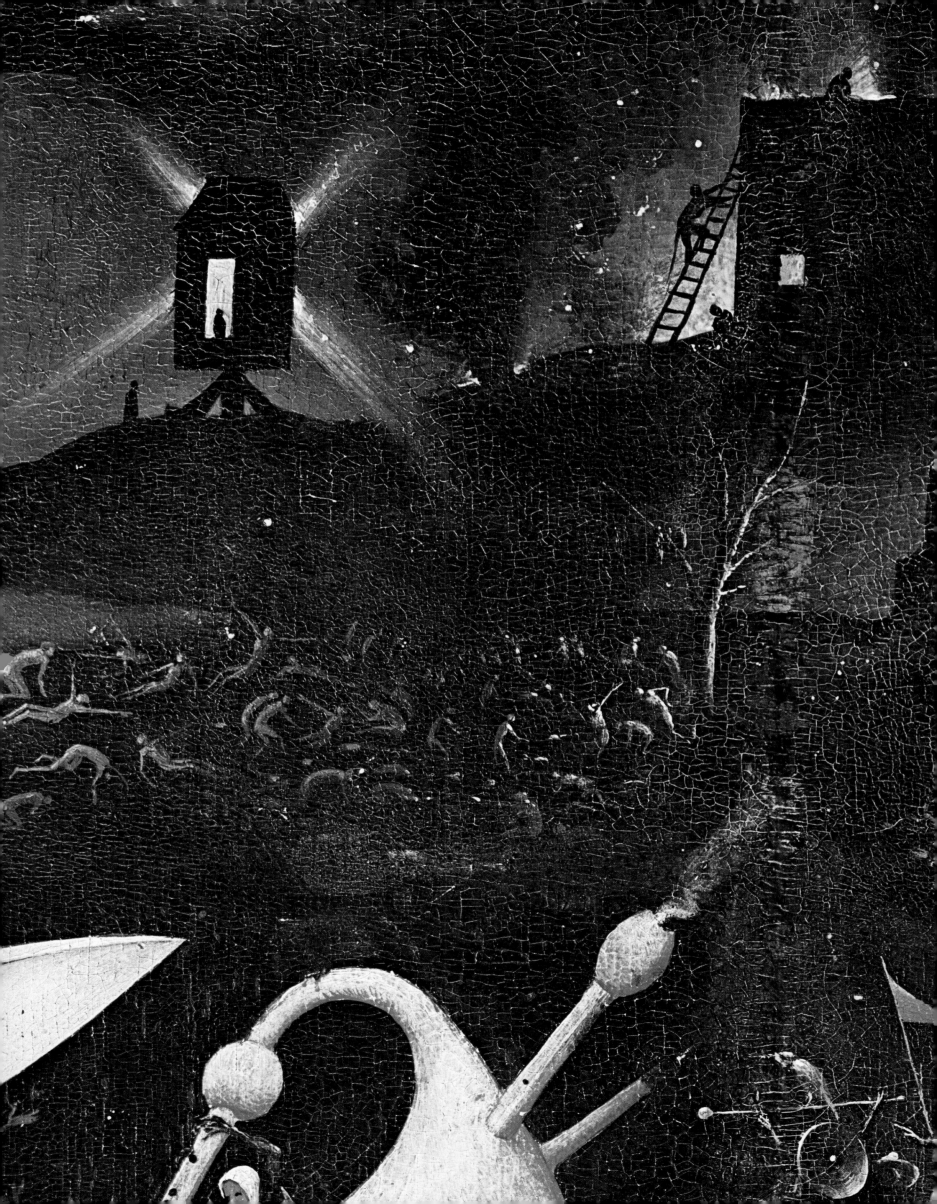

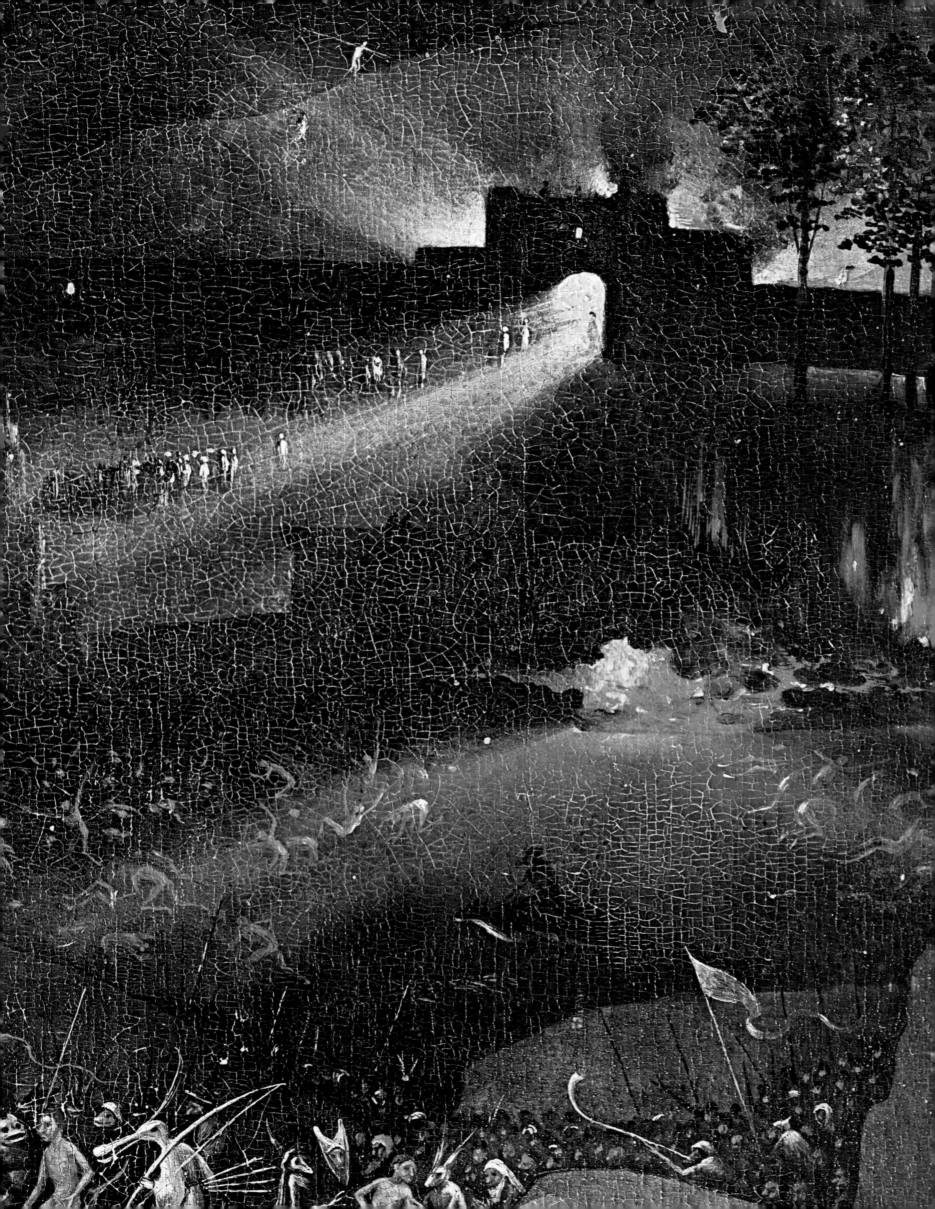

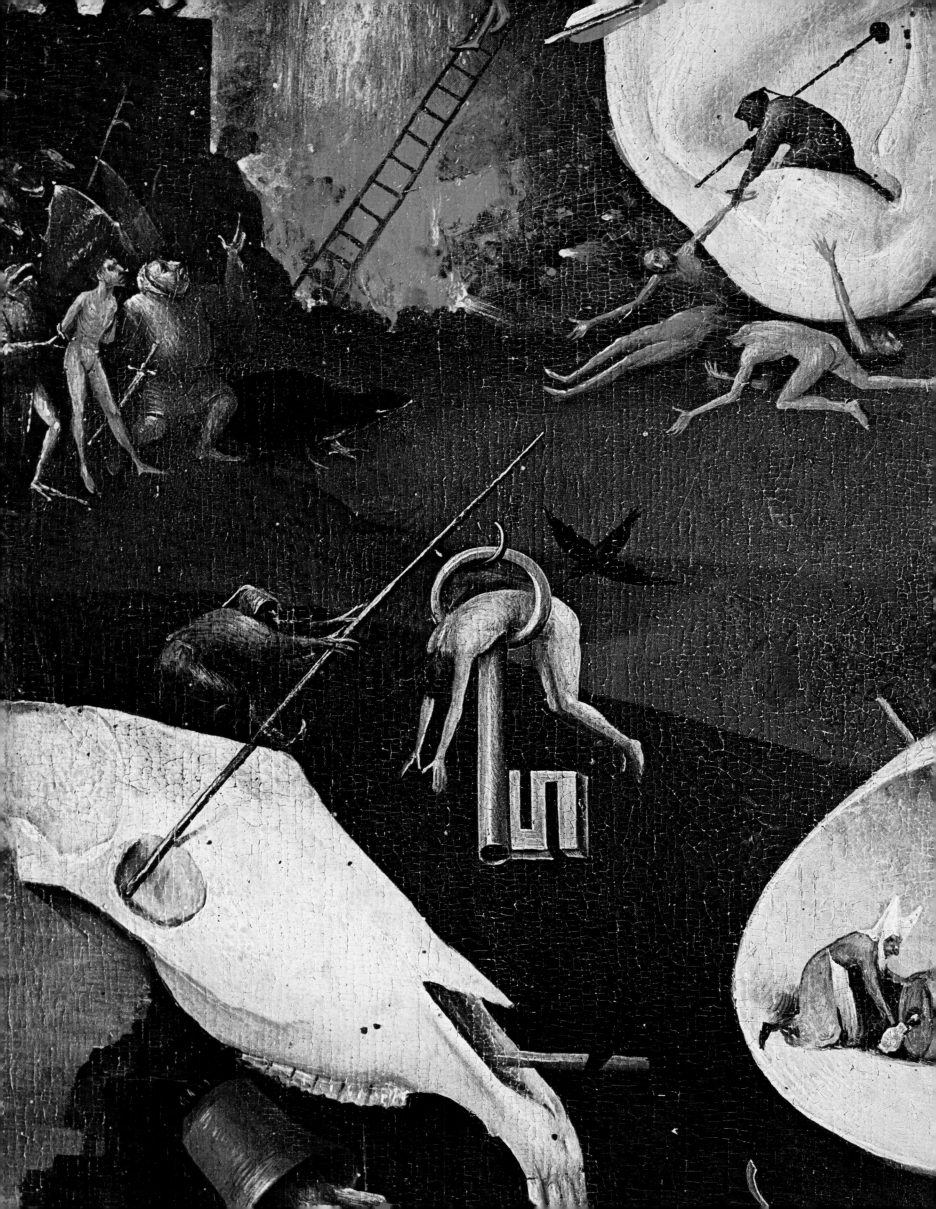

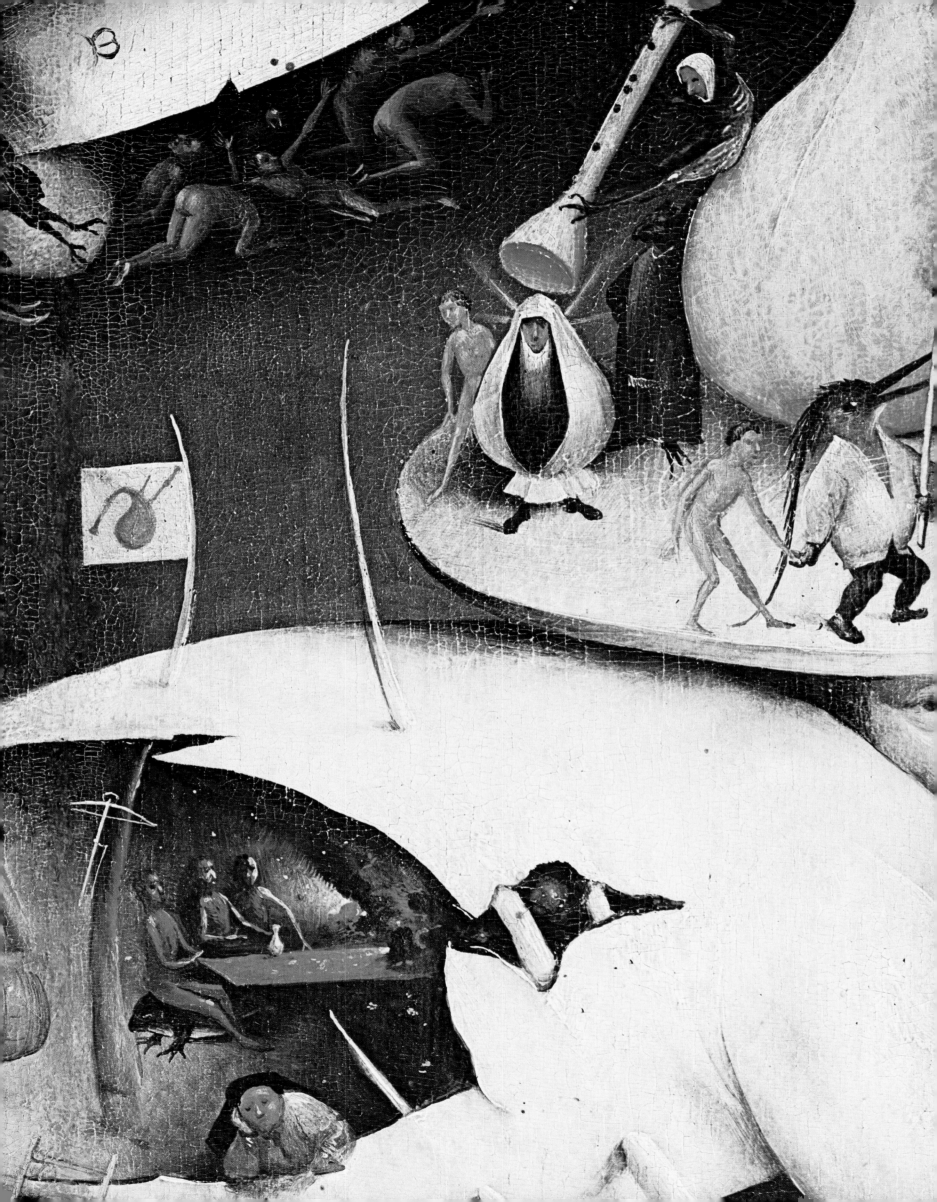

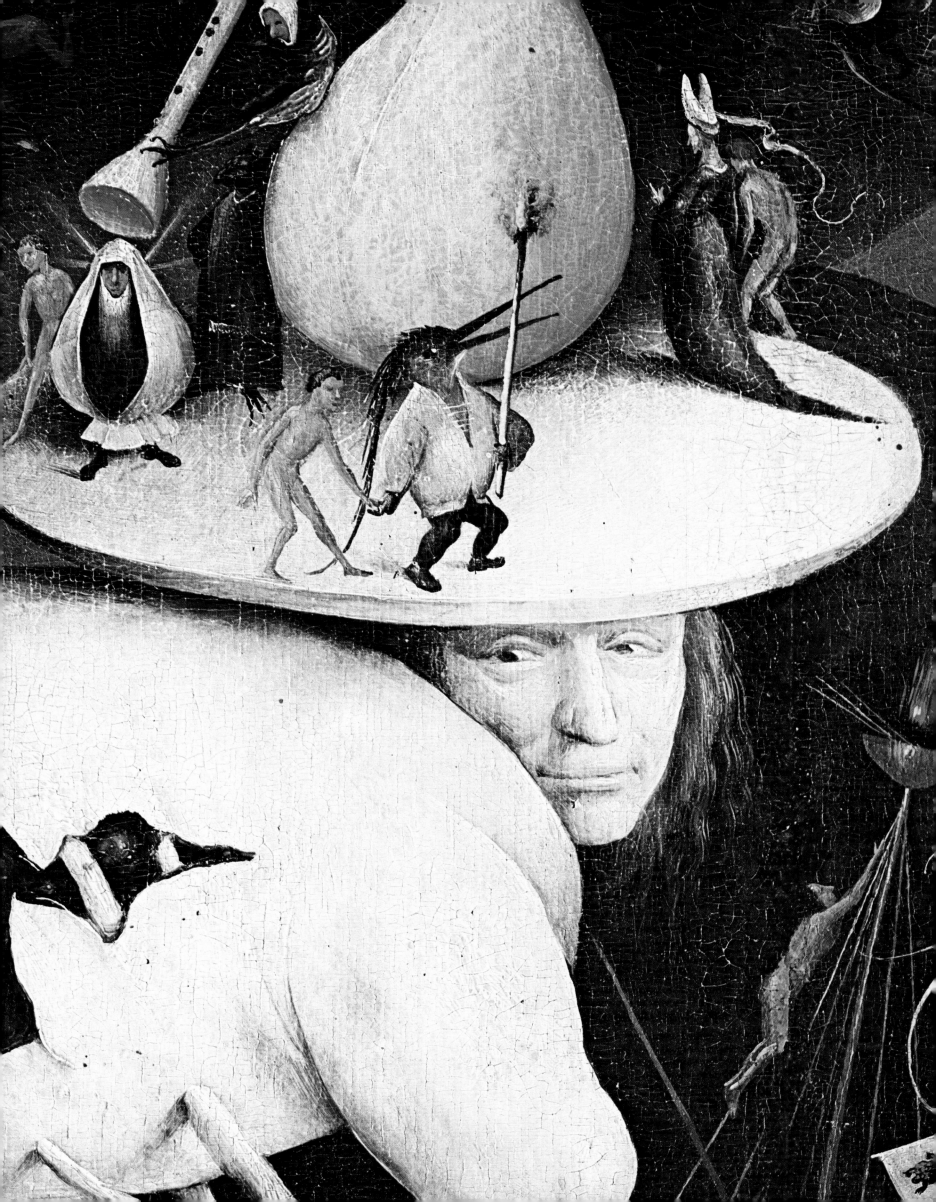

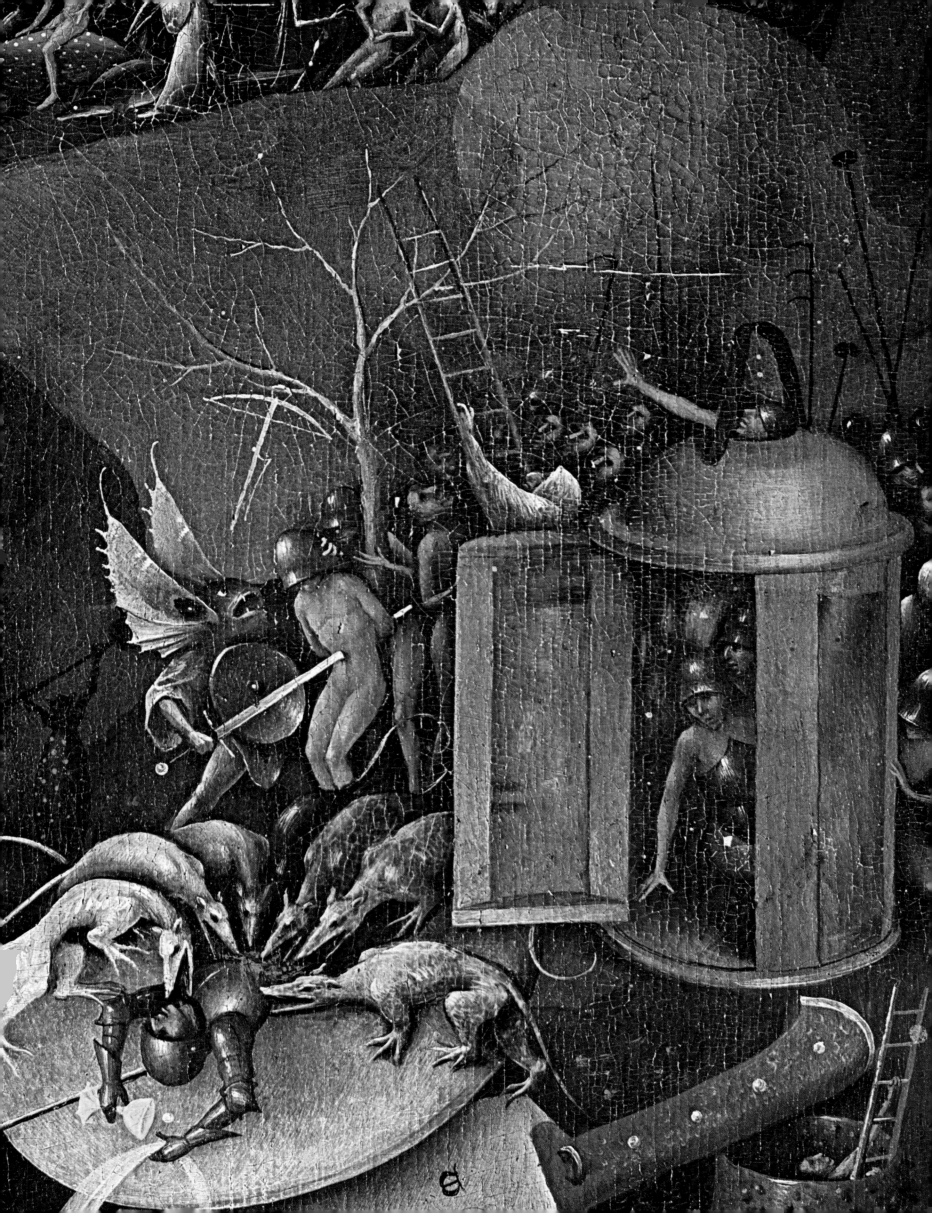

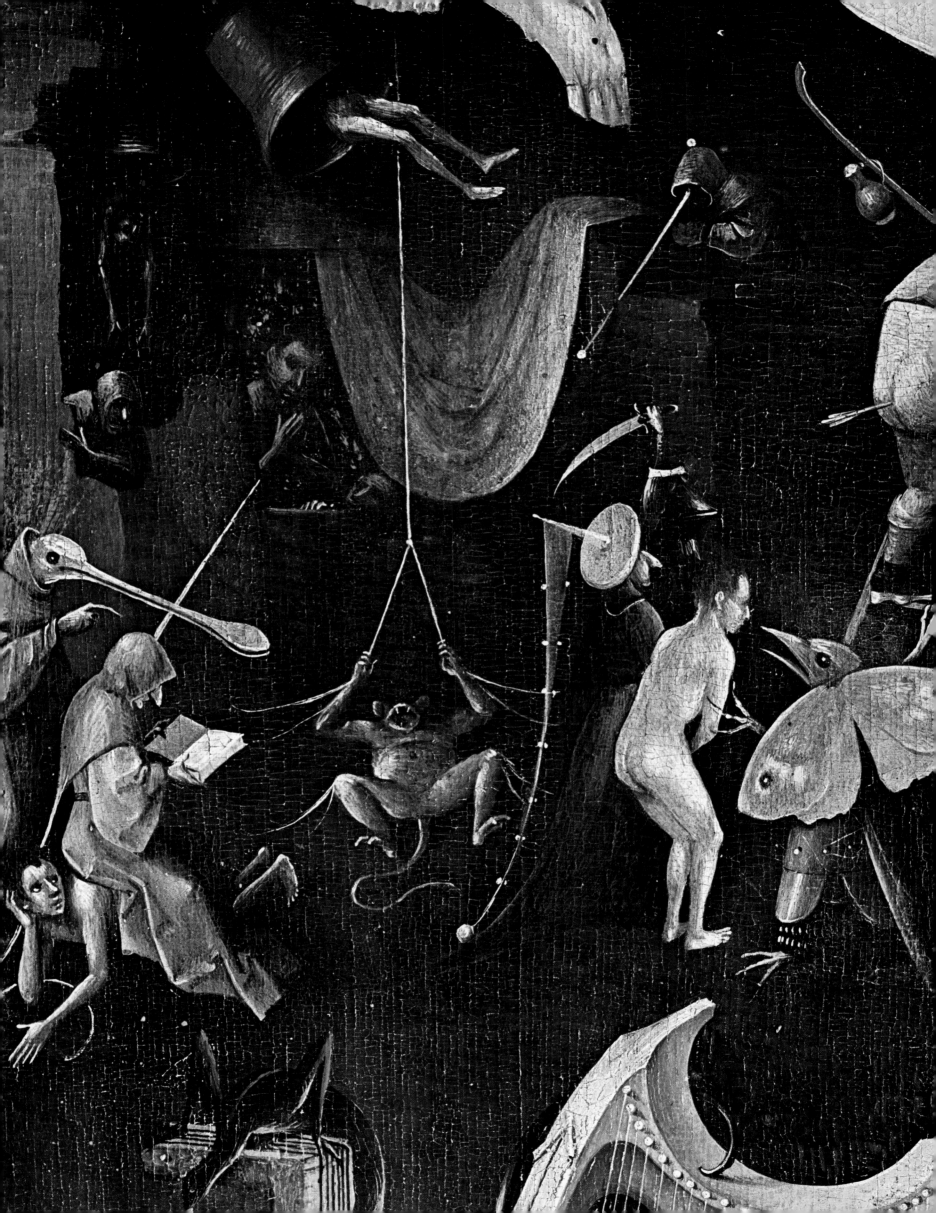

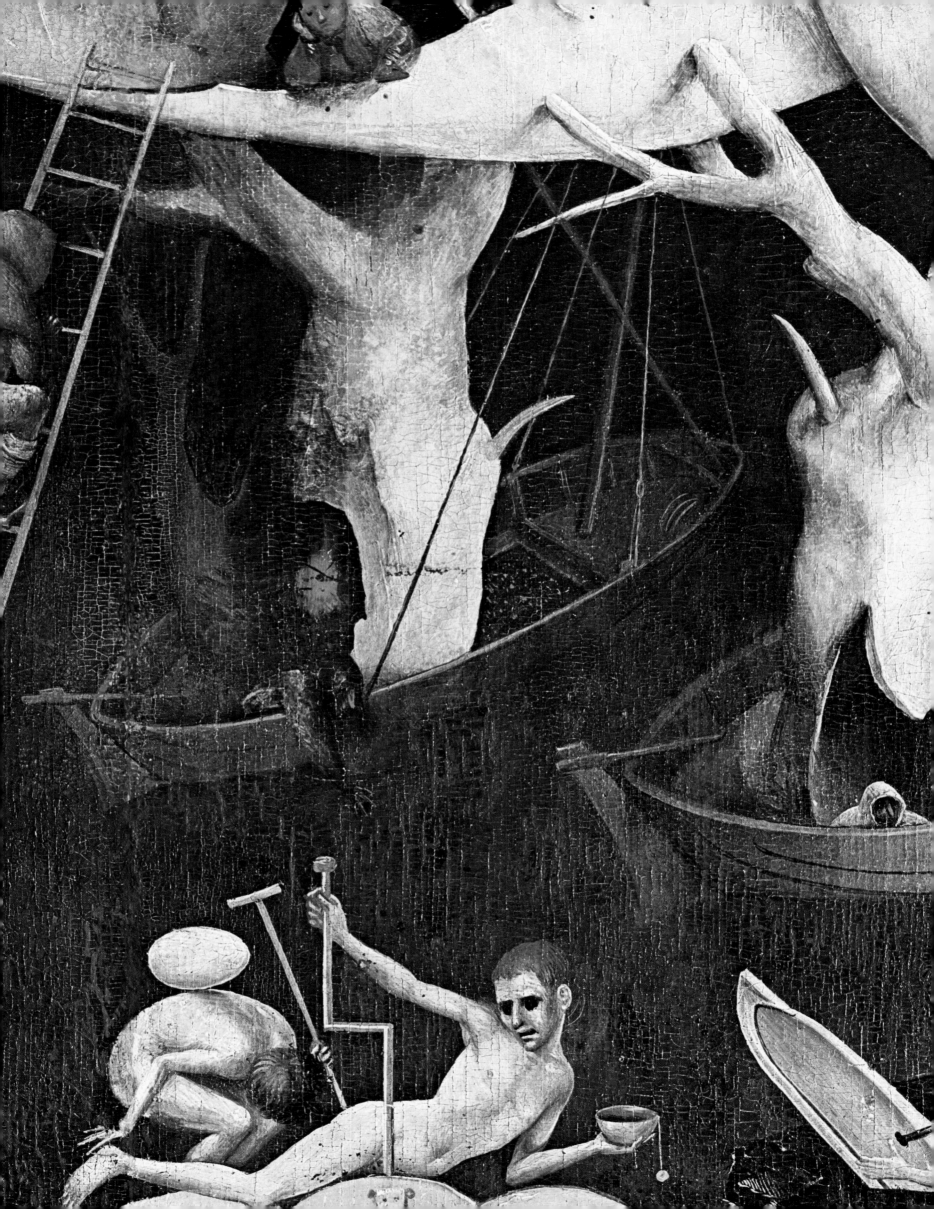

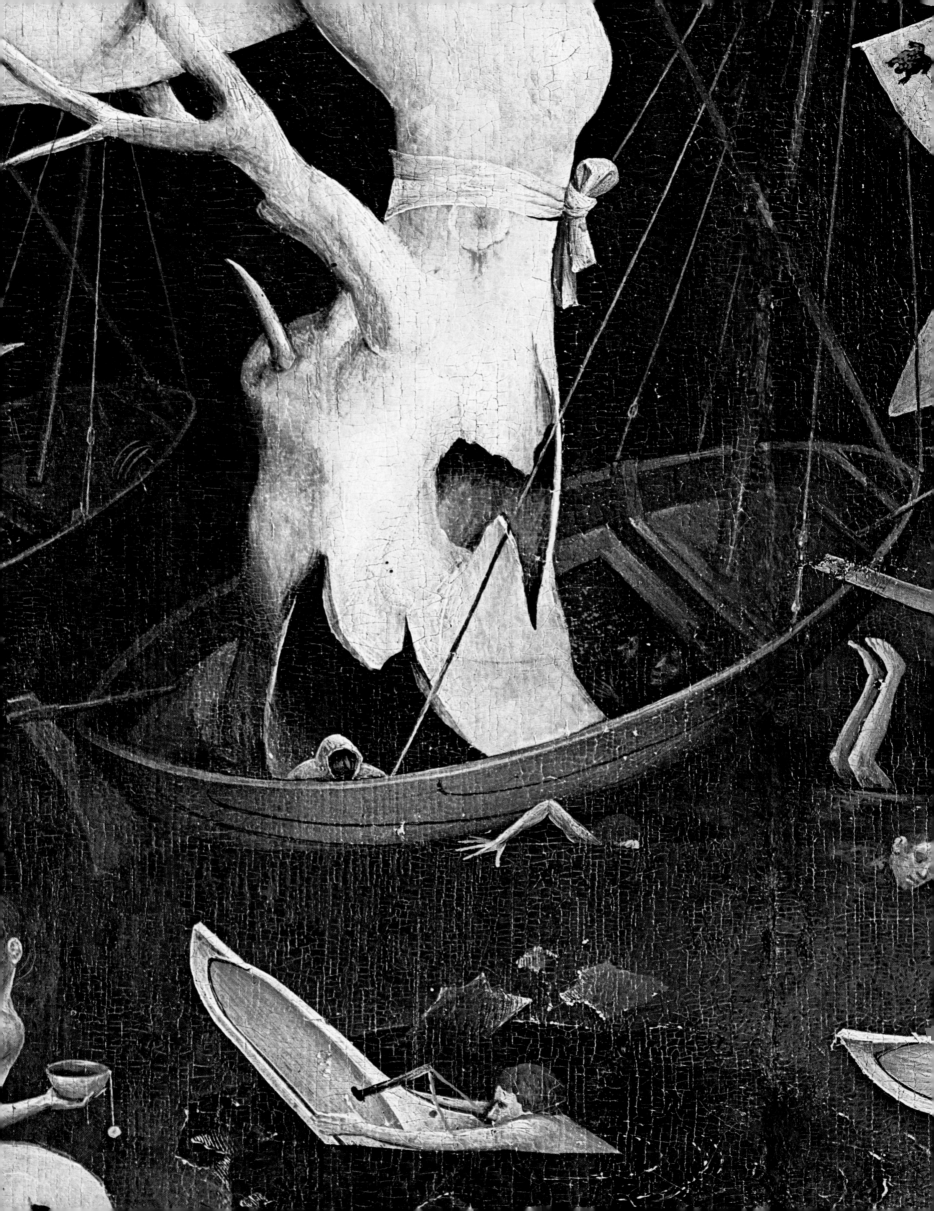

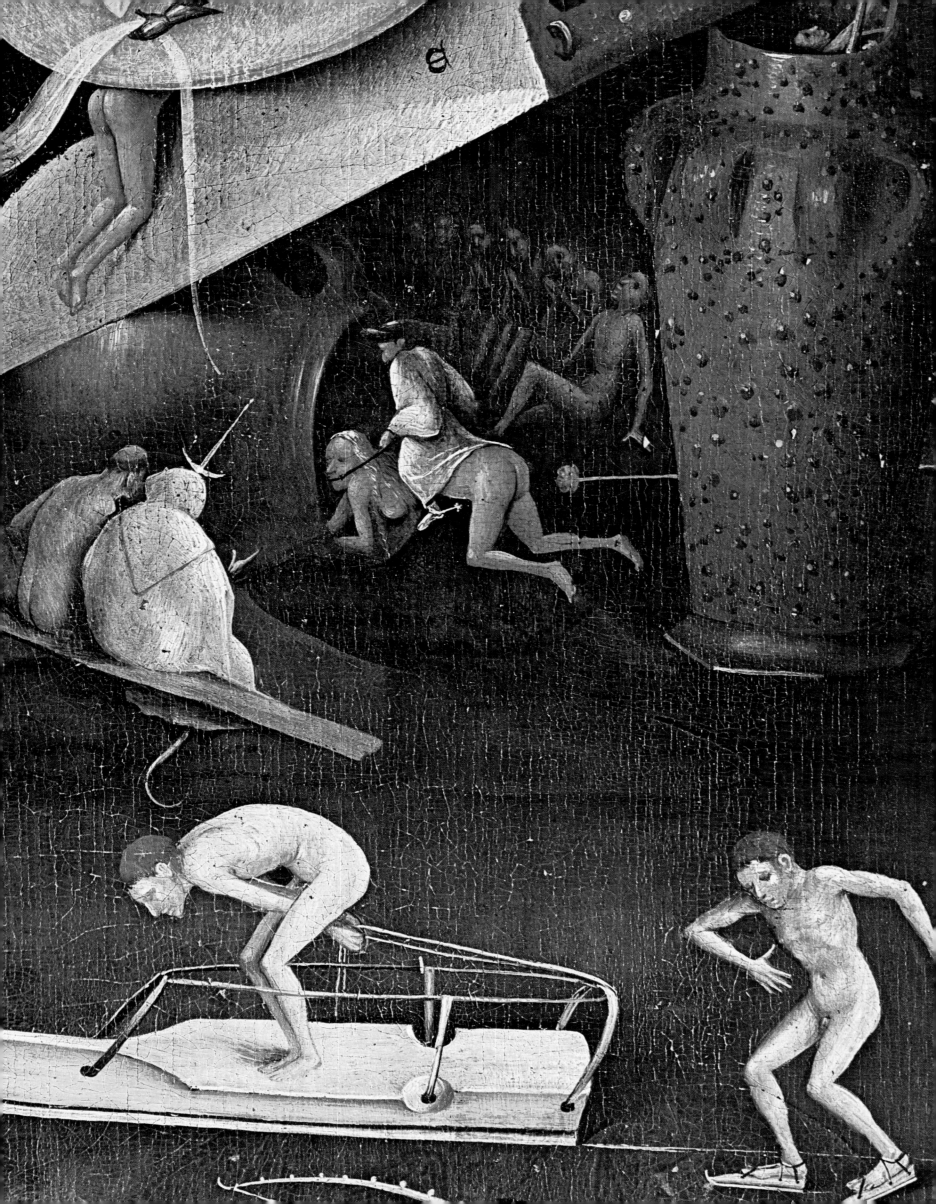

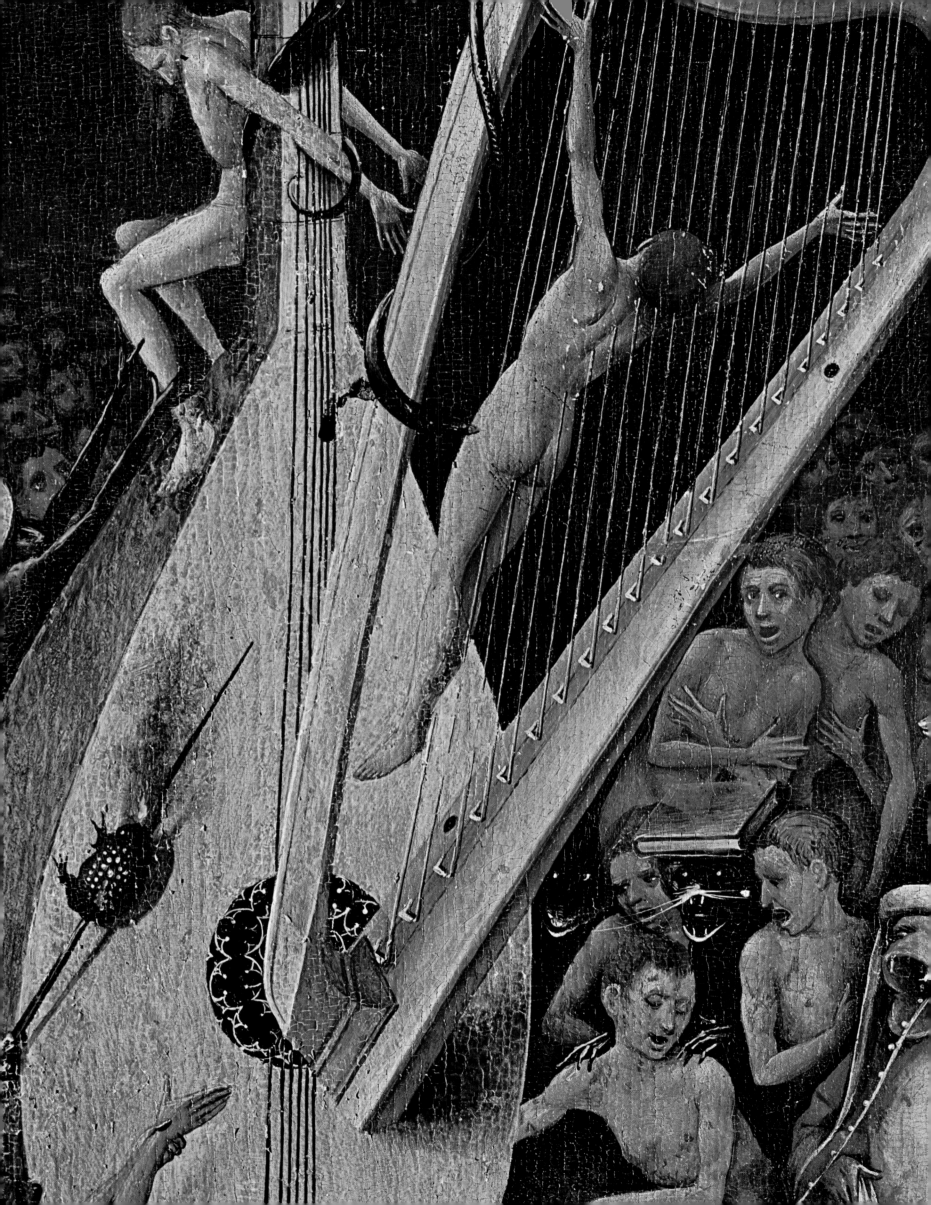

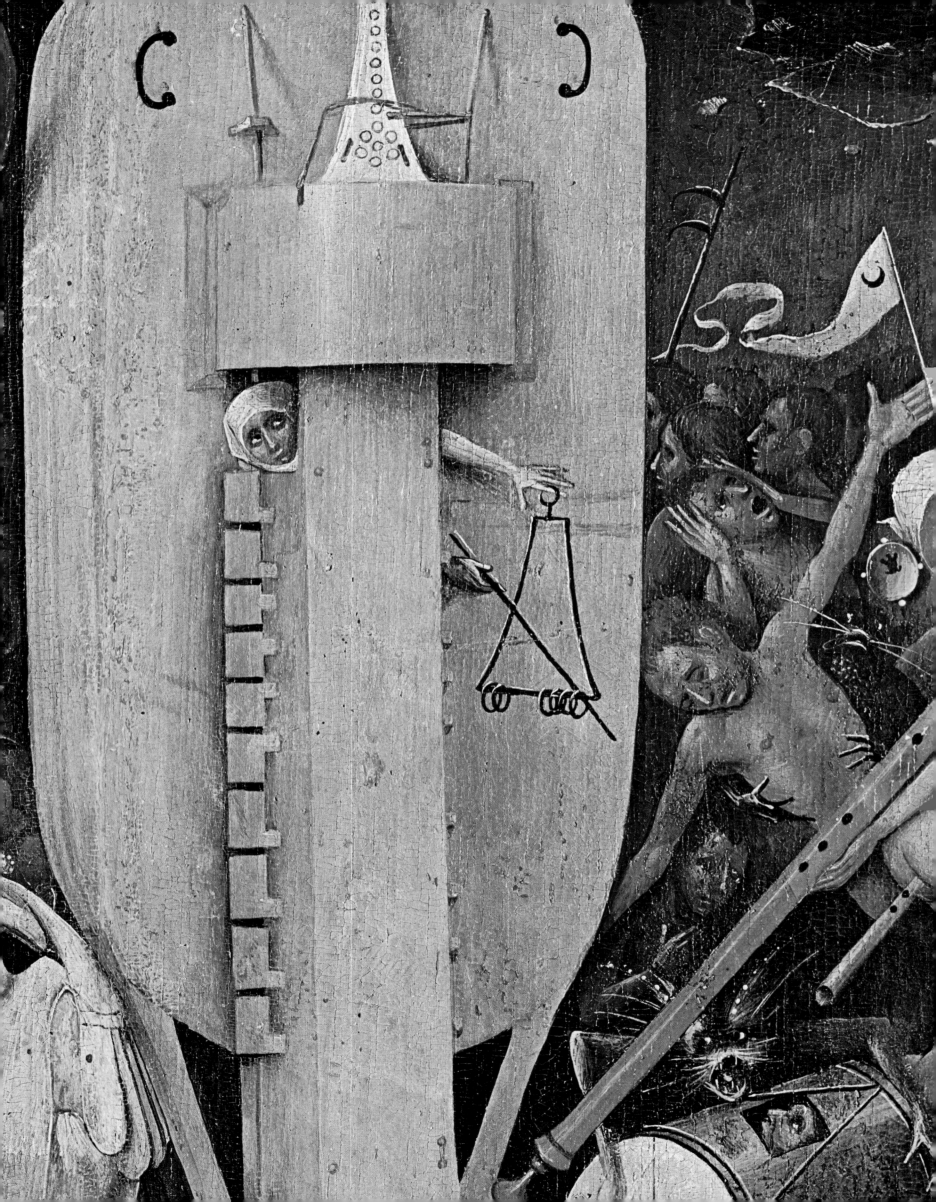

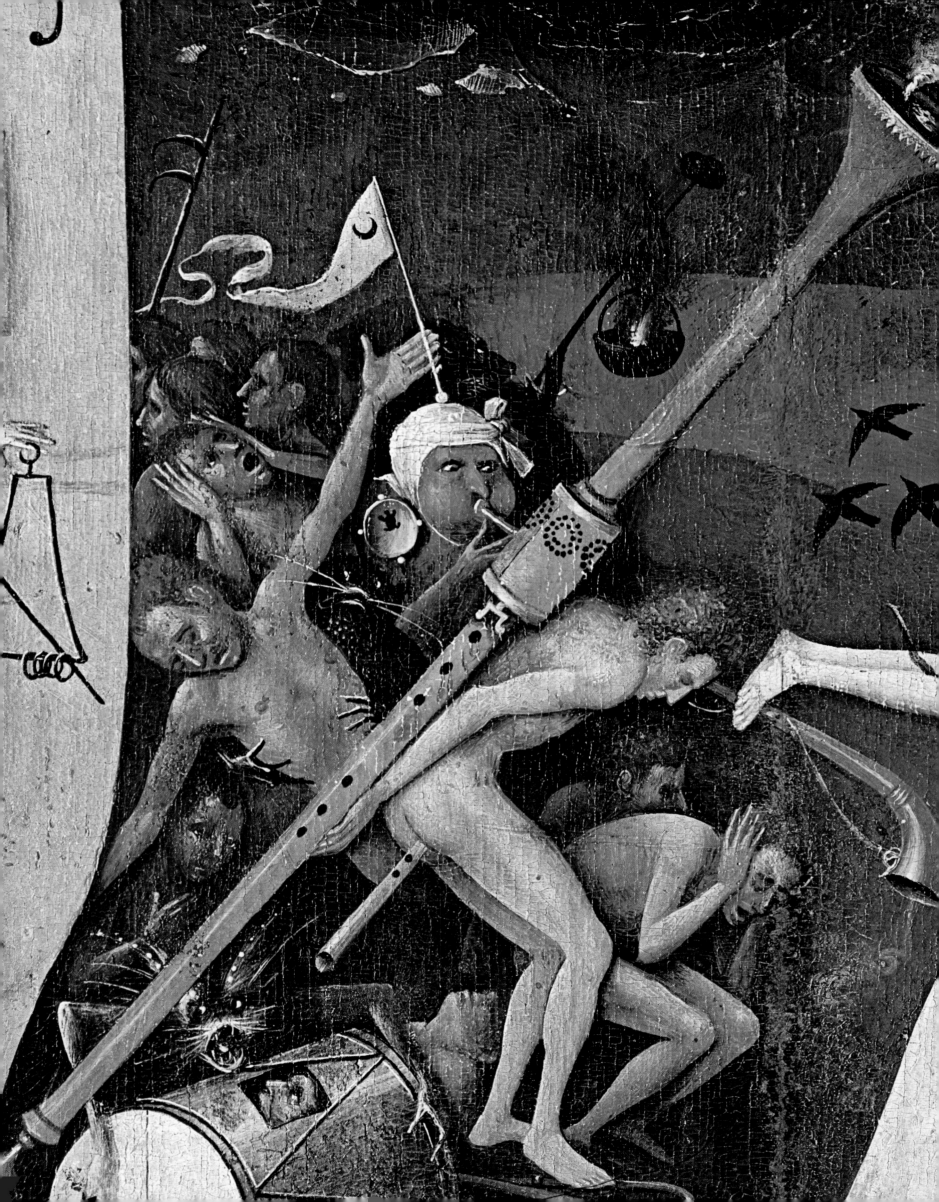

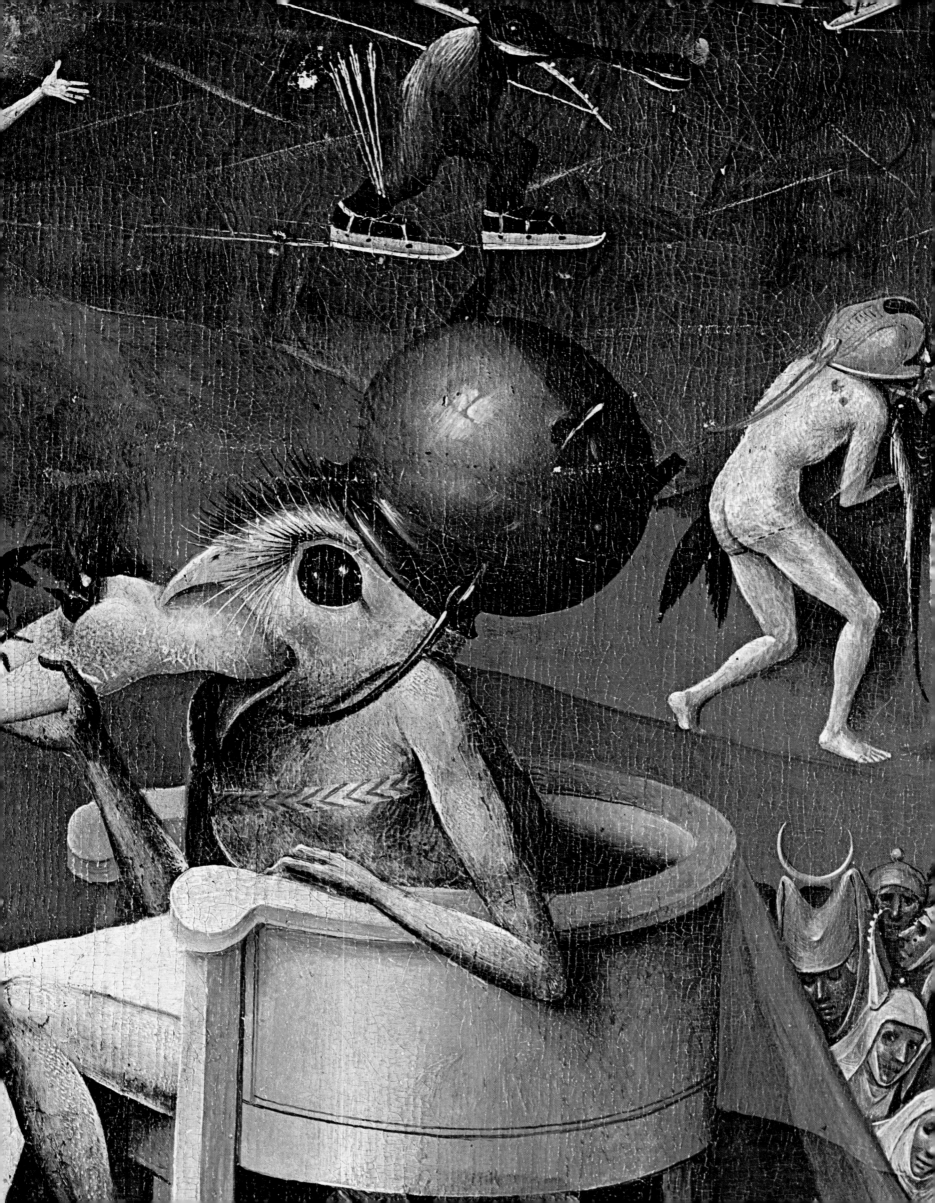

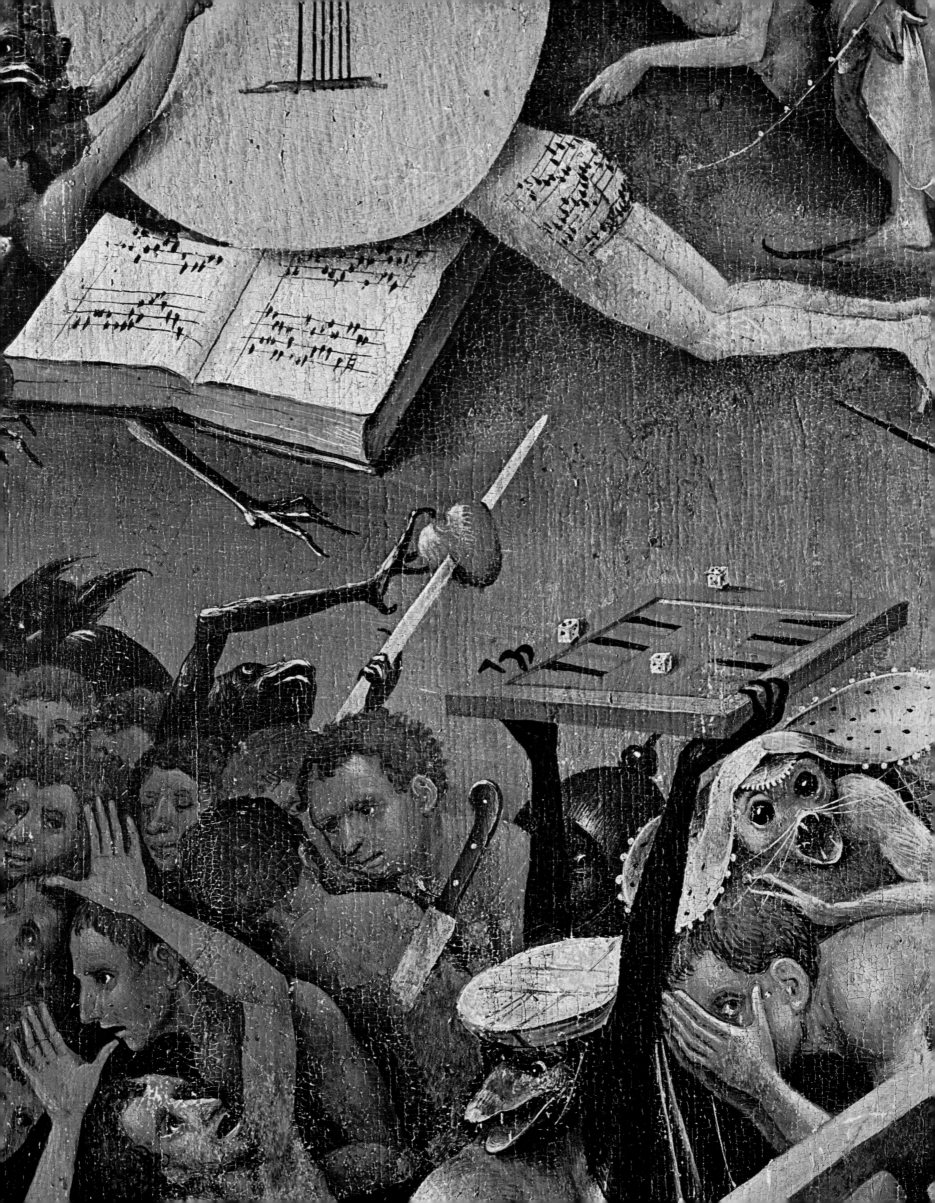

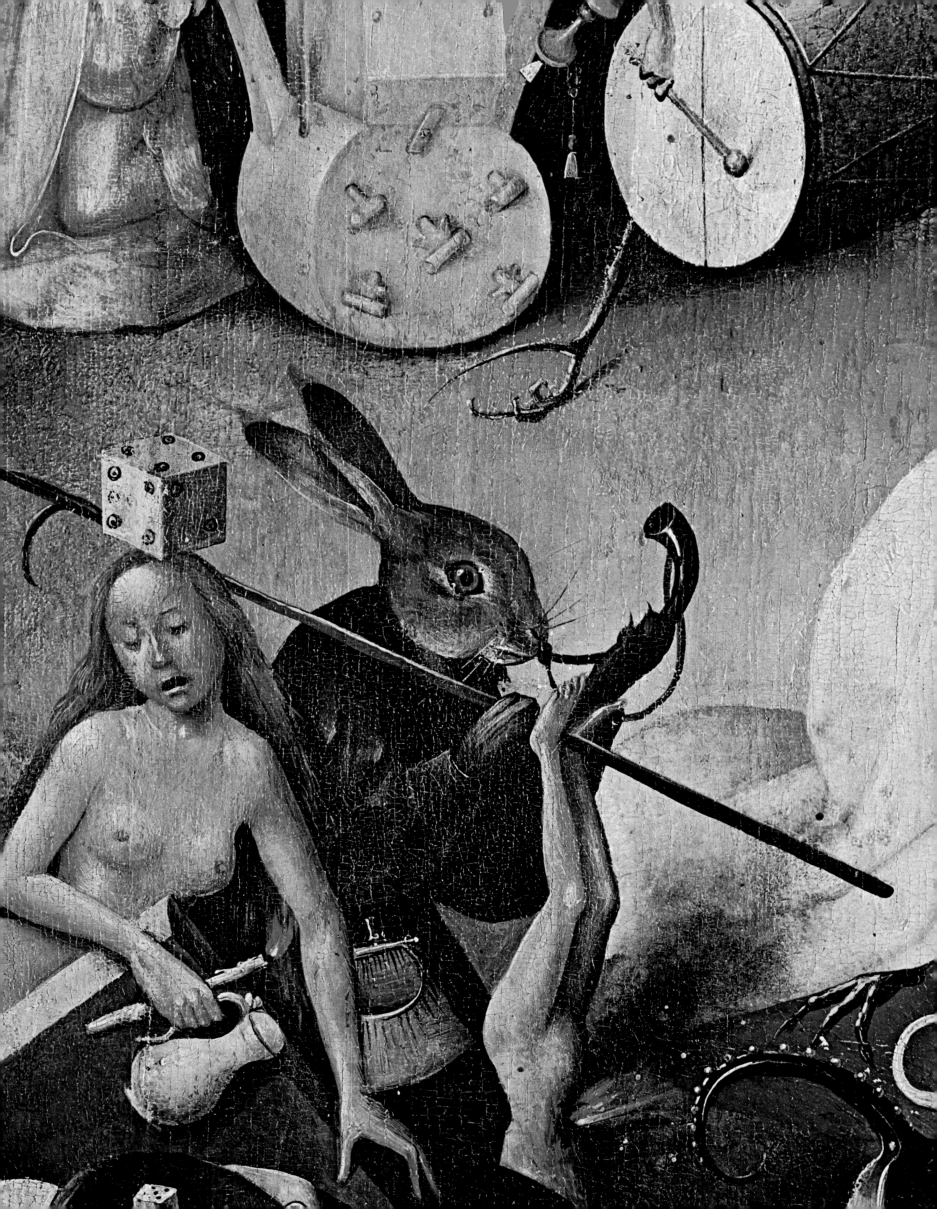

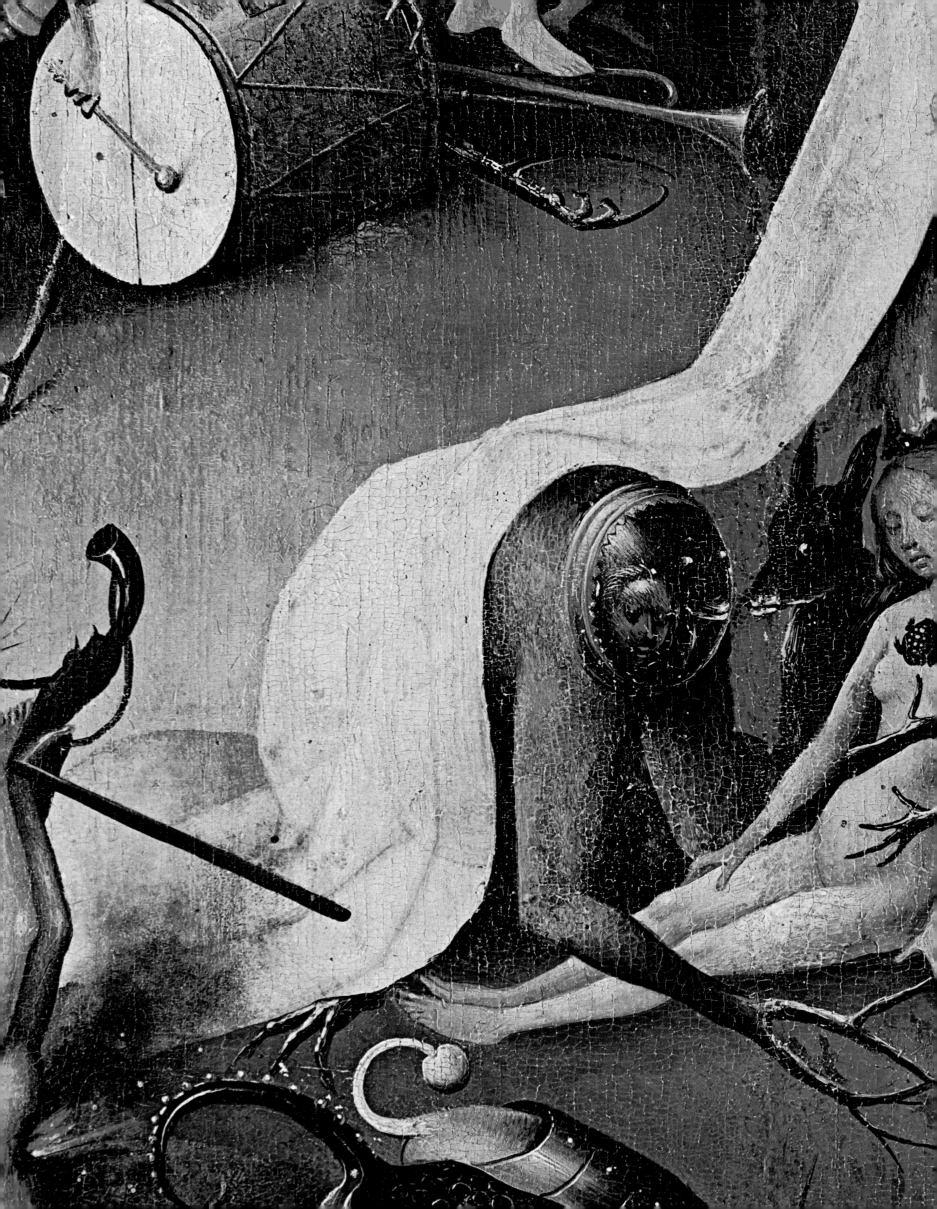

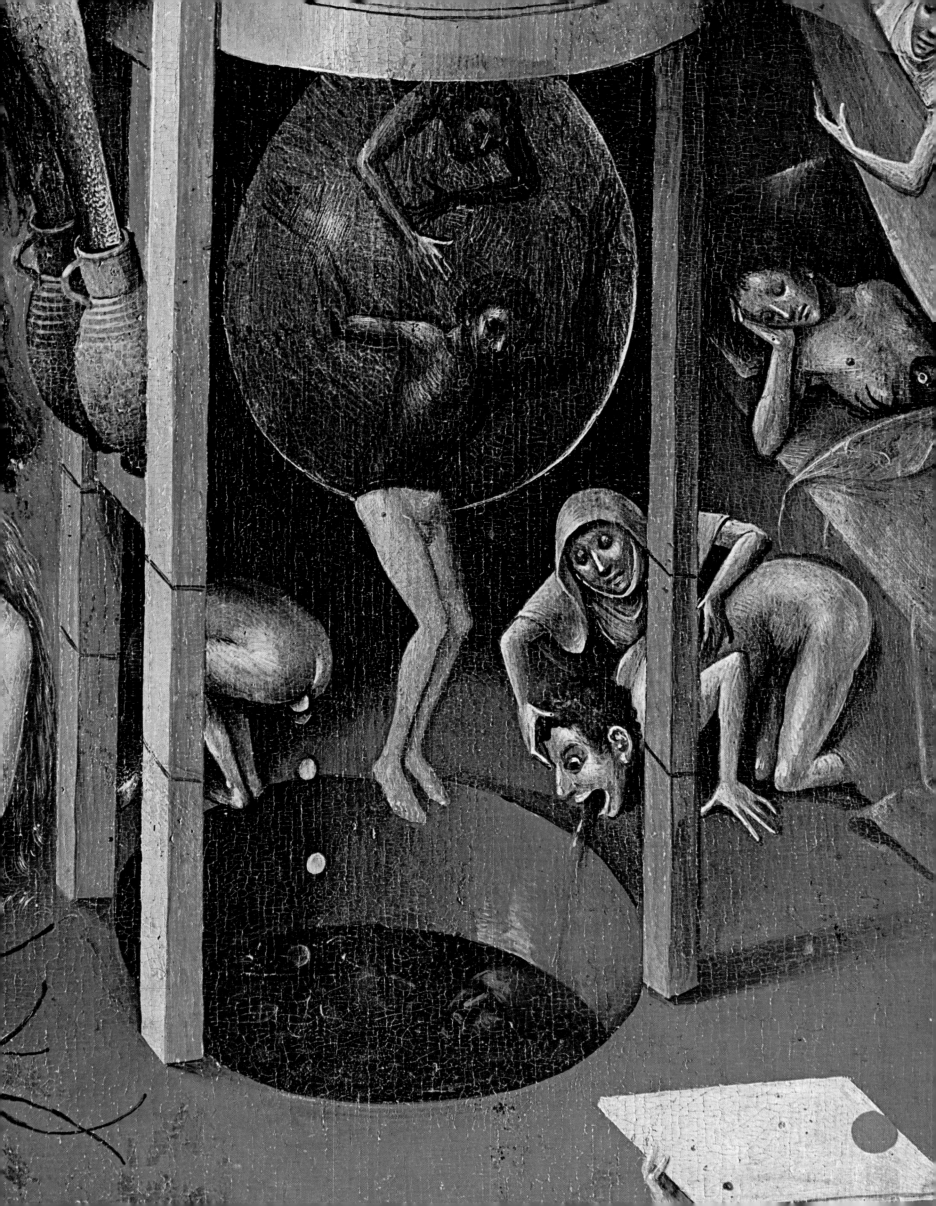

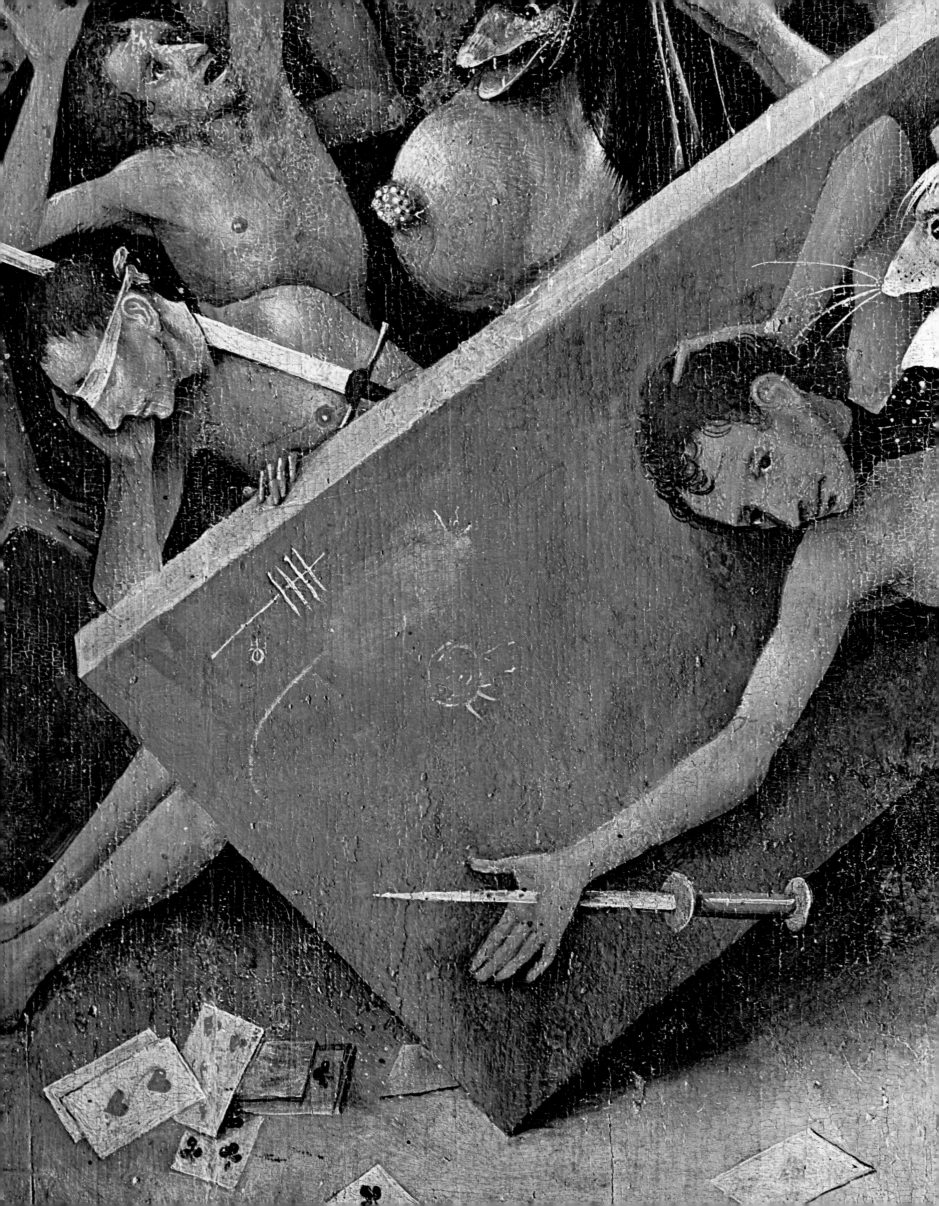

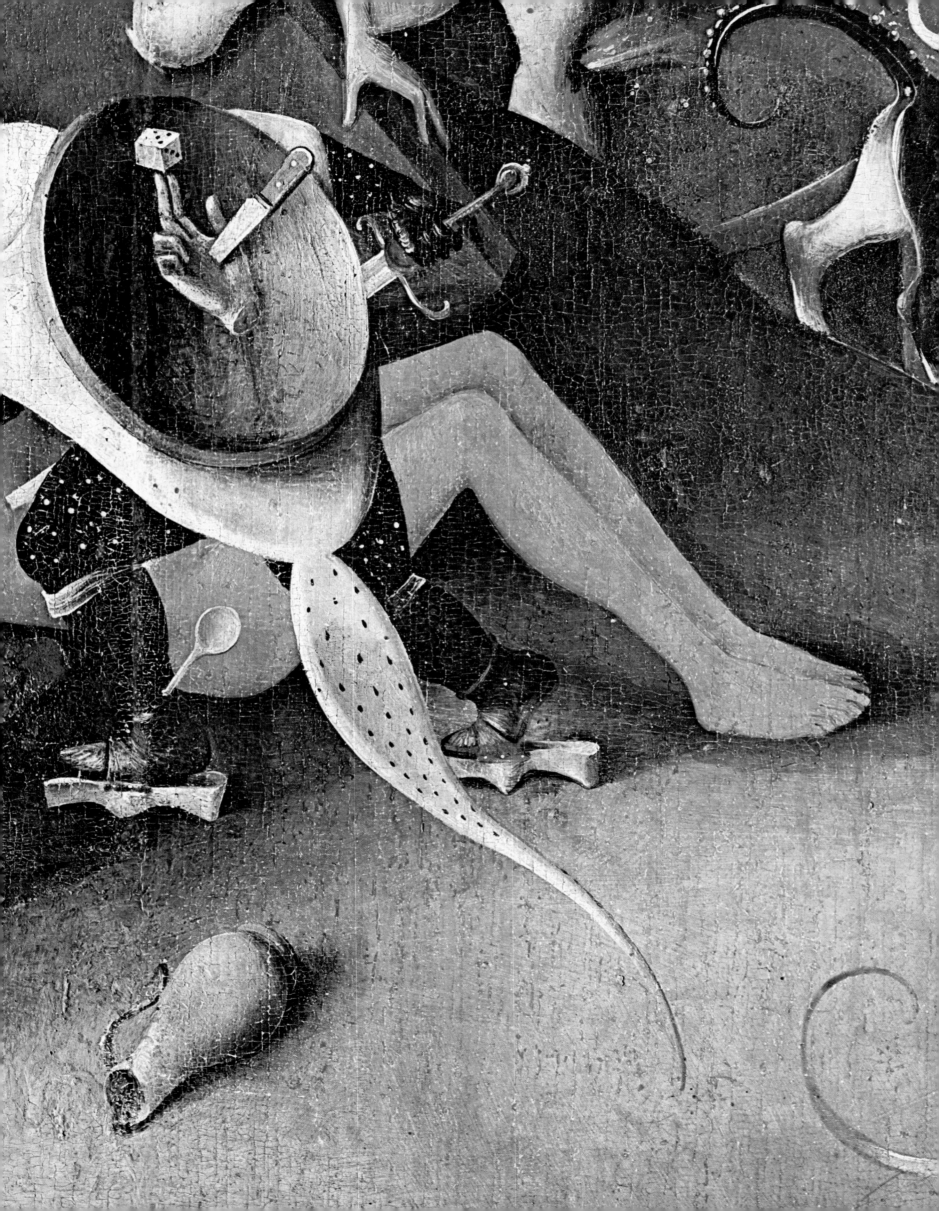

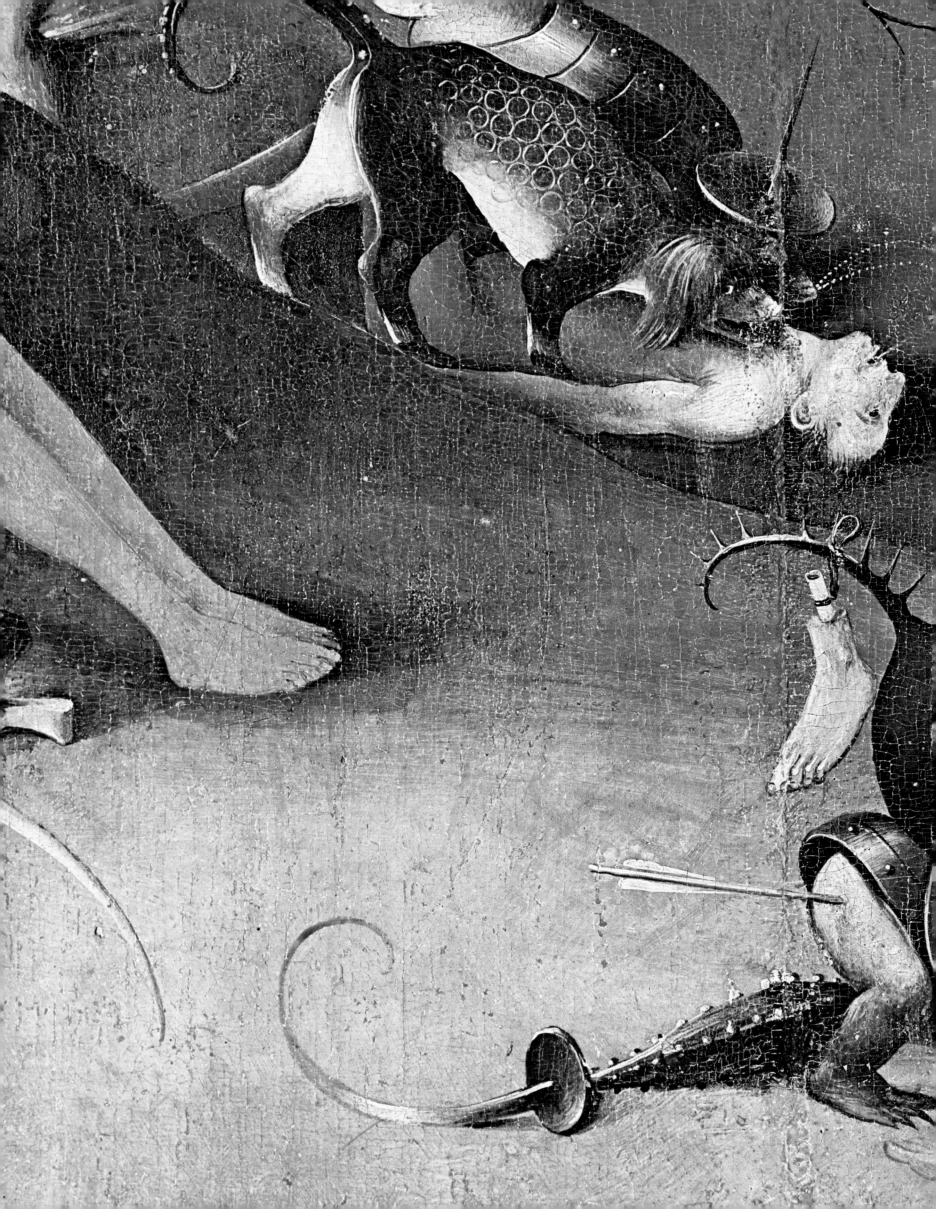

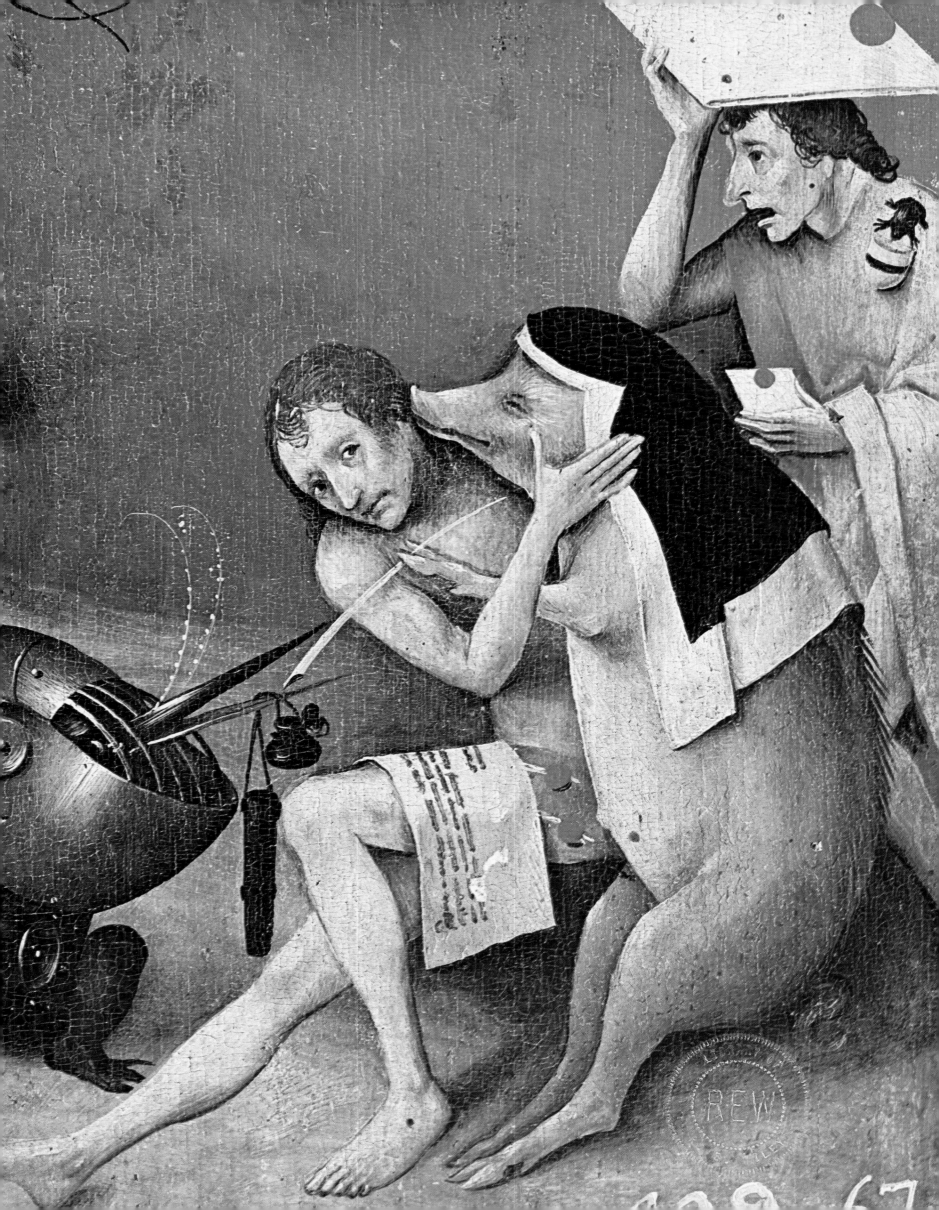